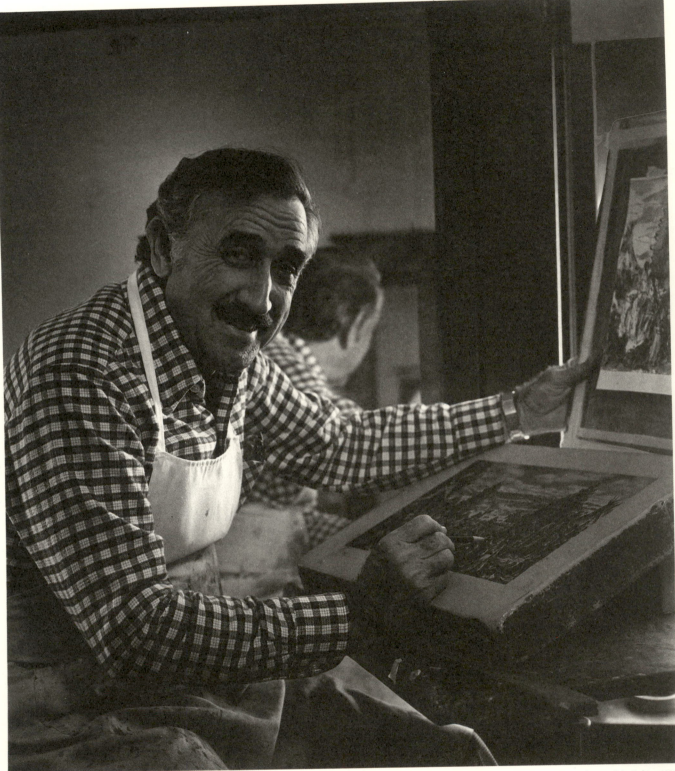

The Lithographs
of Charles Banks Wilson

By David C. Hunt

With Commentary by the Artist

UNIVERSITY OF OKLAHOMA PRESS : NORMAN AND LONDON

BY DAVID C. HUNT

Guide to Oklahoma Museums (Norman, 1981)
(with Marsha V. Gallagher) *Karl Bodmer's America* (Lincoln, Nebraska, 1984)
(with Paul A. Rossi) *The Art of the Old West* (New York, 1985)
The Lithographs of Charles Banks Wilson (Norman, 1988)

Library of Congress Cataloging-in-Publication Data

Hunt, David C., 1935–
 The lithographs of Charles Banks Wilson.

 Includes index.
 1. Wilson, Charles Banks—Catalogues raisonnés.
I. Wilson, Charles Banks. II. Title.
NE2312.W55A4 1988 769.92'4 88-40211
ISBN 0-8061-2151-3 (alk. paper)

The paper in this book meets the guidelines for permanence and durability of the Committee on Production Guidelines for Book Longevity of the Council on Library Resources, Inc.

Contents

v

Illustrations

The Lithographs

A Note to the Reader

When I left my home in Oklahoma in 1936 to study at the Art Institute of Chicago, America was still suffering the effects of economic disaster on the home front, and chaos was developing in Europe; most of the Great Plains were blowing away, and the Okies had been set adrift. An era of social consciousness was slowly awakening, and concern with things American was being emphasized in literature and the visual arts. Although the genesis of the movement known as American regionalism preceded me slightly, the concept still excited my interest in using my surroundings as subject matter.

The American regionalist movement emerged when people as a whole in this country were looking inward. Their concerns were with American rural and urban life. The whole country seemed to be taking stock; and because art does not lead, but reflects, artists fulfilled a social function by expressing the perceptions of the spectator as well as of the artist—and they spoke in understandable forms.

My America was not the urban America that gave motif and inspiration to John Sloan, Reginald Marsh, and Edward Hopper, nor was it the same rural America depicted by Thomas Hart Benton, Grant Wood, and John Steuart Curry. My America was Oklahoma—an environment of varied landscapes, farmers, cowboys, miners, and Indians.

In the nineteenth century Oklahoma had been the place of relocation for sixty-three Indian tribes from far corners of the country. At that time the territory was known to be a beautiful, bounteous place, a hunter's paradise, but it wasn't long until pioneer Americans began to need these lands too—and there went the neighborhood. The sodbusters tore up the earth, turned under the buffalo grass, and planted their crops. Coal, lead, zinc, and oil were discovered, and industry moved in. All this set the scene for me. The regionalist concept had prepared me to see all these phenomena as an artist.

I used to chide Indian artists I knew at the time for using hearsay as their subject matter: Grandfather's stories, for instance. I used to say at every opportunity, "Isn't *this* an exciting time? A whole race of people is moving in such a short time from its own history into a totally foreign society—and you are seeing it, you are a part of it—paint your personal experience." Although few took heed of my advice, I did, and from that point on I dedicated myself and my work to my neck of the woods, its people, landscape, and history.

As my interest in recording modern American Indians grew, however, I became aware of the public's ambivalence toward them. Despite its appreciation and delight in things "Indian," the public found in Indians much to criticize and discriminate against. There was little interest in "modern Indians." This attitude so influenced me that eventually I found myself concentrating on other subjects—farmers, cowboys, miners, rivers, creeks, and scenes along country roads. After 1941, when I portrayed Indians in lithographs they were in either ceremonial or historical contexts.

During and shortly after World War II a concern for things European developed in America, and the national art movement became more European. Regionalism was submerged in "abstractionist" trends: art inspired art; "art" became its own subject. "Art for art's sake" became the catch-phrase of the era, avoiding cultural meanings. Critical and aesthetic society denounced regionalism as "provincial."

A new nostalgia has arisen in the 1980s as America looks backward with fondness for simpler times and expresses once again an interest in things American. There is a revival of interest in the Indians of the Old West, and the art of the 1930s and 1940s is in the midst of a regrowth of national interest.

I have often said, and I believe it is true, that an artist is important if he records his time and place, and I have tried to do that. Kenneth Clark, in his book *Civilisation,* however, brings up a provocative point when he observes that Raphael spoke of *his* time in his painting and is today not as much appreciated as Michelangelo, whose painting speaks of *all time* and *all men.* Thomas Hart Benton wrote in *An*

American in Art that "responses to art must rest on its form and the willing participation of the spectator to give it meaning." Thus, I suspect that, in the end, the success of my art must be judged on its aesthetic form rather than on what motivated or inspired it. Simply put, these lithographs must stand, finally, as works of art above anything else.

CHARLES BANKS WILSON

Miami, Oklahoma

The Lithographs of Charles Banks Wilson

Charles Banks Wilson: A Biographical Sketch

David C. Hunt

Almost anyone who lives in Miami, Oklahoma, can direct you to Charles Banks Wilson's studio, on Main Street. Wilson has occupied this studio, which is on the second floor of a commercial building overlooking a busy downtown intersection, for much of his professional life, and he still spends most of his time there, employed at the drawing table or easel when he is not out sketching or on the road gathering material for one of his projects.

On entering the studio for the first time, visitors often experience a certain amount of confusion. Encompassing several rooms off a large hallway that runs the length of the building, the studio presents a somewhat formidable aspect to those unfamiliar with the artist's environment. The merely curious tend to be distracted by displays of paintings, prints, Indian artifacts, and pottery casually placed on tables and shelves, although the serious student or collector soon realizes that amid all the seeming clutter is a good deal worth closer examination. This is a workplace, not a showplace, but one where the studio guest is sure to meet with a welcome and may be encouraged to stay long enough to learn something about the creative process firsthand.

Wilson is accustomed to interruptions and takes them in stride, having accepted over the years the celebrity that comes with success. He never seems too busy to show visitors around the premises, discuss his latest commission, or explain his ideas about art. He is especially proud of the litho press standing in the back room, which is reserved for printmaking. Widely known today as a portrait painter and muralist, Wilson thinks of himself chiefly as a lithographer, preferring the original print as a medium of expression because he has always liked to draw. Form and line in a composition matter more to him than color, and as he says, "Form and line are what lithography is all about."

Wilson's philosophy with regard to art is entirely practical. He thinks that an artist should know something about almost everything and be able to represent almost anything. At the same time he insists that, as an artist, it is necessary for him to know how he fits into the scheme of things, to understand himself in relation to his own time and place. Representing that time and place is the artist's primary mission, according to Wilson, who feels strongly that in depicting the local and regional scene he has "been in the right place at the right time to record something important." If he has any regrets, he makes no apologies for having been more of an observer than a participant in the activities he has chosen to portray.

"I've missed a lot by watching instead of doing," he now admits, "but you can't be a reporter and on stage at the same time. Being an artist is a full-time job. You don't just work when the mood strikes you. You have to work at it every day like people at other jobs. It doesn't leave much time for anything else."

Born in a small town in Arkansas and reared in a small town in Oklahoma, Wilson continues to demonstrate that his native environs are conducive to creativity and uniquely suited to his own approach to art. Nearly everything that has inspired him as an artist he has discovered within a comfortable distance of home. Sometimes criticized for presenting his subjects in an "uncompromising" manner, he credits this attitude to an upbringing by parents who were more concerned with developing his character than his talent and from whom he acquired the concept of integrity as a primary virtue. In terms of art, "getting it right" was more important than the sensibilities of the viewer or the possibility of adverse opinion from critics.

Most people relate personally to Wilson's depictions of everyday life and respond positively to their realism. This response is due in no small part to Wilson's gift for graphic description and his ability to communicate ideas through the effective use of familiar forms and images. Humor, too, is a predominant feature in Wilson's makeup, and it shows in much of his work. The satire implicit in many of his drawings and prints is unmistakable, but even when he is pointing out the inconsistencies in human nature, he never makes light of the human condition.

Although his style has changed as he has ma-

tured, Wilson has always followed his own instincts and seldom, if ever, worried about conforming to current taste or changing trends. More often than not, the differences in subjects have dictated variations in technique, or his feeling for a person or a place has suggested a particular medium or method of handling. For Wilson, however, style is merely the "surface quality" of art, reflecting temporary influences in the life of the artist. The underlying principles remain the same.

In the fifty-odd years since he pulled his first impression from the stone, Wilson probably has printed and sold more lithographs than any other artist now living. The popularity of his work and the attention it has received are evident in the number of examples to be seen in museums and private collections in the United States and abroad. Yet for all of the recognition that has come his way, Wilson is aware that the artist's place in the world is not what it was even thirty years ago, and that some of the forms art takes today seem less relevant to the average person than once was the case.

Acknowledging the isolation in which many artists now work, Wilson nevertheless feels that art makes a vital contribution to society through its interpretation of contemporary life. Indeed, he affirms that a work of art, whatever its form or content, cannot avoid making a reference of some kind to the age or society that produced it as well as a statement, perhaps its most significant statement, about the personality of the artist who created it.

"Art has to say something," Wilson declares. "It has to talk about something other than itself—present a subject outside itself. The artist's idea may provide a motive or a subject for art, or sometimes the subject gives him the idea; but then art takes over. The result, as art, has to stand on its own."

Wilson's grandparents on his father's side were Oklahoma pioneers. His grandfather John Joseph Wilson made his living as a trapeze performer in his brother's circus and later drove a stagecoach between Neosho and Springfield, Missouri, before moving in 1903 to Miami, in what was then Indian Territory. With him came his wife, Carrie Viola, and his son, Charles Burtrum, who had been born in Illinois, where the Wilsons lived before moving south.

In Miami, J. J. Wilson found work as a house painter. Carrie opened a restaurant and also served the community as a Christian Science practitioner.

Charles Burtrum grew up hoping to become a professional musician. The trombone was his speciality, and at one point in his youthful career he studied in Chicago under the celebrated H. A. Vandercook. Later he played with a group known as Crawford's Comedians. That was before he married Bertha Juanita Banks, a grade school teacher.

Bertha and Charles Burtrum Wilson's first child, Charles Banks Wilson, was born on August 6, 1918. At that time Bertha was staying with her parents in Springdale, Arkansas, where her father, John Jefferson Banks, was a figure of some importance in state politics. Husband Charles was stationed with the U.S. Army in France. Having entered World War I as a musician, he had advanced to the position of director of a divisional band. Also a stretcher-bearer in combat, he was at the front when he received word of the birth of his son.

After the war the Wilsons resumed life together in Miami. The elder Charles, like his father before him, worked as a house painter and eventually opened a small paint and wallpaper store downtown. He left off playing the trombone except on special occasions. He took an active interest in his son's development and devoted much time and attention to him as he grew up.

"Hardly a day goes by," Charles Banks Wilson says today, "that I don't do something and then realize that my father taught me how to do it."

The paint store furnished young Wilson with his first drawing materials. He tended from an early age to draw on whatever came to hand: sheets of cardboard from paint cartons stored in the family garage, the backs of pictures, the undersides of tables and chairs. He recalls that his "first mural" was executed underneath the table in the kitchen.

In time his parents supplied him with better materials but took care neither to push him forward nor to hold him back where his interest in art was concerned. When he showed his mother an example of his work, she often would not say what she thought of it but instead would ask him, "Do *you* like it?" This encouraged a habit of self-criticism and an independence of mind that were to serve Wilson well in later years.

Wilson was a youngster when his grandmother Carrie Wilson lost her eyesight, a misfortune that had the effect of bringing the two of them closer together. Carrie's sense of personal worth and her unfailing good humor in adversity made a lasting im-

pression on the boy. She, in turn, came to depend on him for visual information.

In describing the world for her as he saw it, Wilson learned to pay close attention to the appearances of ordinary things and to the details of forms and faces, a trait that later distinguished his work as a portraitist and printmaker. He now feels that in many ways the women in his family, especially his mother, his wife, and, in recent years, his daughter, have had a greater influence on both his character and his career than have the men.

Wilson received no formal training in art until he entered high school, when he enrolled briefly in a beginning class and took a correspondence course through the Federal Art Schools program. Finding instruction by mail too impersonal, he lost interest and quit after three lessons. While actively involved in high school dramatics, music, and sports, he continued to draw in his spare time, including among his projects sets for school plays and blackboard murals in colored chalk for English and history classes; but drawing and painting were more in the nature of pastimes than serious pursuits.

He gained some experience from townspeople who were willing to help him in his artistic efforts. A local newspaperman showed him how to reduce pictures to scale. The manager of the Coleman Theatre allowed him to paint posters. He became friends with the owner of a sign shop, who let him use his brushes and paint. The principal at the high school also encouraged him.

An exasperated study-hall teacher once wanted to expel Wilson from school because he spent too much time in class drawing pictures and distracting the other students, who enjoyed watching him. The principal advised, "Leave him alone. I think he may be something special."

Wilson now reflects: "In a small town of only 8,000 inhabitants, I became a kind of community effort."

During his senior year Wilson began thinking about what he should do when he graduated. Grandmother Carrie suggested that he might be able to earn a living as a cartoonist. His parents were skeptical about art as a career choice, but at the urging of a family friend they allowed him to apply for admission to the Art Institute of Chicago, which he entered in the fall of 1936 at the age of eighteen. He was placed immediately in advanced classes with students several years older and more experienced than he was.

"I was put into really deep water," he says today. "I should have been put into the beginning class, not the upper class; but it turned out to be a good thing. I had to work like the devil to keep up."

The challenges Wilson faced in Chicago were formidable. Composition was stressed at the institute, and a strong emphasis was placed on the "old master" approach to drawing and painting. Art history was a required course. At the same time students were advised not to forget where they had come from and what they already knew. The axiom to "draw what you know" came to have a particular significance as Wilson applied it to himself.

His roommate, "Tex" Hammill, some ten years Wilson's senior, kept him from feeling too discouraged during this first year at the institute by insisting that he work hard at his studies, "get down to business," and draw something every day. Wilson began spending many hours drawing outside of class, sketching people and exhibits at the Field Museum of Natural History, travelers at the railroad station, and live models at the drawing class that Hamill held on Saturdays for some of his friends.

The institute offered a course in lithography to students who thought they might like to draw on stone. Francis Chapin had charge of the printmaking department in those days. He gave no specific instruction in drawing, as such, but supervised the technical aspects of the printing process. What the student chose to draw was up to the student.

Wilson was interested primarily in people as subject matter, although he felt that his life up to that point had not offered the kind of subjects to inspire serious art. Also influenced by the regionalist trends of the time, he concluded that his part of the country possessed one truly unique feature. Oklahoma had been the final settling place in the nineteenth century for more than sixty tribes of American Indians. Wilson's area, Ottawa County, was home to thirteen tribes.

In Chicago everyone wanted to know where you were from. When Wilson said he was from Oklahoma, one of the first things he was asked about were the Indians; so when he began drawing on stone, he drew Indian and western subjects, mostly from imagination. Then during the summer of 1937 he went home between semesters and visited the powwow grounds near the town of Quapaw, east of

Miami, to take a closer look at what he had been trying to represent.

"I went out with a friend," he recalls, "pitched a tent, and participated in the powwow, the war dances, and all that was going on. I made a few drawings that I kept under my cot and never showed to anyone because they weren't very good; but there at the powwow that July, I began to see a different side of Indian life. When I went back to the institute in the fall, my subject matter became almost entirely Indian."

His instructors in Chicago were not particularly impressed at first with his efforts. He was embarrassed when one of them dropped by the lithography studio one day, noticed what he was doing, and promptly dismissed it as "*National Geographic* art." What compensated him for his instructors' initial lack of appreciation was the favorable response of his fellow students to his work:

"They bought my prints nearly as fast as I could pull them off the press. Not all impressions were accounted for, so there were actually more prints made of some drawings than the number of the edition would indicate today."

Most of these early lithographs were printed in editions of ten to twenty prints. At the time Wilson supposed there were not more than twenty people in the world who would want one of his prints.

In 1938 he began entering his work in regional shows. In 1939 he exhibited in Washington, D.C., in the National Student Show sponsored by the U.S. Office of Education, and at the Carnegie Institute, in Pittsburgh. That same year he also received a purchase award from the Chicago Society of Lithographers and Etchers and the Student Achievement Award from the Advertising Council of Chicago. Following the International Watercolor Show and the International Graphics Show, which were held at the Art Institute of Chicago in 1940, examples of his work in both media were added to the institute's museum collection.

Awards were gratifying, but after nearly three years at the institute Wilson felt that he still had not hit upon what he really wanted to do as an artist. Hoping to focus his energies on a subject he knew best, he decided to stay out of school for a semester and devote all his time to painting Indians.

At home again for the summer in 1939, he set up a studio above the family paint store downtown. The store was across the street from the bus station,

where Wilson obtained most of his models, who found the studio a more comfortable place than the station waiting room in which to pass the time while waiting for a bus. Most of those who consented to pose for him were Seneca Indians. Wilson paid them twenty-five cents an hour—not a bad wage, Wilson recalls, during the Depression.

On many days a crowd of people filled the long hallway outside the studio, some smoking clay pipes or combing and rebraiding their hair, others visiting with each other in their respective tribal tongues, while inside Wilson worked at his easel with scarcely a break from morning until evening. A first sitting might require three hours, a finished portrait from one to three days. These were life-size works painted on Montgomery Ward's best cotton canvas, which Wilson stretched and primed himself.

His sitters knew little or nothing about art. Their judgment of his work as a portraitist was based simply on whether or not he managed to produce a convincing likeness:

"So I concentrated on getting a good likeness. If a man came to me in overalls, I painted him in overalls. I drew directly on the canvas with oil and turpentine, then covered it as quickly as possible in color to establish values. I had to paint fast because some subjects never returned for a second sitting, and two or three sittings were all I was ever apt to get."

Back in Chicago at the beginning of 1940 and still wondering what would happen to him when he left school, Wilson sought the advice of political cartoonist Carey Orr, of the *Chicago Tribune*. Orr was interested in Wilson's cartoon samples, but even more so in the lithographs he showed him.

"I tell you what," Orr said. "You teach me what you know about lithography, and I'll teach you all I know about cartooning."

This arrangement worked well, and Orr soon considered Wilson competent to try for an apprenticeship with the *Chicago Tribune-New York News* syndicate in New York City. With portfolio in hand, Wilson headed for New York, where he was introduced to several well-known strip cartoonists. He was disappointed, however, when the task he was assigned consisted of inking in the drawings for a syndicated comic strip. After about a week he gave it up, convinced that it "just wasn't art!" When he left New York and returned to Chicago to resume his studies at the institute, he felt a sense of relief at

having escaped from what seemed to him an un-fulfilling line of work.

Back in Miami that summer, he varied his Indian studies with a series of sketches made underground of the workers employed in the lead and zinc mines of the tri-state area of Oklahoma, Kansas, and Missouri. Several of these sketches were reproduced in the *Miami News-Record*. National exposure followed in October, when *Coronet* magazine featured three of Wilson's lithographs in an article about Indians by Louis Zara entitled "Native Within Our Gates." The *Federal Illustrator* subsequently published an article on Wilson entitled "Indian Lore His Specialty," which reviewed the exhibitions and awards of his student career and mentioned his earlier participation in the Federal Arts Schools program.

Meanwhile, in Chicago, painter Aaron Bohrod encouraged Wilson to send a selection of his prints to the Associated American Artists organization, in New York City. Missouri artist Thomas Hart Benton, a member of the association, noticed Wilson's work and recommended to the professional artists' group that it commission something from Wilson. Wilson offered to come to New York to execute a print. Heartened by the positive response to this proposal, he made plans to return to the East Coast. First, however, he returned home to Oklahoma with a proposal of a different kind.

In 1937 while attending the powwow at Quapaw, Wilson's attention had been drawn to someone he had never really noticed before: a young Quapaw woman of considerable charm and grace. Her name was Edna McKibben. As he watched her from across the dancers' circle, illuminated by the flickering light of the cottonwood fire, she seemed to him "the most beautiful girl in the world." The emotions of the man and the imagination of the artist were immediately captivated.

Wilson was unaware that he and Edna had attended school together in Miami, and only later did he learn from Edna that at the time she had regarded him as something of a snob. After graduating from high school, Edna had gone on to attend the local junior college while Wilson pursued his studies in Chicago. They began dating when he was home again between semesters at the institute. In the summer of 1941, Wilson asked Edna to marry him.

The wedding, a private ceremony witnessed by the respective families, took place in Miami's First Presbyterian Church. Edna's brother Harvey served as the groom's best man. Following a hurried reception, Charles and Edna boarded a train for New York City, where they lived with a relative of Edna's while they looked for a place of their own. Eventually they found what they wanted in the remodeled attic of a house in Bay Ridge, Brooklyn. The apartment featured a large living area with a skylight at one end. Here Charles set up his studio and began work on the commission for Associated American Artists.

"It was a garret," he recalls today. "Maybe not in Paris, but it was an artist's garret if there ever was one."

Associated American Artists paid him two hundred dollars for that first print, but even in 1941 that was not enough to live on, so Wilson looked for steadier employment in the offices of newspaper and magazine publishers downtown. *Collier's* gave him some work, but he soon began to feel that illustrating magazine articles was only a step above cartooning. Where art was concerned, his hopes ran higher than that.

Those first few months in New York were lonely ones:

"I remember coming back in the afternoons and catching sight of Edna, crouched beneath the sloping roof of our apartment, peering out of the small porthole of a dormer window, waiting for me to come down the street and home. It was some experience for two 'Okies,' living in New York."

Wilson began frequenting the studio of George Miller, New York's leading lithographer. Miller had printed the lithograph Wilson did for Associated American Artists. At Miller's studio Wilson met Alan Crane, also a lithographer and a writer and illustrator of children's books. Hearing Wilson's voice one day when he dropped by Miller's place, Crane had recognized the regional accent and promptly befriended the young artist from Oklahoma. Crane happened to be acquainted with Hollywood cinematographer Lucian Ballard, who had grown up in Oklahoma. Wilson's mother had taught Ballard in the third grade, and Ballard still remembered her fondly. Crane introduced the Wilsons to New York life and Charles in particular to other artists and writers whom he thought would be able to offer him advice and perhaps help his career along.

Wilson made several such acquaintances in New York, forming friendships with various celebrities, including author Marquis James, poet Lynn Riggs,

and folk singer Woody Guthrie, all of whom, like Wilson, were from Oklahoma. Most of these associations were unimportant professionally; but they made him feel "a part of things," bolstered his self-confidence, and encouraged a sense of accomplishment in his work, which was really what mattered to him at the time.

He met John Steinbeck when Lewis Gannet, book editor for the *New York Herald-Tribune*, invited Steinbeck to a party he gave for a number of friends from Oklahoma in the city. New York's fascination with things Oklahoman reached a climax in 1943 with the opening of the musical *Oklahoma!*, which was based on Rigg's play *Green Grow the Lilacs*. The show made Broadway history during its record-breaking run, and Wilson still remembers the opening-night party for the cast and crew as one of the highlights of his stay in New York.

Meanwhile, Wilson continued doing his own work and entering shows. He won first place in painting at the Brooklyn Art Museum's annual regional exhibition in 1941. His portrait of Edna was exhibited at the National Academy of Design in 1942, and that same year he was represented in an exhibition organized by the Metropolitan Museum of Art. Entitled "Artists for Victory," this show encouraged national support for the war, which the United States had entered following the Japanese attack on Pearl Harbor, in December, 1941.

Wilson produced two more lithographs for Associated American Artists in 1942, while *Collier's* published a two-page spread of selected, earlier prints from his Chicago Art Institute days to illustrate a special feature on the American Indian powwow. He also executed two war-related subjects during this period, both of them lithographs. One, entitled *Freedom's Warrior*, appeared in *This Week*, a syndicated magazine, in January, 1943, with an article Wilson himself had written about the role of the American Indian soldier in World War II. This article was reprinted in eighteen languages for international distribution by the U.S. Office of War Information, in Washington. Editions of the print were included in an exhibition, "America at War," organized by the Library of Congress for a tour of fifty American museums.

Wilson wrote other articles for the Office of War Information and produced a series of posters promoting the war effort; and he illustrated his first book. The latter project came about when Alan Crane introduced Wilson to Lewis Gannet's wife, Ruth. An artist in her own right, Ruth had just finished illustrating John Steinbeck's *Tortilla Flat*. According to Crane, she was scheduled to produce the illustrations for another book but was not sure she would have time to complete them.

The book in question was *The Hill*, by another of Crane's friends, California poet David Greenhood. Its subject was a history of California's gold-mining camps. Because of his experiences in the lead and zinc mines of northeastern Oklahoma, Wilson was certain that he could relate to such a book; so Ruth introduced him to the author and his wife, Helen. David Greenhood was impressed with Wilson's portfolio, but it was Helen, an art editor at Holiday House, a publisher of children's books, who actually proved to have the greater influence on Wilson's career in New York.

"Helen Greenhood encouraged me and demanded my best," Wilson says today. "I learned a lot of what I know about illustrating from her. A number of women as well as men have had an important influence on my life and my work over the years. Helen, certainly, was one of them."

The Hill was published in 1943 with Wilson's illustrations. That same year his work also appeared in Jim Kjelgaard's *Rebel Siege*, issued by Holiday House. These were the first two of nearly thirty books that Wilson illustrated over the next two decades. Several of the books were literary classics, and a number of them won national awards for book design.

Elsewhere that year Wilson won a first place award in graphics at the Brooklyn Art Museum, and Abbott Laboratories bought one of his paintings, *A Nation's Wealth*, for its corporate collection. But the excitement of New York was not destined to last. The war had changed the tempo of life in the city. Expecting to be called into the service at any time, Wilson decided that he would rather be inducted in Oklahoma than in New York. With this prospect before them, the Wilsons returned to Miami.

After an arduous trip home on a train crowded with military recruits, where he had been forced to sleep on the floor of his car using a suitcase for a headrest, Wilson presented himself for a physical examination at the regional induction center in Tulsa and learned that, because of a foot injury he had sustained on the track field in high school, he would not be immediately called up. He received this news with mixed feelings. Waiting around at

home to be drafted was a letdown after the last two years in New York. Wilson could think of nothing to do as an artist in Miami, even on a temporary basis.

Never one just to sit back and wait for something to happen, however, Wilson did not remain idle for long. Discovering that his professional associations in New York could still work to his advantage in Oklahoma, he returned to the old studio over the paint store downtown, enlarged it to include adjoining rooms recently vacated by a former tenant, and was soon at work on illustrations for another book.

That summer, national literary journals carrying reviews of *The Hill* mentioned the illustrations by C. B. Wilson. In August, Oklahoma City's *Daily Oklahoman* published a Sunday feature on Wilson, illustrated with his sketches of the Seneca-Cayuga Green Corn Ceremony. A Springfield, Missouri, paper announced that one of Wilson's lithographs had been awarded first prize in a regional exhibition.

In 1944, Wilson was represented in the National Print Annual, sponsored by California's Laguna Beach Art Association, and at the Oakland Art Gallery, the Seattle Art Museum, the Library of Congress, and the Corcoran Gallery of Art, in Washington, D.C. In March the *Tulsa Daily World* reviewed the opening of an exhibition of Wilson's work at the Philbrook Art Center, in Tulsa. Included in this show were prints and original drawings Wilson had used in illustrating *The Hill* and *Rebel Siege* and other drawings that had been published in *Collier's* and *Coronet* magazines.

Newspapers nationwide carried reviews of *Champlain: Northwest Voyager,* by Louise Hall Tharp, in which Wilson's illustrations received favorable notice. This book was published in 1944 by Little, Brown and Company. In 1945, Wilson's work appeared again in *Gid Granger,* by Robert Davis, Jr., and in *Henry's Lincoln,* by Louise A. Neyhart. Both books were issued by Holiday House, and both won awards, *Gid Granger* being selected by Eleanor Roosevelt to receive the Junior Literary Guild's Award of Merit and *Henry's Lincoln* receiving a Fifty Books of the Year Award for children's book design.

In addition to these national honors Wilson enjoyed a growing reputation at home. He won first place in painting in 1945 at the Oklahoma Artists Annual Exhibition, at the Philbrook Art Center, for an oil entitled *Montana Grandson;* he also won the show's Popular Prize for his *Oklahoma Portrait.* A review of the show in the *Tulsa World* referred to

Wilson as "one of Oklahoma's best-known artists. It also mentioned that his name had been added to *Who's Who* and *Who's Who in the Western Hemisphere* and remarked in passing that Wilson and his wife, Edna, had recently become the parents of a son, Geoffrey Banks Wilson.

By this time Wilson was busy putting material together for a book of his own. Having involved himself in the life of the local Indian community, especially that of the Seneca, many of whom he had painted, and the Quapaw, to whom he was related by marriage, he conceived the idea of publishing something definitive on the history and customs of the tribes in northeastern Oklahoma. In collaboration with journalist H. B. Hutchison, Wilson compiled and illustrated *Quapaw Agency Indians.* Published in 1947 and reprinted three times, the book eventually realized sales of more than 60,000 copies.

This period marked a turning point for Wilson. Finding that life as an artist in Oklahoma could be productive and rewarding if he worked at it, he thought less and less about returning to Chicago or New York. He also became involved in teaching, an activity that increasingly occupied his attention.

"I wasn't educated to be a teacher," he says today. "It just happened. During the war, Indian boys from the college in Miami often approached me and asked me to teach them to draw. We had no art department here then. One thing led to another, until finally the president of Northeastern Oklahoma A&M asked me to teach a night class once a week in one of the study halls. This class was later moved into an army barracks on campus. It was a good thing for me, teaching. It encouraged me to start painting again."

Wilson's first class attracted a large number of students, not all of whom were serious about art. Some came merely to watch him work. By 1947, however, he was teaching three afternoons a week and had become, in effect, a one-man art department. In the 1950s he moved out of the barracks and into a new building he had helped design and in which he shared space with classes in agriculture, chemistry, and biology. Art demonstrations, lectures, and field trips with his students drew heavily on his creative reserves—"but not so much that I didn't do my own work," he emphasizes today. "This I managed by carefully budgeting my time. For years I did what I did with one eye on the clock!"

His enthusiasm for teaching lasted until he felt

that he could no longer contribute what he thought it demanded:

"I felt that the better I got as a teacher, the more fundamental my instruction became. Over the years I found that I had to start at the beginning again with every class. I grew tired of that; and of course I had my own career as an artist to consider. I had to weigh that in the balance of the time and effort it took to be a teacher."

He continued illustrating books: *Company of Adventurers* in 1946, *River Dragon* in 1948, and a new Lippincott Classic edition of Robert Louis Stevenson's *Treasure Island* that same year. In 1952 he produced the illustrations for *The Mustangs,* by J. Frank Dobie, published by Little, Brown and Company. At the time Dobie considered *The Mustangs* his best book, and it has since become a classic in its field.

Alexandre Hogue, chairman of the art department at the University of Tulsa and a longtime friend of author Dobie, wrote a review of *The Mustangs* for a Tulsa paper in which he stated:

"The Mustangs," like the 12 other Dobie books, will be a collector's item, and much of the credit for establishing its mood for the reader will go to the excellent illustrations created by Charles Banks Wilson of Miami, Okla.

To me, these are the most meaningful illustrations that have appeared in any of Dobie's works, and I did the pictures for one book myself.

Wilson later remarked:

"I got the job of illustrating J. Frank Dobie's book because Dobie's first choice, Tom Lea, was busy writing a book of his own, and my friend Alexandre Hogue told Dobie that I could do the job just as well as Lea. When Dobie asked me to do it, I told him that the only one qualified to illustrate his book about horses was a horse. I wasn't kidding.

"As I began to sketch, I tried to think like a horse—see the world as a horse sees it. When making an illustration showing wolves attacking horses, I drew from inside the group of mustangs with the wolves located somewhere outside. I kept thinking as I drew that I was in there with them, not out there with the wolves looking at them."

Wilson took such assignments seriously. Before accepting a publishing commitment, he read the author's manuscript several times to acquaint himself thoroughly with the story, determine the type of illustrations that would best suit its mood, and decide where they should be placed to help carry it along. Then followed a period of intensive research to collect the background material relative to the subjects or the period to be represented.

For Wilson, the story always came first. His credo as an illustrator was essentially that pictures should attract the readers' interest and enhance their appreciation of the story but never tell the story or "give it away." As an artist he never imposed himself or his style on the reader. If a subject or character seemed to require a particular interpretation, he varied his drawing technique and adapted his style to suit what he felt was consistent with the theme of the story or the general feeling conveyed by the writing:

"For *Henry's Lincoln,* I used crayons to do the illustrations, because that medium seemed to suggest itself to me from the nature and content of the book. But when I came to illustrate *Treasure Island,* I found in my research that the records of that period, the pictures of the time, were mostly engravings; so I did the illustrations for the Stevenson novel in the manner of steel engravings.

"In drawing the horses for the Dobie book, I didn't want the mechanical limitations of the steel pen. It seemed alien to the nature of a horse's fluid movement. I wanted something to draw with that would capture the smooth flow and feel of a horse. So I learned to make quills out of turkey feathers to create a calligraphic line. I did all of the illustrations for *The Mustangs* with a quill."

Over the years Wilson found that he preferred illustrating children's books because in his view young readers possess the most active imaginations.

"In children's books," he observes today, "nothing in the way of research or draftsmanship is ever overlooked or wasted, and that's very satisfying to the artist."

Since leaving New York City in 1943, Wilson had issued no new lithographs, and nearly four years elapsed before he returned to printmaking, in 1947, to produce *Shawnee Ribbon Bets,* based on an earlier painting of the same title. In 1950, Associated American Artists commissoned another subject, *Old Injun.* Both were printed in New York by George Miller.

In 1952, Wilson began pulling prints on his own press:

"After I came back to Oklahoma, I didn't do many prints for some time. Then I found a press and a few old stones over in Springfield, Missouri, owned by a man who was willing to sell them to me. I borrowed

a truck and went up there and brought them back to Miami and set up the press in my studio. It wasn't long until I was doing prints again."

The first of these prints was based on one of the illustrations for *The Mustangs*. Over the next four years Wilson produced nine new lithographs. Except for a print entitled *Shawnee Indian Cooks,* none of these prints pictured Indian subjects.

In 1954 the Wilsons' household increased again with the birth of a daughter, Carrie Vee, and Wilson accepted his first mural commission. This came from John D. Rockefeller, Jr., who was then engaged in building a multimillion-dollar resort in western Wyoming. A Rockefeller representative visiting the Gilcrease Museum, in Tulsa, saw Wilson's *Montana Grandson* displayed there and approached the artist with a proposal to design a large painting to go behind the bar in the lounge of Rockefeller's Jackson Lake Lodge. This was something new in the way of assignments, and Wilson set to work with characteristic thoroughness to develop a subject fo the mural, in this instance a fur trappers' rendezvous in the Rocky Mountains.

He obtained much of the historical background for the painting from research in libraries and museums in Denver, Chicago, and New York. Meanwhile, he had to decide what kind of painting should go behind a bar. To uncover that information, he tried a different approach to research and he looked up an old friend to ask him what sort of picture he would like to see behind a bar.

"He went right to the heart of the matter," Wilson said later, "when he admitted that he didn't now much about art but could state from experience that if you spent enough time on a bar stool, you eventually read every label on every bottle."

This answer gave Wilson the freedom to create a picture that had as much activity and detail in it as possible to give bar patrons something to study at their leisure.

Measuring four feet by nine feet, the completed *Trapper's Bride* was installed in June, 1955, when the governors of three western states, the U.S. secretary of the interior, and other dignitaries attended the dedication of Jackson Lake Lodge, in Grand Teton National Park, and the unveiling of Wilson's canvas.

In thinking back to that first mural, Wilson now declares:

"I've always prided myself on doing the best I can with a drawing or a painting, whether I was being paid fifty dollars or fifty thousand dollars. Once I accept a commission, the fee is forgotten, and I give it my best shot."

The mid-1950s proved to be one of Wilson's busier periods. In 1955 he completed forty illustrations for a new Oklahoma history textbook for the public-school system. Almost immediately he began work on a series of portraits of Oklahoma humorist Will Rogers for a national calendar company and on a group of watercolors on lake fishing in Oklahoma for the Ford Motor Company. The latter were published in 1956 in the *Ford Times* as a part of a series of paintings on regional themes that had been commissioned by the Ford Motor Company.

In 1957, Wilson produced *Ten Little Indians,* his most popular lithographic series to date. Sold in a limited-edition portfolio and later reproduced in both color and black and white, this series depicts children from several different tribes performing traditional, native dances. Also in 1957, Wilson secured his first important portrait commission, from the Thomas Gilcrease Foundation for a portrait of Tulsa oilman and collector Thomas Gilcrease. Others soon followed.

In 1960, feeling the pressure of conflicting commitments, Wilson resigned as head of the art department at Northeastern Oklahoma A&M College. He also stepped off the board of Miami's public library, on which he had served for nearly fifteen years, including a stint as chairman of the committee that raised funds for a new library building.

In 1961, Wilson's work was included in an international exhibit sponsored by the U.S. State Department. In 1962 he was elected a fellow of the International Institute of Arts and Letters, based in Geneva, Switzerland. That same year his portrait of artist Thomas Hart Benton was unveiled by former president Harry S. Truman in ceremonies held in Neosho, Missouri, Benton's hometown.

The Benton portrait grew out of the relationship that had developed between the two artists over several years, Wilson having first come to Benton's attention in 1941, when Wilson had sent a selection of his lithographs to Associated American Artists, in New York City. The two had met again, in 1958, when Benton, on the recommendation of Oklahoma artist Acee Blue Eagle, sought out Wilson because he needed help finding Indian models for a mural he was designing for the New York State Power Authority.

A closer friendship developed when Benton was commissioned to produce a mural for the Harry S. Truman Library, in Independence, Missouri, and again asked Wilson for assistance obtaining models.

"Tom was faced with a year's study and planning for the Truman mural," Wilson recalls. "He needed Pawnee and Cheyenne models, and I helped him to find them. We went to Tulsa for a Pawnee model, then drove into western Oklahoma and located some Cheyennes. After that we followed the Santa Fe Trail into eastern Colorado, where Tom wanted to sketch the site of Bent's old fort on the Arkansas River."

Eventually Benton invited Wilson to paint his portrait, and Wilson visited the elder artist at his Kansas City studio, where he sketched him at work on the Truman mural. Benton found it difficult to pose for Wilson.

"Through the years," Wilson recalls, "he hadn't minded being snapped by photographers, but sitting for an artist was different. It was an ordeal for him. That portrait of mine is the only one of him ever made from life that he didn't paint himself."

Benton was seventy-three years old and suffering from bursitis when he worked on the Truman commission. He told his wife, Rita, that should anything happen to him before he completed the painting, he wanted Charles Banks Wilson to finish it for him. Wilson learned of this only several years later.

"I knew then," he says, "what I really meant to Benton as an artist, and as a friend."

Reflecting today on what this friendship meant to him, Wilson adds:

"Benton gave a real lift to my career by convincing me that to be an artist was to be a person of some value in this world. He did this not so much by anything he said as by the respect he commanded from others and also showed to me as a fellow artist.

"To feel, after getting to know Benton, that what I was devoting my life to was worthwhile—this is the most important thing I learned from him. I guess I had always thought of myself as a pretty good illustrator who had produced a few good paintings; but Benton made me see that I had a future beyond that."

Wilson benefited from the relationship in other ways as well. On a visit to Miami in 1957, Benton remarked while looking over Wilson's lithographs that "Rita could sell some of these for you." At the time Wilson had not met Mrs. Benton, but he was aware that she handled Benton's business affairs.

"She had a reputation for promoting young artists," Wilson remembers, "and at least while I knew her, she never took a commission from the sale of their works."

Rita later sold Wilson's lithographs in Kansas City, where the first real interest in his prints outside his own circle occurred in 1960:

"I'm certain that she showed my prints to collectors who couldn't afford to buy Tom's, his having increased so much in price. Rita also badgered some galleries into handling my work, not only prints, but also paintings. A high point came when Rita and Tom's neighbor Ann Constable, who had been collecting my prints for some years through Rita's encouragement, opened her own fine art gallery in town. Today the largest collection of my prints is owned by Frank Johnson of Kansas City.

"I admit I'm disappointed that more individuals in Missouri own something of mine than do Oklahomans—except in my hometown, where a great many of my paintings and prints now hang on the walls of people's homes."

In 1963 the Oklahoma legislature authorized the creation of works of art in public buildings for the first time in its history when it commissioned Wilson to produce life-size portraits of outstanding Oklahomans to be exhibited in the rotunda of the capitol in Oklahoma City. Initially the commission named three individuals for representation: humorist Will Rogers; Cherokee linguist Sequoyah; and U.S. Senator Robert S. Kerr, whose recent death had stirred up considerable sentiment among legislators that the state should do something to honor one of its favorite sons. The selection of a fourth portrait was temporarily shelved, although Wilson already had decided to depict Olympic athlete Jim Thorpe. Several legislators opposed this choice, favoring other candidates for the honor; but Governor Henry Bellmon backed Wilson's preference for Thorpe, and the debate ended.

In fulfilling this commission, Wilson faced a difficult task, because none of the men to be represented was alive in 1963, when Wilson accepted the job, yet all were international figures known to millions and, except for Sequoyah, well represented in photographs and the memories of families and friends. Sequoyah, more of a myth than a man, presented a

special challenge to the artist, as did Rogers, whose public image had also taken on the character of a legend.

For reference in developing Sequoyah's portrait, Wilson had only a photograph of a crayon sketch made some years earlier from a painting by Charles Bird King. He took this with him when visiting residents in and around Tahlequah, the old capital of the Cherokee Nation, looking for living subjects, who might resemble it in any way and from whose physical types and facial details he might be able to compose a convincing likeness.

With Will Rogers he experienced the opposite problem. Rogers's life was documented in hundreds of photographs and motion pictures, although for Wilson, none was exactly suited to expressing what he felt had been Rogers's perceptiveness and "uncommon intelligence." He wanted the portrait to include those qualities above all, while also reflecting the easy dignity of his subject.

He employed live models for the portrait of Rogers, as he did at some point in developing all of the capitol paintings. "I drew the hands of five different men before I found the hand that looked correct," he said in an interview for *Oklahoma Today*. "Rogers's hands were strong hands, always busy. To me, the wrong hand would have looked as out of place as the wrong nose."

Wilson worked approximately a year on each of the portraits. When the design of a painting had been worked out to his satisfaction, he made a line drawing of the subject, then a three-dimentional figure in clay to serve as the model for a small black-and-white painting establishing relative values. Color was developed in a second painting. He included in the portraits various details descriptive of the background of each subject, picturing Sequoyah holding his famous syllabary and standing in front of a log cabin in the wilderness. He painted Will Rogers on the landing strip of an airfield.

Wilson's initial research for the Robert S. Kerr portrait suggested that Kerr should be represented in his office in Washington, D.C., standing in front of a map of the Arkansas River navigation project that now bears his name. A former state governor, rancher, and oilman, Kerr, at the time of his death, had been one of the nation's most influential senators. Wilson placed Kerr at his ease before the viewer in a business suit. "Many old friends smile today,"

Wilson says, "when they notice that his tie is typically uneven."

Jim Thorpe's portrait required the most exhaustive search for specific details. At the outset Wilson consulted John Steckbeck at Lehigh University, in Bethlehem, Pennsylvania. Steckbeck had written a book on Indian athletes at the Carlisle Institute, where Thorpe had played football. Thorpe had later achieved international fame at the 1912 summer Olympics in Stockholm, Sweden, by winning the gold medal in both the pentathlon and the decathlon. It was this aspect of Thorpe's career that interested Wilson, who had never wanted to paint him in a dated football uniform that covered up his magnificent physique.

Steckbeck's collection of photographs was useful, but Wilson still found it necessary to sketch from life various physical aspects of many well-developed men. Contemporary Indian athletes at the Haskell Institute, in Lawrence, Kansas, willingly served him as models. He was also fortunate in having Thorpe's exact physical measurements, which had been taken by a board of experts shortly after he won his Olympic honors. Wilson reduced these figures to fractions in constructing his fifteen-inch clay model of Thorpe.

Although Kerr's portrait had been the first to be commissioned, the Will Rogers painting was the first to be dedicated, in 1964. Sequoyah's portrait was unveiled the following year by W. W. Keeler, principal chief of the Cherokee Nation, and Kerr's portrait by members of the Kerr family in 1967.

The most colorful presentation involved the dedication of Jim Thorpe's portrait in 1968. The Oklahoma Indian Commission was in charge of the ceremonies. On the grounds in front of the south facade of the capitol an all-day powwow was staged by tribal representatives from around the state. Elmer Manatwa, chief of the Sac and Fox, Thorpe's tribe, unveiled the full-figure portrait, while outside on the capitol lawn other members of the tribe prepared a feast in Wilson's honor. Someone later pointed out that three of the four capitol portraits represented American Indians or persons of Indian descent, Will Rogers having been part Cherokee.

The portraits in Oklahoma City received national attention and were reproduced throughout the state and region. The Southwestern Bell Telephone Company featured all four of them on the cover of its

Oklahoma directories in 1969, and the Oklahoma Historical Society mounted a major exhibit of Wilson's work, including almost all of the preliminary drawings, models, photographs, and related artifacts used in developing the portraits. Meanwhile, Wilson turned to other projects as the demand for his services increased.

Hardly two years had elapsed since the 1968 installation of the Thorpe portrait when the thirty-second session of the state legislature authorized the creation of additional works of art for the capitol, this time envisioning a series of murals illustrating the history of Oklahoma. Again the commission went to Wilson, who by now was a much-publicized artist frequently quoted in the press and related media. An article in *Oklahoma's Orbit* in November, 1970, revealed the principal themes selected for the proposed murals: discovery and exploration, frontier trade, Indian immigration, and settlement.

Wilson explained to *Orbit* readers:

"I want to utilize subjects that point up certain unique characteristics in the state's history. The whole story of Oklahoma can't be told in a few paintings; but the symbols can be expressed, the basic fundamentals. What I really want to do is depict Oklahoma's roots."

Before beginning to paint, Wilson devoted nearly two years to primary research, visiting museums and libraries throughout the state, consulting authorities on state history, and traveling to specific sites to study the local geography. He interrupted this fact-finding in 1971 to accept an invitation to England to assist in the designs for "First Americans," a medallion series issued by the Wedgwood pottery works near London.

Returning to the states, he spent several days in New York City examining the murals that Thomas Hart Benton had painted in the 1930s at the New School for Social Research. Wilson was impressed with Benton's work but did not consult Benton personally about the Oklahoma project:

"By the time the commission for the Oklahoma City murals came up, I had been around Tom so much that I was beginning to feel dominated by his personality. So I pulled away completely to the point of not writing to him or calling him on the phone. I knew that if I didn't make the break, I might be tempted to ask him to solve some problem of the murals for me, and I didn't want that. I wanted to paint those murals on my own."

From the beginning, Wilson had been intent on portraying representative types instead of specific, historical figures in the murals. He conducted an extensive search for models and found them wherever he could: in the man who came to repair his air conditioner one afternoon, and in another he happened to observe at the Miami post office. A Vietnam veteran he discovered mowing a lawn in Lawton served as the model for a Comanche warrior featured in the *Indian Immigration* panel. Wilson's daughter, Carrie, posed for a young Indian student in this same painting.

The Wichita Tribal Council furnished him with a list of full-blood members from which to choose models for the *Discovery and Exploration* mural. Wilson selected the chief as one of the models.

"The Wichitas knew that they were passing into history," he says today, and that soon the only full-blood Wichitas left would be those looking down from the murals in the capitol building."

Models for the animals to be pictured were more difficult to obtain in some instances. Horses and buffalo generally were easier to locate than oxen or mules. The local pound furnished a variety of canine subjects. For examples of authentic period clothing and equipment Wilson searched museums from St. Louis to Washington, D.C. The curator of the armorial collection at the Metropolitan Museum of Art, in New York City, was especially helpful.

Wilson abandoned his first idea to paint the murals directly onto the interior walls of the capitol dome after he climbed up into the dome and looked around. The shape of the dome and its distance from the ground floor, four stories below, quickly discouraged this notion. The next level beneath the dome appeared to be better from the prospective viewer's standpoint. This level featured four large, slightly concave wall spaces between supporting arches about twenty feet above the previously installed portraits. These spaces, however, also presented problems, both practical and aesthetic, and Wilson finally decided not to paint the murals in place but to produce them in Miami instead and install them later on independent supports.

Realizing that he would need more working space than his studio afforded, he moved across Main Street into the old theater where as a teenager he had been hired to paint posters. Upstairs he renovated a large room formerly used as a meeting place by the Masonic Lodge. Unoccupied for many years,

it was in a shabby state. Water from a leaky ceiling had encouraged the growth of grass and weeds in the dirt of the old carpet. Wilson had to clean this up before he could begin painting. Then he brought in the necessary equipment and installed a telephone in his new workplace—"one thing I had on my scaffold that Michelangelo didn't," he now reflects.

Meanwhile he undertook another commission when he agreed to paint two portraits of Carl Albert, then Speaker of the U.S. House of Representatives, one for the U.S. Capitol, in Washington, D.C., and the other for the Oklahoma statehouse. Working on the Albert commission in the morning and on the Oklahoma murals in the afternoon, Wilson often spent twelve hours a day in his improvised studio above the theater.

Work on the murals seldom proceeded without interruption, as friends, neighbors, or reporters dropped in to pass the time and view his progress firsthand. Among the more frequent visitors were those who had agreed to serve as models for the people in the paintings, such as Joe Benny Mason of Fairfax, who posed for the central figure of the Osage chief in the *Frontier Trade* panel.

As Wilson tells it, when Mason, himself a descendant of Osage chiefs, first entered the studio, he brought with him a ceremonial fan made of an eagle's wing and with it proceeded to exorcise Wilson's workplace.

"I have the power given to me by the Old People to cleanse this place from all trouble," Mason assured Wilson, who, in recalling the incident, says that he gladly accepted this good medicine at the time.

Several weeks later, while sitting on a chair up on the scaffold, absorbed in his painting, Wilson forgot momentarily where he was. Intending to put a highlight on a piece of Spanish armor just out of reach, he thoughtlessly moved the chair over a foot or so and fell backward over the edge of the scaffold, chair and all, to the floor some fifteen feet below. On the way down he hit a ladder, which flipped him onto his head. He was not seriously injured, however, and a few hours later, after receiving emergency medical attention, he was back on the job.

A friend subsequently remarked that apparently the Osage blessing "didn't work too well."

"Who knows?" Wilson replied. "I could have broken my neck!"

In 1975, Oklahoma City's WKY-TV (now KTVY) prepared a documentary, entitled *Names We Never Knew* on the murals in progress. That same year Wilson traveled to Norman to receive a Distinguished Service Citation from the University of Oklahoma. In May, 1976, he accepted the first Governor's Art Award ever issued. In July the completed murals were installed in the capitol.

The installation required a series of complicated steps, involving a support system devised by Wilson, in which individual molds conforming to the curvature of the rotunda walls had been made to the exact size of each painting. From the molds, thin fiberglass shells had been cast to serve as sturdy, lightweight backings for the canvases, which then could be secured to balsa-wood grids and bolted in place. A local boat company manufactured the fiberglass shells according to Wilson's specifications. These were later cut in half to get them through the capitol doors and then were reassembled on site.

A crew of six riggers from an Oklahoma City construction firm, three representatives of the company that had made the fiberglass shells, and Anton Konrad, a curator from the Smithsonian Institution, assumed the task of installation. This job took several weeks. Each painting had to be adhered to its backing with a hot-wax resin, while other members of the crew built the grids on which the assembled murals would be permanently mounted. Lifting the large paintings, which weighed several hundred pounds apiece, on one-eighth-inch steel cables gave Wilson, who watched from below, some of his most anxious moments; but no accidents occurred. When all the panels were in place, each was trimmed to fit the exact area it was designed to occupy; then a coat of protective varnish was applied. The results surpassed all expectations.

A great crowd thronged the capitol rotunda on Statehood Day, November 16, 1976, as the murals were formally dedicated by the late Professor Arrell Morgan Gibson, of the University of Oklahoma. Governor David Boren, House Speaker Bill Willis, and Senate President Pro Tem Gene Howard accepted the paintings on behalf of the state. Professor Gibson and Speaker Willis expressed a personal interest in the murals, since both of them had served as models for figures in two of the panels.

In 1977 the city of Miami, Oklahoma, observed the anniversary of Oklahoma statehood as "Charles Banks Wilson Day." That same evening Wilson was formally inducted into the Oklahoma Hall of Fame, in Oklahoma City. The Honorable Carl Albert was

on hand to deliver the citation in tribute to Wilson. The citation reviewed Wilson's career and accomplishments as an artist, his contributions as a citizen to his community and to the state, and several of his more recent honors and awards. Thus acknowledged by his peers, Wilson once more returned home to his studio to resume work on other projects.

In 1977 he issued what has proved to be his most popular lithograph, *Plains Madonna,* one of a series of six prints based on figures and compositions represented in the capitol murals. Between 1977 and 1979 he also completed the second Carl Albert portrait, the one for the Oklahoma capitol, in addition to a bronze sculpture of Thomas Hart Benton for the Benton Foundation, and a life-size portrait of W. W. Keeler for the Cherokee Indian Foundation.

In 1979, Wilson painted portraits of rodeo stars Tom Ferguson and Jim Shoulders for the National Cowboy Hall of Fame and Western Heritage Center, in Oklahoma City. He did the studies for the latter at Shoulders's ranch near Henryetta, Oklahoma, where, he recalls:

"After Jim had posed for me for about two hours, I told him I was finished. Without even a peek at the study, he just walked disinterestedly away. 'A real cool cowboy,' I thought at the time.

"Later when the Shoulders painting was unveiled at the Cowboy Hall of Fame by film stars Slim Pickens and Ben Johnson, the same evening that I received the Western Heritage Special Trustees Award for my life's work, I told this story on Jim. He also said a few words in reply and explained, 'It's just that I told Wilson if he wouldn't ride broncs, I wouldn't paint pictures.'

"Jim liked the painting."

Publicity relating to the capitol murals created a demand for more information about the artist, and in 1979 the National Endowment for the Arts, in cooperation with the state, produced an audiovisual documentary entitled *Roots of Oklahoma,* featuring Wilson's life and work, which was distributed to schools and libraries throughout the state. Even while this film was being produced, Wilson committed himself to another project, in which, this time, the emphasis was on the present instead of on the past.

Wilson had at last decided to complete his collection of American Indian portraits. Although he had been drawing and painting Indians since 1937, it was not until 1947 that he thought about making a comprehensive record of Oklahoma's tribal groups. Concerned with the disappearance of contemporary full-blood and pureblood Indians, he had approached Thomas Gilcrease in Tulsa for funding of such a project; but at the time Gilcrease, himself part Indian, felt that the matter was not urgent.

In the early 1950s, Wilson made a similar request to the Guggenheim Foundation, but his proposal was rejected in favor of a study of the tsetse fly. Wilson put the project aside until he started work on the murals for the capitol rotunda, at which point he concluded that if such a record of the American Indian was to be made in his lifetime, he would have to do it himself, on his own.

In 1979 he set out to complete what he had actually begun nearly forty years earlier. Over the next three years he traveled to all parts of the state, interviewing individuals from many different tribes, determined to make a drawing from life of at least one surviving, pureblood, or as nearly pureblood as he could find, representative of every group.

He looked for his subjects everywhere: in dime stores, pool halls, city apartments, and tree-shaded pastures. He found them at work, at home, in church, in jail, and even among the members of his own family. From the beginning of the project, he used pencil exclusively in rendering these portraits. Wilson explained this choice to a journalist in Oklahoma City:

"It's hard to hide your ignorance with the sharp point of a pencil," he said. "When I leave a drawing and come back to it later, I'm often surprised at what I see, the story the drawing tells.

"I've been able to go into places with a pencil and paper where the subject never would have allowed a camera. While drawing a portrait I've had the advantage of the sitter's philosophy and comments. This is a very personal experience for me. A photographer misses this." .

In 1981 the Oklahoma State Society in Washington, D.C., sponsored an exhibition of Wilson's portraits at the U.S. Capitol. Early the following year the Stovall Museum of Science and History (now the Oklahoma Museum of Natural History), at the University of Oklahoma, organized a larger show entitled "Search for the Purebloods," which toured throughout the state. Wilson wrote his own catalog for this show, which was enlarged to include draw-

ings of seventy tribes for a national tour in 1985 and continues to receive wide exposure in exhibits throughout the United States.

Questioned recently about his ability to distinguish one ethnic type from another, Wilson responded:

"I never worried about it. I'm neither an anthropologist nor an ethnologist. I'm an artist. My job as I saw it was to draw what I found, not judge whether or not a face was the ideal face to represent a tribe.'"

To date, the project represents more than one hundred American Indian tribes. Wilson has had to travel out of state for some of his subjects:

"Some tribes today don't have any pureblood members left, and others have only one pureblood still living. I just draw whoever is left, and sometimes I'm disappointed."

He knows, however, that he has presented these subjects true to life, because, as he says, "I sat with them, I talked with them. I drew them."

Wilson believes in his work and understands its importance. He also enjoys what he does for a living and likes to talk about it. His experiences over the years have provided material for numerous magazine articles, newspaper interviews, and filmed reports in which he has been variously described as a regionalist, a documentary artist, and an artist-historian. For himself, he prefers to be called simply an artist—or, if pressed, a lithographer.

While taking himself less seriously than he takes his work, he is sometimes offhand even about art, as when he says, with reference to lithography, which requires physical strength for handling the printing stones:

"I've had friends come up to me and grab my arm and exclaim, 'where did an artist get an arm like that?' I tell them it comes from being consigned to the rock pile all these years."

He estimates the volume of prints he has produced since 1938 at around 10,000, distributed among approximately 3,000 purchasers, collectors, and museums.

"Some collectors own only one or two," he is quick to point out, "others half a dozen, and a few as many as twenty or more. No one has the entire series except me."

The American Indian still holds an important place in Wilson's interests. Paintings and prints of Indian subjects hang everywhere on the walls of his studio. Exhibited on tables and shelves are numerous Indian-made items he has collected or that have been given to him during the course of his career. Pipes, beadwork, pottery, and baskets are displayed on the tops of cabinets or under glass in cases. Navajo rugs cover the floor of the hallway at the top of the stairs.

As a young man, Wilson discovered that he had a flair for learning Indian languages, a talent that proved advantageous in his work. He later announced the powwow at Quapaw and served as arena director on more than one occasion. The desire to record contemporary Indian life has taken him into all parts of the state.

"I don't believe there is an Indian in Oklahoma," he now declares, "who doesn't know someone I know."

Wilson today is probably known to most people as a portraitist, yet he insists that he does not like painting portraits, or at least not the "formal" kind. "I prefer to paint people," he says, in explaining the distinction, and he recalls with evident pleasure the period when he first undertook portraiture seriously, in Miami between semesters at the Art Institute of Chicago:

"I don't think I've ever been happier in my life than I was that summer when I painted one portrait after another. I was happy because I was painting to please only myself."

That he later worked with the viewer in mind is apparent from the carefully researched steps he followed in executing his public commissions and in remarks such as those he made during an interview in Oklahoma City after he undertook his first commission for the state of Oklahoma. Discussing portraiture again he said:

"A portrait is one thing, and a public portrait another. In a public portrait the artist has, I think, a certain responsibility to those who will see it as well as to the person he is painting.

"When you represent a national figure, I think you have an obligation to your viewers to say 'this is his ear' and 'this is his mouth.' I believe you should at least capture the spirit of your subject and not do some meaningless exercise that expresses more of a desire to achieve style than to reveal character."

In a simialr vein he later emphasized, with respect to his capitol murals:

"A mural is public art. People are going to see it, so they have to be considered. I'm not painting murals in a public building for a clique of art critics or

museum directors. I'm painting for everyday people, the ones who built this building with their tax money."

Wilson's popularity with the public is evident in the many commissions he has executed over the last thirty years. His concern for authenticity and his attention to particulars are among the most distinguishing characteristics of his work. He has been commended often for the accuracy of the details in his murals and portraits, yet he now concludes upon reflection that "details, actually, are inconsequential. It's the essential you strive for in a painting."

In 1984, Wilson accepted another portrait commission from the state of Oklahoma. The subject was Angie Debo, noted author and regional historian. In his preliminary research, Wilson read all of Debo's books on Oklahoma history and visited the ninety-four-year-old writer several times at her home in Marshall, Oklahoma.

"I felt," he explains, "a great obligation to her life and work to get her 'just right.'"

Wilson painted two portraits. He was not satisfied with the first, which he felt made her look like "an old lady who snapped beans in the summertime" and was not strong enough to represent "the first lady of Oklahoma history." The second portrait was dedicated in ceremonies at the capitol in April, 1985. Later that year Wilson issued a lithograph of "Miss Angie," which presented the subject in a less formal pose than did the official portrait in Oklahoma City.

Miss Debo wrote to the artist on June 9, 1985:

I am so very grateful to you for the genuine-plus integrity that went into the painting of that portrait. It is not beautiful . . . I have never been beautiful. It does not conceal my age. I *am* 95! But it shows the characteristic that I now know dominated my life. I don't know how you discovered it, for I did not tell you. I did not even realize its importance, but it was always there . . . It was *Drive*. It carried me through a whole lifetime.

In the fall of 1985, *Oklahoma Today* reproduced the Debo portrait with other artworks in an article about Wilson entitled "Artist on Main Street." In this article Wilson again answered many of the same questions he is often asked by reporters and journalists, including what he feels he has accomplished as an artist, and whether he thinks he might have achieved more by pursuing a career in Chicago or New York.

Wilson responded frankly that a number of people had expressed surprise, not at his success as an artist, but that he had been able to realize it in Miami, Oklahoma. He then allowed that he had "always liked this corner of the world," where he had found such varied subject matter for his art.

He says today:

"I think my work has been better, by far, than if I had stayed in Chicago or New York, and certainly it is different. I've had the chance to do just about everything I ever wanted to do right here in Oklahoma.

"Today almost any artist of some age or reputation can say that he's represented by work at the Metropolitan, the Library of Congress, or the Smithsonian. I'm represented in all of them; but what I am proudest of is that there are few homes in Miami which don't display something of mine. The people here identify with what I do."

But perhaps he expressed this sentiment best when he addressed the same question in a radio talk aired in 1952 as one of a series of informal lectures on art. The subject was regionalism, and he used himself as an example:

In view of the times and the direction of events, I believe it is safe or at least honest to present myself as a regional artist, although a regionalist today is, in my view, something different from the artists who were given the name in the 1930s.

The land had inspired artists ever since John White first recorded the Virginia Indians . . . but never before the 1930s did such a concern for every aspect of America take place. People began to look inward, and artists to see themselves as born and bred to the ways of a region. Their styles, subjects, and personalities were different, as were their feelings about art. The only thing they shared in common was their feeling about America.

To some extent the regionalist movement deserved the criticism it was to receive. Much of it was subject and social comment that tended toward provincialism as it recorded the lore, customs, and things peculiar to an isolated society. Today the artist can hardly live so far back in the woods that he is unaware of the interdependencies of his remote spot and the rest of the world.

An artist anywhere must make his own world . . . make something out of his subject. What he makes depends on his creative power. He may use the subjects of his surroundings to interpret certain universal truths, as I have, or be simply inspired by the form, color, and

design of his region; but good art of a region is only good to the extent that it has universal appeal.

Wherever I am known today, I am associated with this area. I didn't come back here by choice, but once back I found that I could work and so I stayed. I don't think I would recommend a small town as ideal, for really, there is little advantage to living in one place over another . . .

Any place is the right place if it inspires you to produce.

The Lithographic Process

Charles Banks Wilson

Creative lithography is my preferred medium, but I was drawing and printing lithographs for thirty-five years before I knew the lexicon meaning of the term. *Litho* is the Greek word for "stone," and every print in this collection was pulled from a stone. For me, lithography represents the ultimate expression of my art.

I was taught the process at the Art Institute of Chicago. My instructor was the much-admired Chicago artist Francis Chapin, whose six-foot-seven-inch height gave him a unique vantage point from which to inspect his students' work. I do not remember now why I enrolled in the course in 1937. Perhaps someone at the institute noticed that I liked to draw and put me in Chapin's class. It may have been the best thing that ever happened to me.

As I learned it, lithography is a very physical medium, especially the process of drawing directly on the stone. Although some lithographers now use zinc, aluminum, or plastic plates, I still prefer Bavarian limestone. To me, the other materials share few of the exciting qualities of stone.

The stone's natural grain, its feel as my pencil or crayon passes over it, is almost sensual. It inspires me as I draw. Of course, being able to print multiple images of a drawing does offer a commercial incentive to do lithographs, but that is not the reason I love the medium above all others—and I believe I have worked in nearly all of them.

Before a lithography stone can be drawn on, it must be properly surfaced. This is accomplished by taking two stones of about the same size and rotating one on top of the other, using wet sea salt, flint, or quartz between them as a grinding agent, until a uniform surface is attained. While prints can be made with stones of various degrees of surface graining (fineness), a level stone is absolutely necessary for successful printing.

Once the stone is grained, it is ready for the drawing. I draw with a special grease pencil or crayon, which is available in different grades of hardness but is always black in color. The black color allows me to see how much grease I am applying to the stone.

When the drawing is complete, the stone is ready to be "etched." This term refers to coating the stone with a gum arabic solution to which a few drops of nitric acid have been added. This solution sets, or stabilizes, the grease so that it will not wear off during the printing process. A day later, after this mixture has dried, a water and naphtha solution is used to wash it from the stone, along with the visible drawing. The grease from the drawing pencil, however, remains.

The next step is to ink the stone. For this I use an ink specially formulated for stone lithography and a hand roller that looks somewhat like a large rolling pin that has been tightly wrapped with cowhide, rough side out. The stone is lightly sponged with water to prevent the grease of the drawing from spreading. Then the ink is rolled on. The oil-based ink is attracted to the grease of the drawing but repelled by the water, so the image of the drawing again becomes visible, this time in ink instead of grease pencil. The inked image is now given a second, stronger etch, and after sitting for a few hours or a few days, the stone is finally ready for printing.

I have found that a handmade rag paper usually makes the best print, although parchment and rice papers can also be used. I pre-dampen my paper by placing it between wet blotters for twenty-four hours. Properly dampened paper is critical to obtaining consistent prints throughout an edition.

The lithography press itself consists of a flat, movable bed on which the stone sits, a lever for setting the pressure to be applied in printing, and a scraper bar as long as the stone is wide, which is made out of a maple strip covered with leather. A crank on the side of the press is used to move the press bed.

With the inked stone on the press bed, I lay the damp paper directly on the inked drawing and cover it with a pad of newsprint and a blotter, which have been cut slightly larger than the stone. Then a tympan is placed on top of this backing and coated with grease. The stone is then moved until its edge is just under the scraper bar.

21

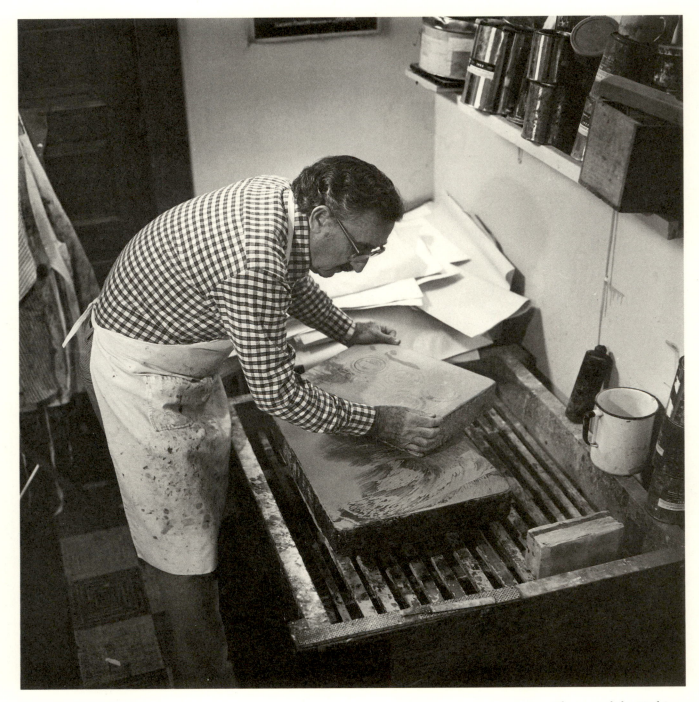

Grinding the stone. Photograph by Karl Lee.

The printing paper is now in direct contact with the inked drawing on the stone's surface. By pushing down on the lever, I apply pressure to the tympan, and as I turn the crank the press bed and its load move under the scraper, and the ink of the drawing is squeezed onto the paper. I release the pressure, pull the bed back from beneath the scraper, and examine the "proof," or print. If it is not perfect I destroy it immediately (before I have time to think about it). Except for the etching, this entire process must be repeated for each print.

Lithographers are often asked what determines the size or number of impressions in an original print edition. I suggest that quality is the primary consideration. Many factors can affect quality. For example, all paper is abrasive, and since the paper

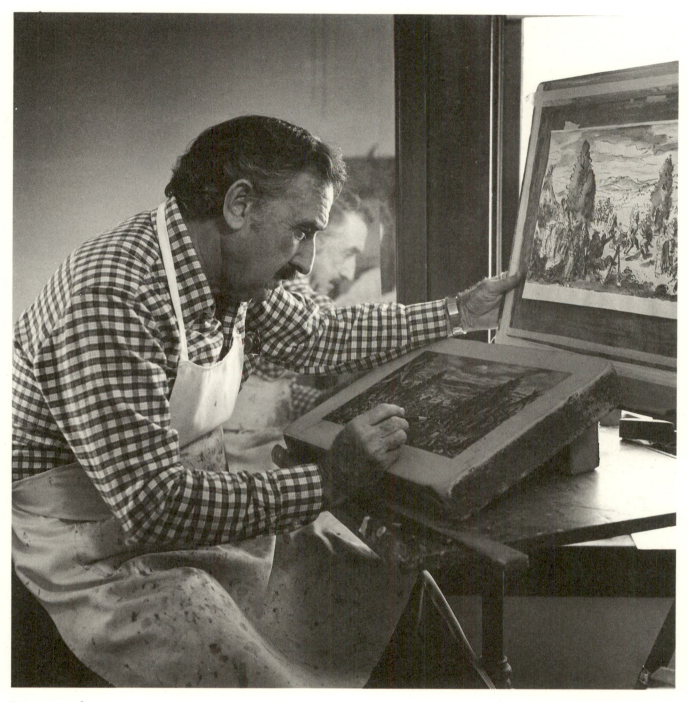

Drawing on the stone.

Photograph by Karl Lee.

comes into direct contact with the stone, it tends to wear away the lighter, more delicate areas of the printing image, resulting in a gradual loss of tone and definition.

Too much pressure during printing can flatten and spread the ink, especially in darker parts of the drawing, causing rich grays to print dead black. Again, this results in a loss of detail and luminosity,

essential qualities in the lithographic proof. When this happens, I stop printing and grind the drawing off the stone. I can then resurface the stone and use it again for another drawing.

A lithograph differs from an etching or engraving in one important respect. It is printed from an entirely flat image on a planographic surface instead of from a raised image or one that has been cut away,

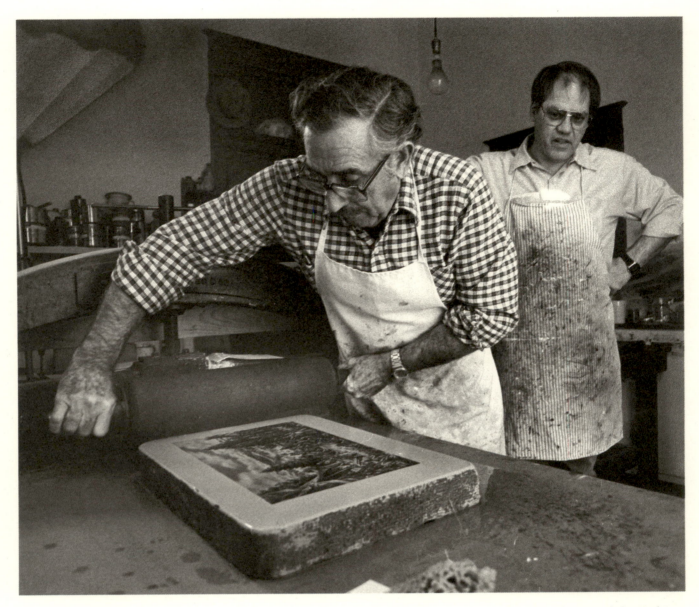

Inking the stone. Photograph by Karl Lee.

as in intaglio printing. For this reason it depends for its results on the mutual repulsion of oil and water. This same principle applies in part to prints produced by modern photo-offset methods, but these are reproductions, not original prints.

Photomechanical reproductions are produced on fast, automatic presses capable of printing thousands of sheets per hour as opposed to the many days of continuous effort required to issue from fifty to one hundred original prints by hand. In creative lithography the impression is made directly from the original drawing. No photography is involved. For stone lithographs printed in more than one color, a separate stone must be prepared for each color to be printed.

Creative lithography is an unrelenting medium. Every phase requires concentrated effort. Because I am acutely aware of the work that is necessary to successfully complete an original lithographic edition, I usually consider only my very best work suitable for the stone.

The lithographic process was invented in Bavaria by Aloys Senefelder in 1789. The most important period for creative lithography culminated in Europe in the works of Francisco Goya, Eugene Delacroix, Jean Baptiste Corot, Honoré Daumier, Jean Louis Géricault, and other brilliant artists. This "golden age" ended in about 1850, and the medium declined into a method used for printing copies of the works of others. Later, Henri Toulouse-Lautrec, Odilon Re-

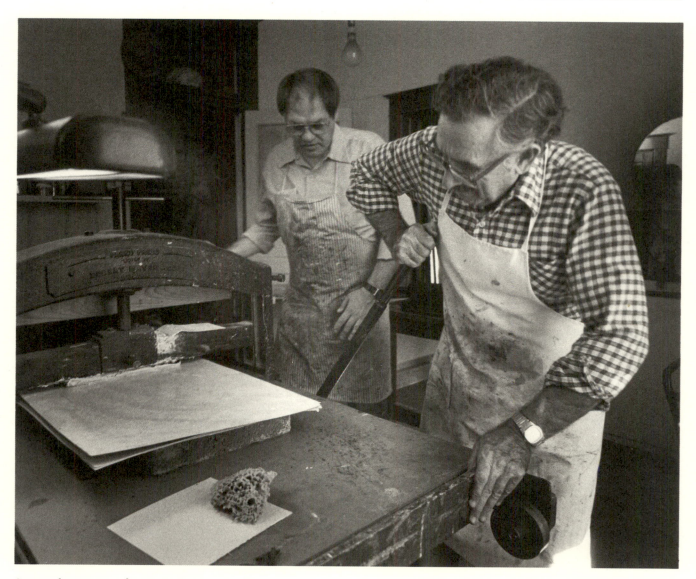

Setting the pressure for printing. Photograph by Karl Lee.

don, and James McNeill Whistler developed an interest in drawing on stone, but the greatest resurgence of interest in the medium took place in America. Modern artists such as Joseph Pennell, George Bellows, Käthe Kollwitz, Stow Wengenroth, and others found inspiration in the stone print. The medium especially lent itself to the reportorial style of the American regionalists, particularly John Steuart Curry, Grant Wood, and the prolific Thomas Hart Benton.

The two largest distributors of stone lithograph prints in America have probably been Currier and Ives, of Philadelphia and New York, whose hand-colored prints were circulated in the 1850s and depicted distinctive subject matter, and Associated American Artists, of New York City, who made fine prints available nationwide for five dollars each in the 1930s and 1940s. The latter group actively promoted individual artists and their work.

My own career in the medium began at a time when interest in regionalism was at its peak. Another war was brewing in Europe, and Americans were feeling isolationist and looking inward. Because artists reflect the times in which they live, so my work recorded my own time and place, which was Oklahoma.

I produced twenty-eight lithographs at the Art Institute of Chicago, all of them depicting Oklahoma subjects. Then, after leaving Chicago in 1941, I had no press available for my use for the next ten years. I continued to make lithographs but had to have them printed for me in New York by George Miller. At least in Miller I had the best.

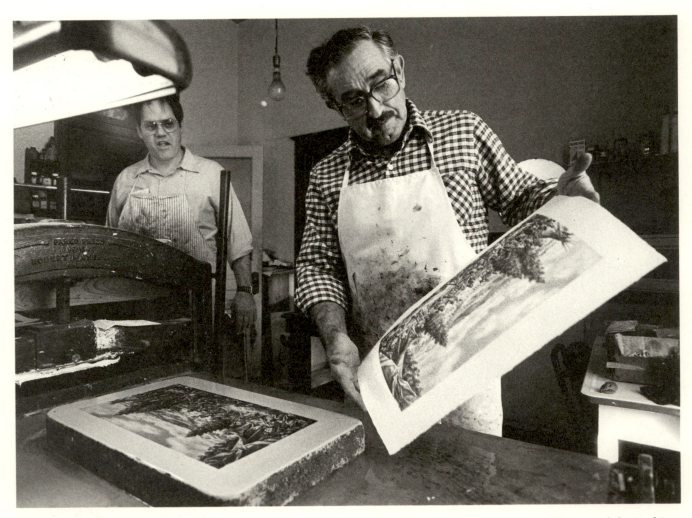

Examining a freshly pulled print. Photograph by Karl Lee.

I was back in Oklahoma again, in 1951, when, as it now seems, Providence intervened. A Latvian immigrant, Adolph Naglins, came to Miami to work on an outlying farm. Having heard that I did lithographs, he looked me up. He had been a lithographic printer in Europe and asked me if I could use his help.

I had no press at the time, but within a few days I learned that an old press, which proved to be identical to Miller's, was for sale in Springfield, Missouri, only ninety miles away. The man who was selling it, a retired artist, had developed arthritis in his hands and could no longer use the press.

Soon Adolph, the press, and ten used stones were in my studio. Only the roller had to be purchased new, and I spent five years breaking it in before I could use it with any degree of confidence. Adolph continued working on the farm and came in to the studio to help me when I needed him. After he left the area, George Miller, in New York, and Alexandre Hogue, the fine artist in Tulsa, remained available to troubleshoot for me: and I had plenty of troubles. Then, in 1964, I was fortunate to find a husky young man, Tony Mayer, to help me with the heavy work. He is still working with me today.

For most of the prints I have made in my fifty years of creative lithography, I have ground the stone, conceived and executed the drawing, etched the stone, and, with Tony's help, pulled the prints myself. There is a satisfaction for me in this process that is unequaled by any other accomplishment in my life. Lithography has encouraged my creative expression and at the same time demanded my craftsmanship, allowing me the full use of all my artistic faculties.

The Lithographs

1 *Cherokee Farmer*

13¾ × 10¾
1938 / Edition 10

The artist's proof may be the only print that still survives from this small edition, issued during Wilson's second year at the Art Institute of Chicago.—D.C.H.

"My 1938 version of American Gothic *voiced a truth I repeated for years to come: Hey, the American Indian no longer rides a pinto pony and chases buffalo across the prairie!"*—C.B.W.

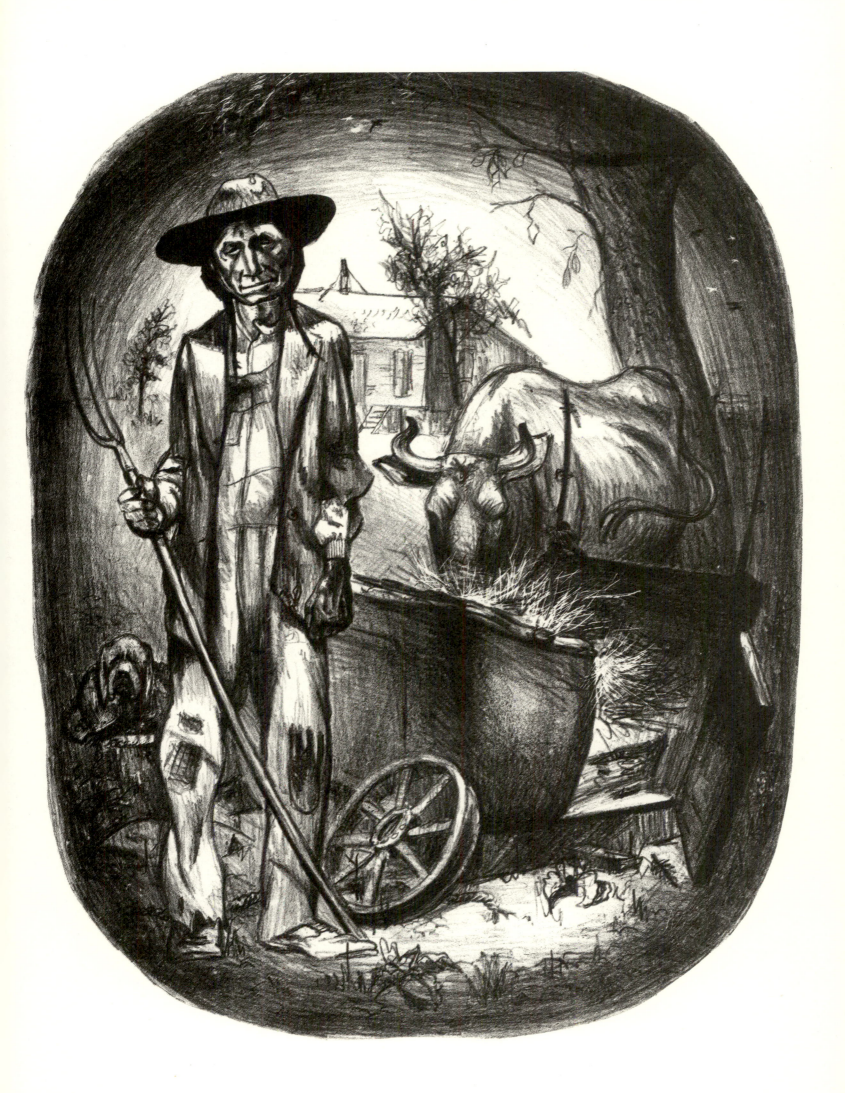

2 *New Rich*
10⅜ × 13
1939 / Edition 20

Oklahoma's mineral resources produced wealth for several Indian tribes, changing the lives of people such as the couple pictured here.

"It was during and after the Depression of the early thirties that some Indians began to get large royalties. I saw new cars come before new homes, which made sense if you think about it. Some people, not just Indians, pretty much lived in their car while the new house was being built."

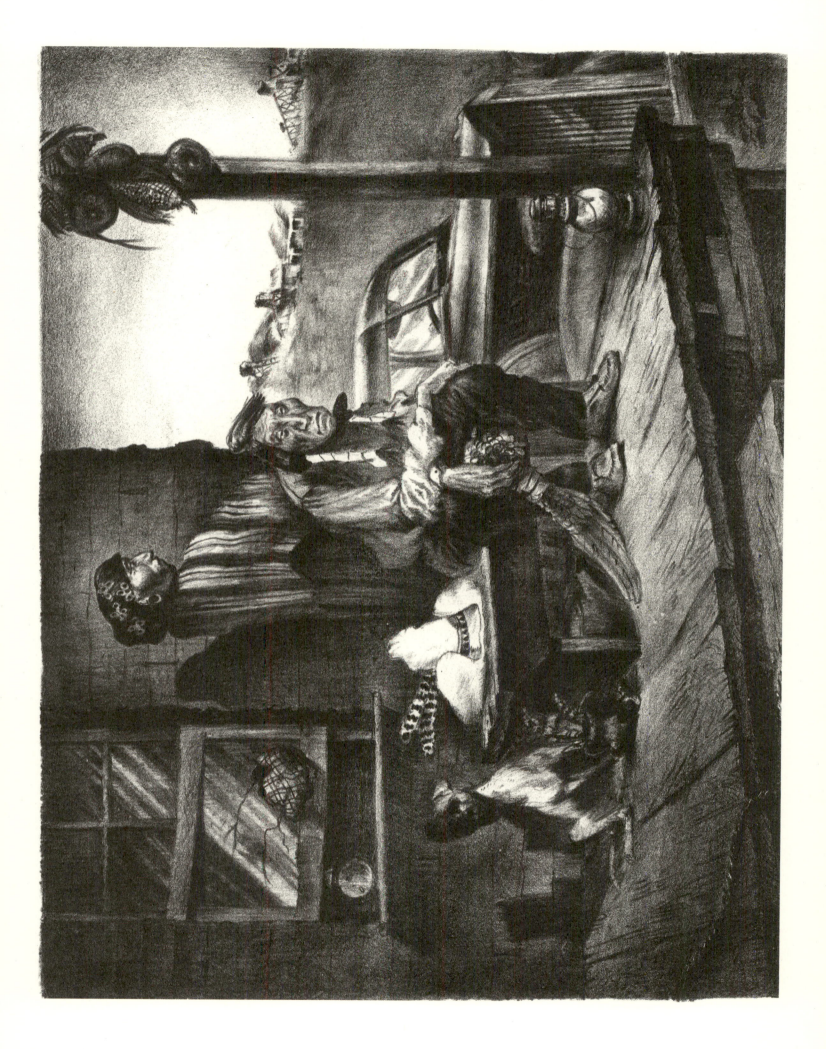

3 *Tribal Honor*
9¾ × 15¼
1939 / Edition 10

Bordering on satire, this early print reveals Wilson's interest in depicting Indians as he saw them rather than as they were represented in films or on posters promoting tourism in the Southwest.

"Indians have an unexpected sense of humor. Accepting money for making someone an honorary chief was sometimes viewed with amusement."

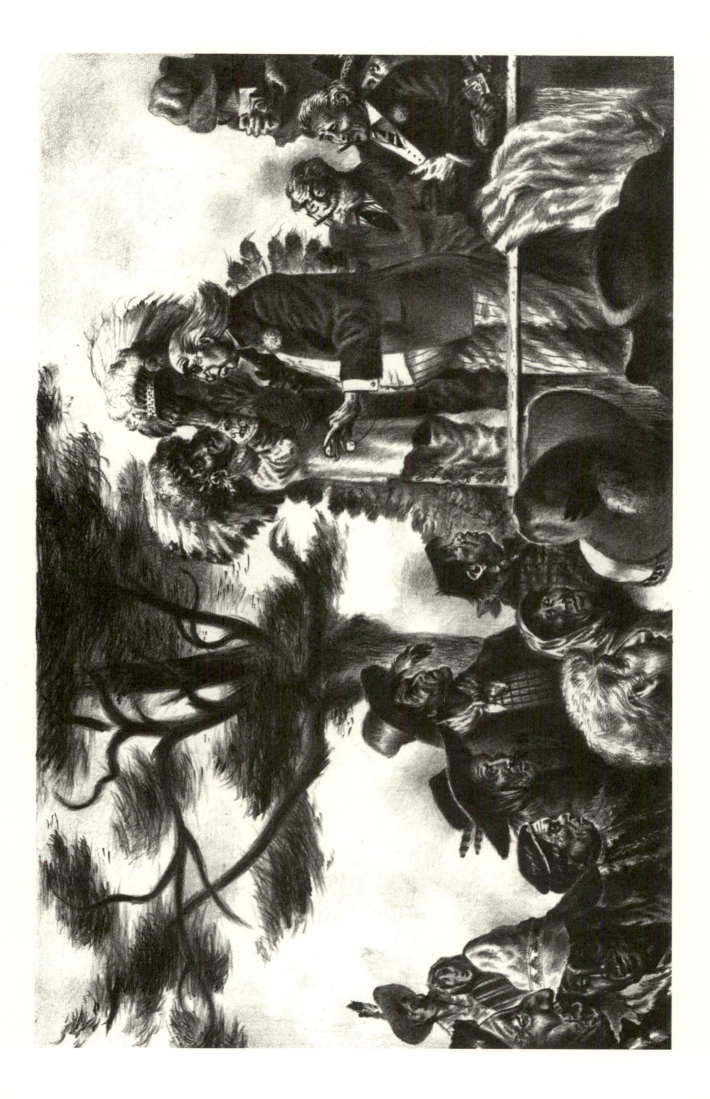

4 *Tribal Band*

9¾ × 13¾

1939 / Edition 10

Indian bands played at many powwows in Okla-
homa in the 1930s, and several tribes formed
their own dance orchestras.

"Costumed Indians with silver saxophones and trom-
bones playing The Stars and Stripes Forever blew
my mind when I saw them at powwows and parades
and even seem concocted in this drawing. At the
same time the sight strengthened my recognition that
the Indian was moving into the white man's world—
or that the white man had moved into the Indian's."

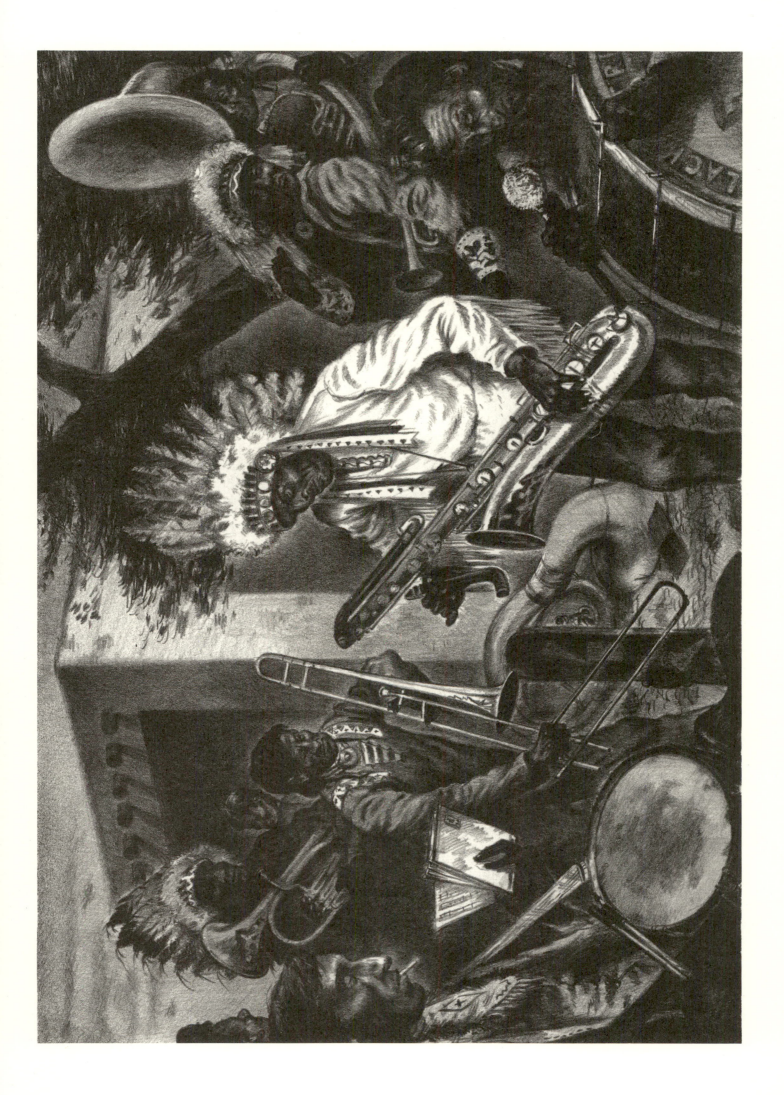

5 *Dance Drum*
12¾ × 8⅛
1939 / Edition 10

Representing Indians from different cultural backgrounds, this print proved to be prophetic of the amalgamation of tribal ceremonies that occurred decades later.

"I saw the drum as a unifying element for people of a divided heritage. The big hat represents Oklahoma; the Pueblo haircut and the Navajo headband the Southwest; the overalled figure the East; and the buffalo headdress the Far West. Yet all are singing the same song."

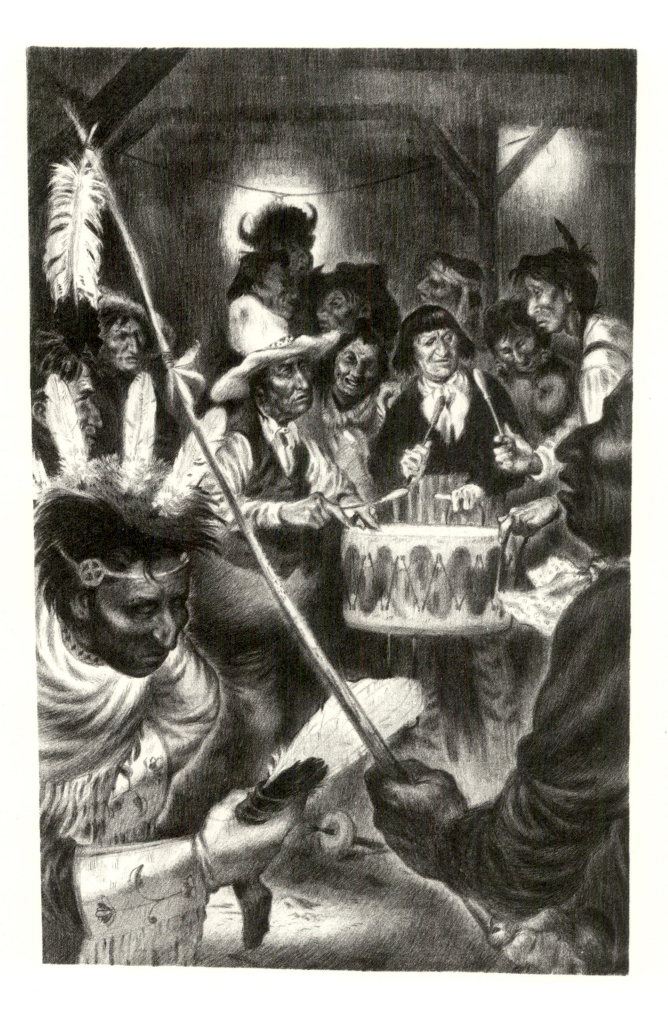

6 *Oklahoma Powwow*
13½ × 15⅝
1939 / Edition 15

First exhibited at the U.S. Department of the Interior, in Washington, D.C., in 1941, this drawing illustrates the point that powwows were organized as much for the fun they offered as for the opportunity they provided to relive old ways.

"The earliest and in some ways best of my powwow stones received adverse criticism. That beer bottle in plain sight was resented by Indians, and non-Indians objected to the Ferris wheel in the background, even though it was there when I drew it."

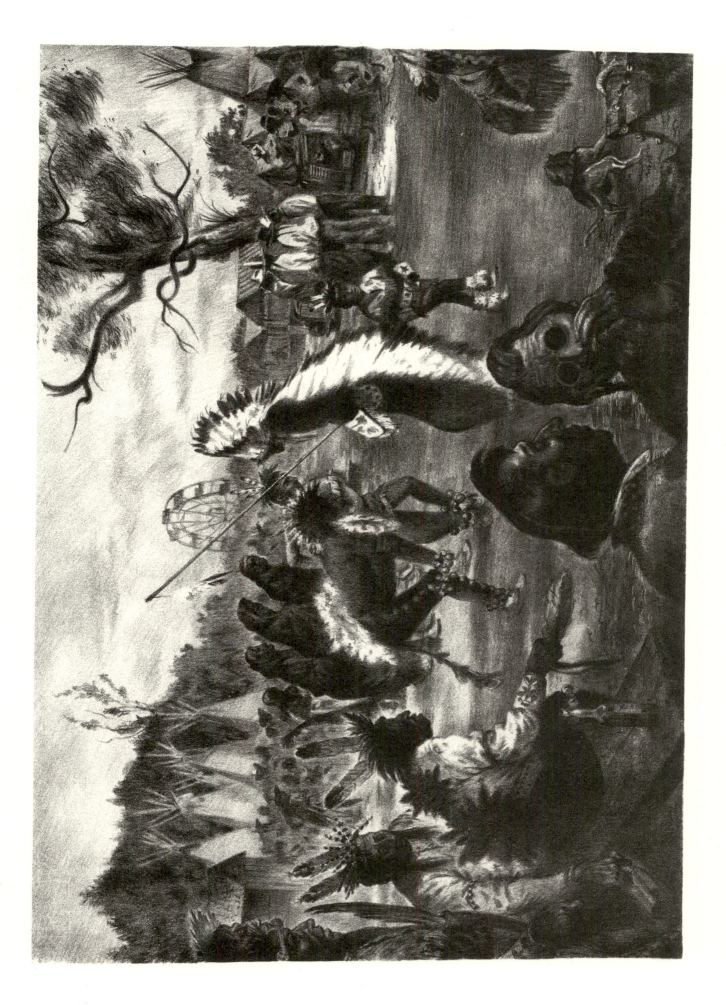

7 *Whitetree*
12¼ × 5⅛
1939 / Edition 10

This portrait of a modern Indian takes its title from the surname of the subject.

"Here is an old full-blood friend who might be anyone in his striped overalls, except for the eagle-tail fan and the feather in his hat, the only outward tokens of his Indian heritage. The Santa Fe Railroad never would have used him on a calendar."

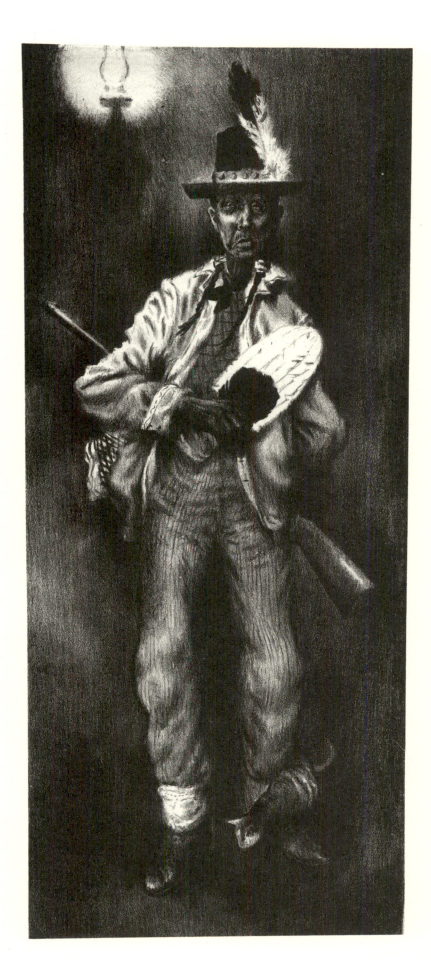

8 *Pete Buck*

12¾ × 8¾
1939 / Edition 22

Coronet magazine published this lithograph in 1940. Popular with collectors, it depicts a Seneca-Cayuga veteran of World War I.

"Pete posed for me for twenty years. His VFW pin indicates that he fought overseas in 1918. This drawing was put on stone at the Chicago Art Institute, where fellow students, seeing my Indians in modern clothing with big hats and braids, referred to them as 'Wilson's Indians.'"

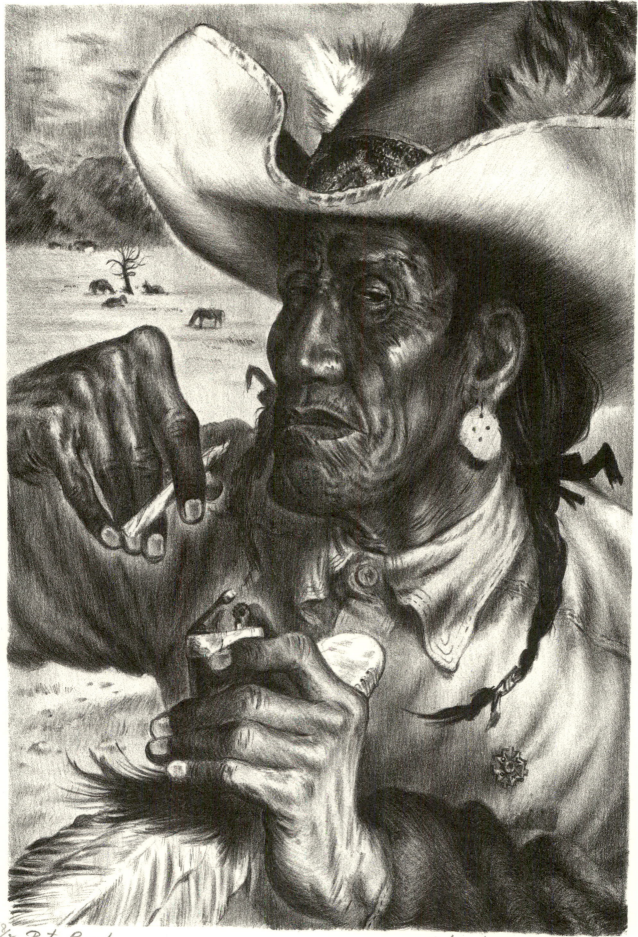

8/12 Pete Buck Charles Banks Wilson 39

9 *Man with a Plow*

12 × 7½
1939 / Edition 26

Depicting another contemporary Indian subject, *Man with a Plow* won a purchase award from the Chicago Society of Lithographers and Etchers and was acquired by the Art Institute of Chicago for its permanent collection.

"People simply liked this design. I believe few who bought it noticed that I was comparing the man with the image on the wall poster. It wasn't until later that I realized I could draw an Indian picture without making a social comment."

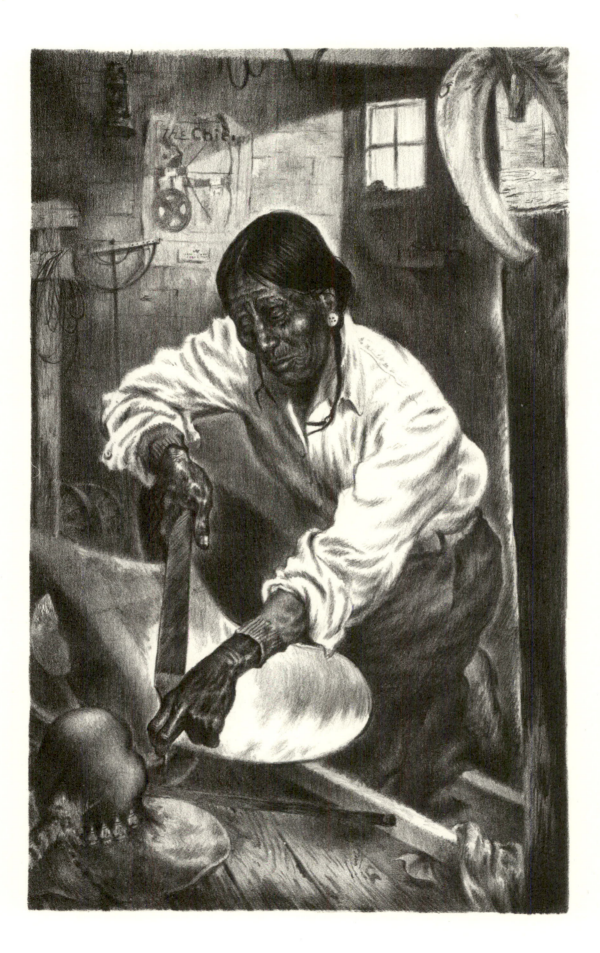

10 *Afternoon Dance*
10¼ × 13⅜
1939 / Edition 16

Offering a behind-the-scenes view of life at an Indian powwow campground, this lithograph suggests that the powwow has changed over the years from a ceremonial event to an entertainment.

"Somewhere my social comment got lost in the activity of the figures. However, the man rolling a cigarette pulls the strings of his Bull Durham pouch in contrast to the notion that all Indians smoked peace pipes. The baby with the kittens is an example of the kind of aetail I often included in my pictures in 1939."

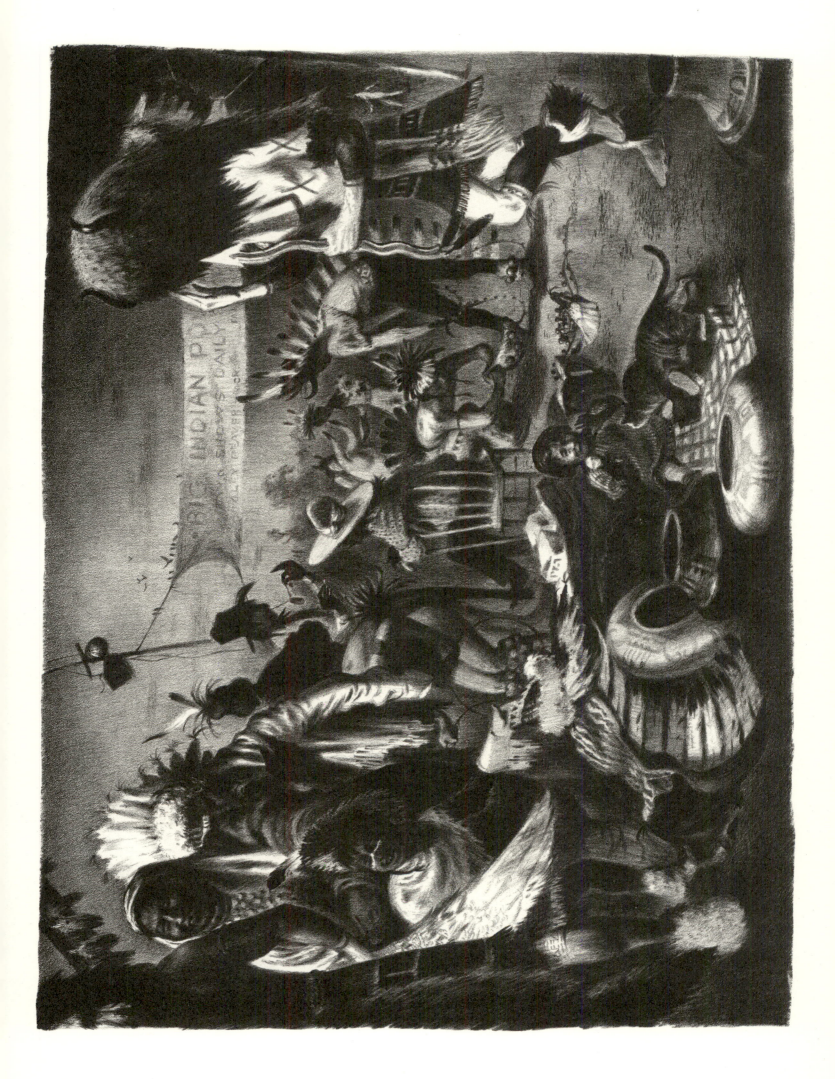

11 *Savage,* or *Portrait of a Wild Indian*

9⅞ × 4⅜

1939 / Edition 16

Wilson sought out this man, reputed to be a rough character, after friends suggested that he might make an interesting subject for a picture. The National Academy of Design exhibited the print in 1949.

"He was a crack shot with a rifle, but preferred to pose for me with one of his Banty roosters. So that's the way I drew him. The title merely points up that he wasn't—!"

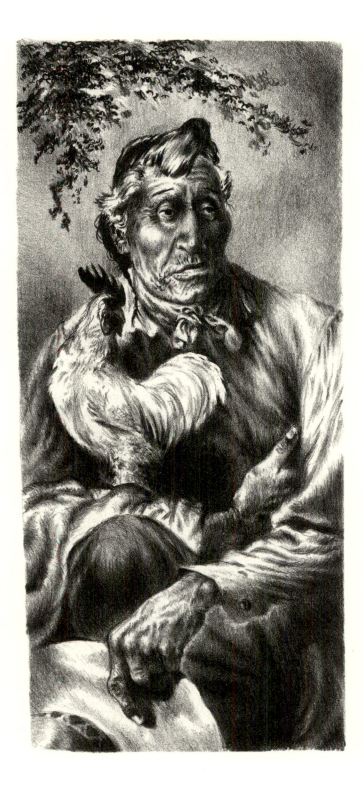

12 **Story Teller**
10 × 12⅞
1939 / Edition 23

Another subject reproduced in *Coronet* magazine in 1940, *Story Teller* was inspired in part by the book *Indians are People Too*, by Ruth Muskrat.

"As I look back, the old man with the little girl carrying her doll Indian fashion would have been enough for a picture; but I added other activities of the camp, such as men pitching horseshoes and little boys chasing little girls."

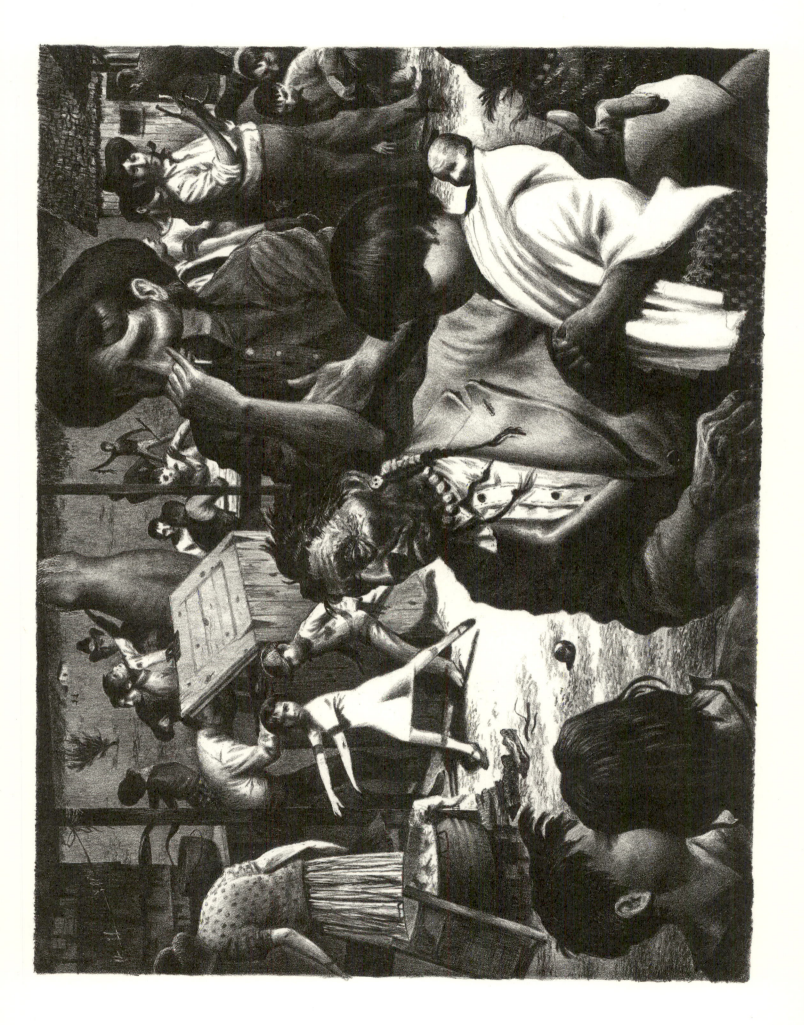

13 *Kiowa Dancers*

12 × 7¾
1940 / Edition 19

Historically the nomadic Kiowa were noted throughout the Southwest as warriors and horsemen. Today they are outstanding among Oklahoma's artists, dancers, and singers.

"No social foil here! Observing dancers as they adorn themselves always fills me with design ideas, just as many artists have been inspired backstage at the ballet."

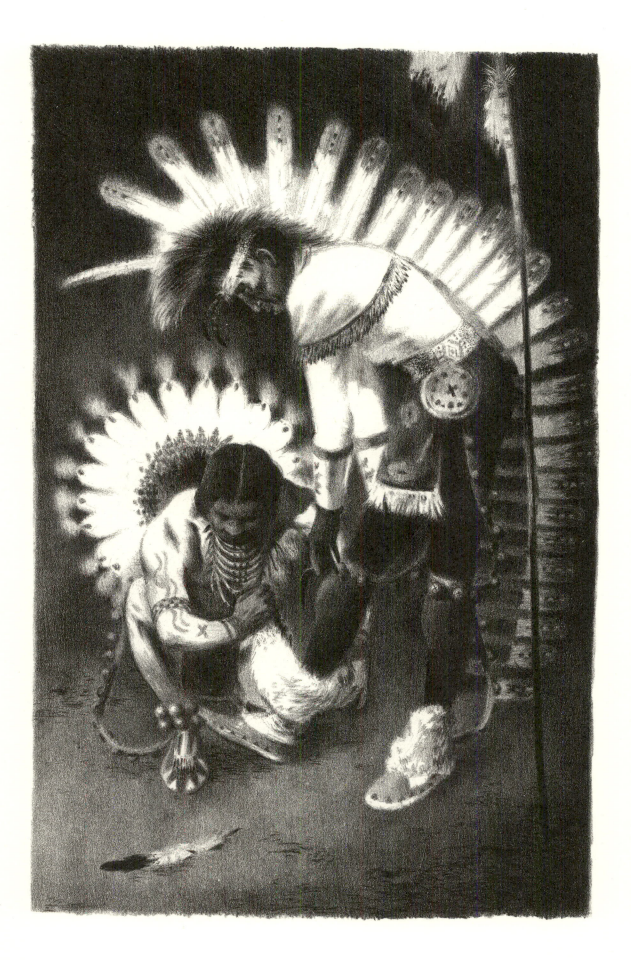

14 *Indian Smoke*

9⅜ × 5⅜
1940 / Edition 10

Design vies with social commentary in this print.

*"My original idea for this little drawing gave way
to the strong faces and the development of the white
pattern of the gloves against the dark shadows of the
figures."*

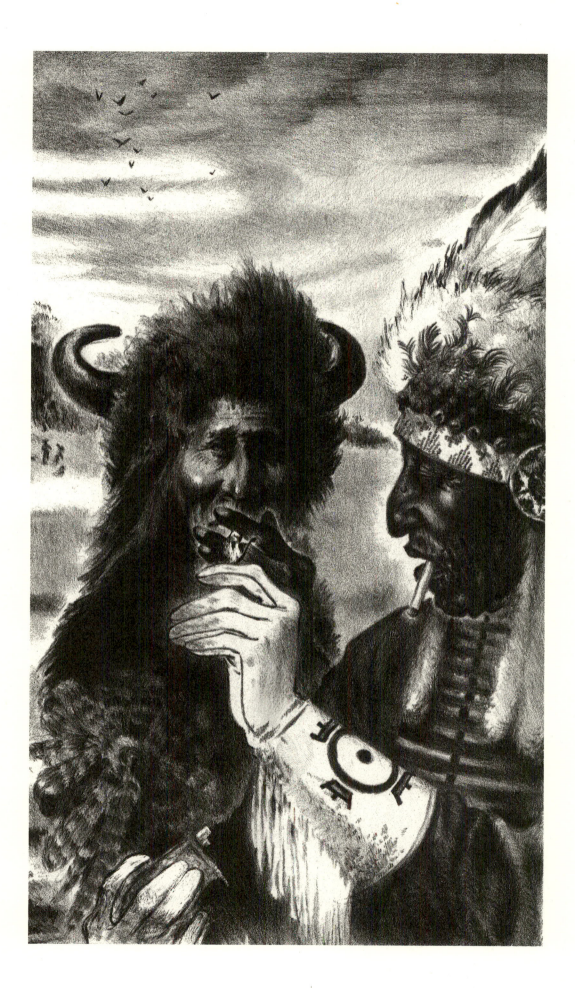

15 *Mealtime at a Quapaw Powwow*

9⅝ × 13⅜

1940 / Edition 19

The relationship of opposing curves and masses enhances the composition of this print, first published in *Coronet* magazine and later exhibited at the Library of Congress.

"When I drew this, the Quapaw had become wealthy from royalties paid on their lead and zinc deposits, and at their powwows they served everyone big meals at long tables. The food—dried corn, wild-grape dumplings, squaw bread, pecan butter, wild meat, and beef—probably brought as many Indians to their festivities as did the colorful dances."

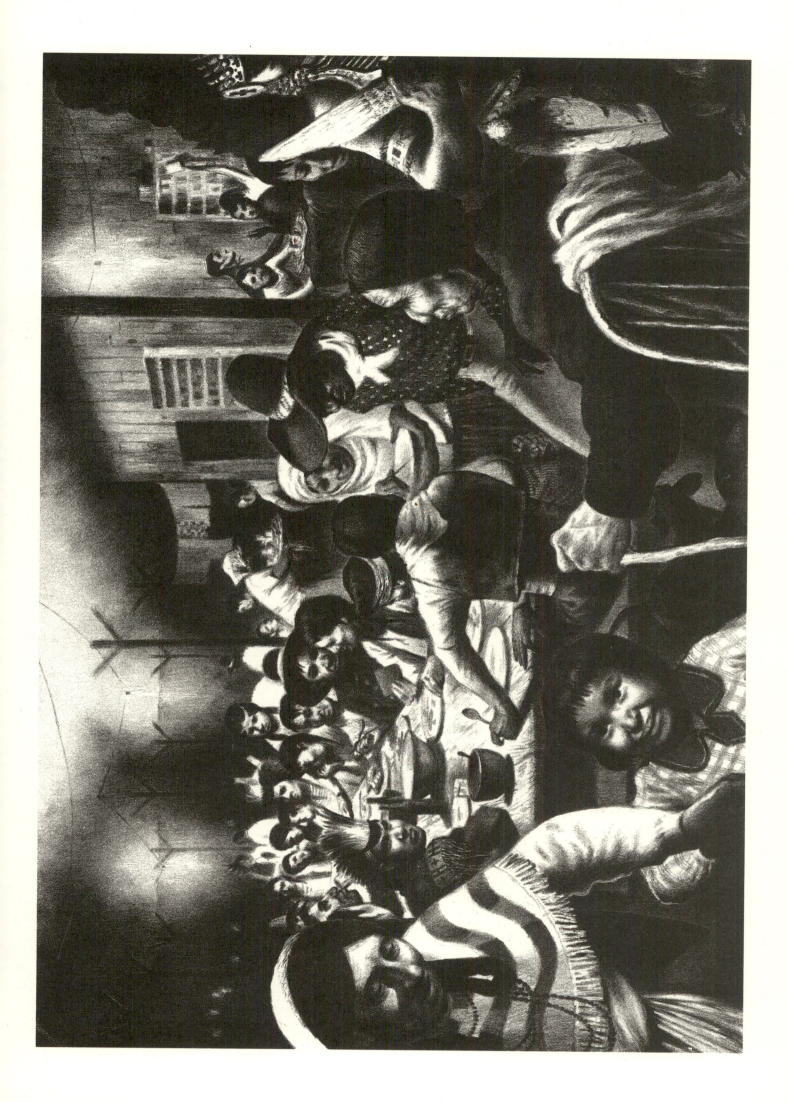

16 *Painting Her Son*
9½ × 13¼
1940 / Edition 21

Here a woman helps her son prepare for a dance. He wears an old-style bustle with "magic" feathers attached to the cloth hanging from his belt. Although such articles may have lost their original significance, they still form an important part of the traditional dress of the modern dancer.

"Watching the metamorphosis of dancers as face paint was applied or costumes assembled made me feel at times that I was a visitor from another planet. A war bonnet, for example, could change someone who considered himself a 'nobody' into royalty, with direct ties to the great chiefs of the past."

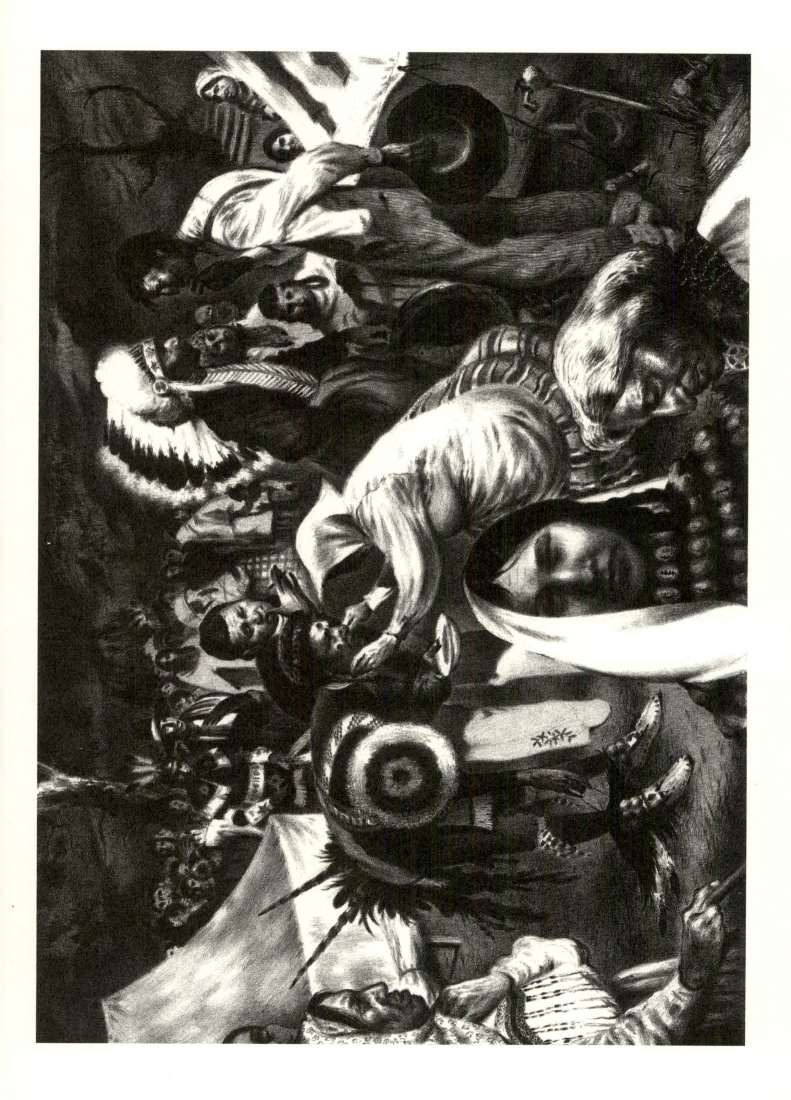

17 *Otoe Eagle Dance*
9½ × 12⅞
1940 / Edition 14

Published by *Collier's* in 1942 and exhibited at the Library of Congress in 1946, this is the only lithograph Wilson ever printed in more than one color, gray and black, requiring the preparation of two stones.

"I sketched this scene from a hill above the dance ground. Actually a dance of southwestern Indians, it was often presented by Oklahoma dancers at Oklahoma powwows."

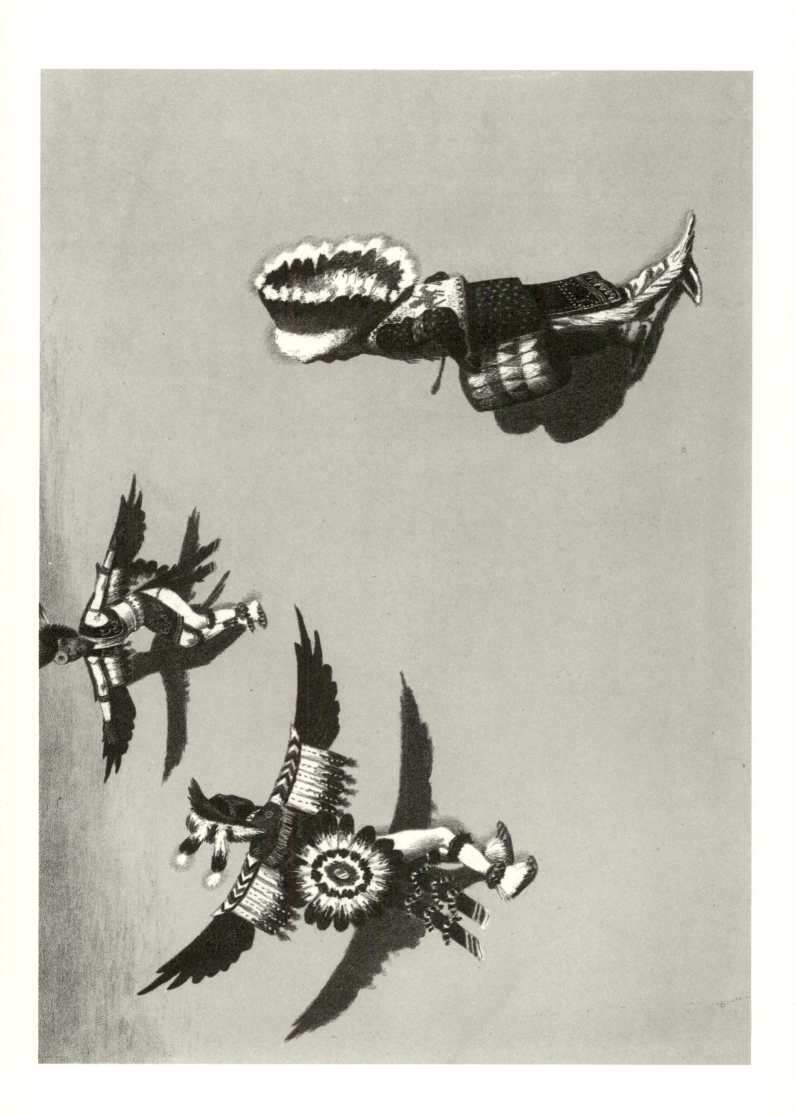

18 Henry Turkeyfoot
10 × 13¼
1940 / Edition 25

As fellow students in Chicago began buying his prints, Wilson issued larger editions of subjects such as *Henry Turkeyfoot*, which was reproduced in *Collier's* in 1942.

"Art teachers advised against placing a principal figure at the center of a composition. I found this as silly as most rules about art and did it often."

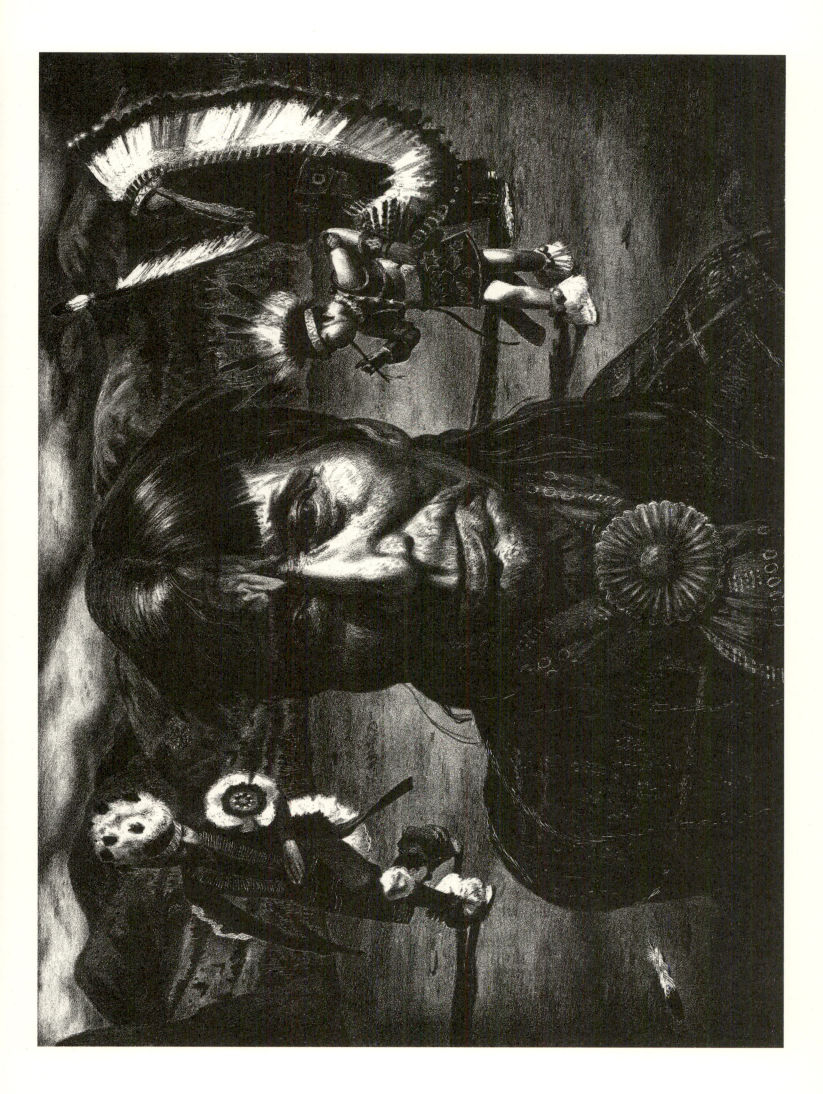

19 *Navajo Horses*
9½ × 11⅝
1941 / Edition 20

Developed from a preliminary, abstract design,
Navajo Horses was one of ten lithographs that
Wilson produced during his last semester at
the Art Institute of Chicago. Indians seemed to
be the subject he knew best, and he used them
as figures in his pictures regardless of the
composition.

*"Navajos trailed their horses through my camp early
one morning at Gallup, New Mexico, perhaps ac-
counting for my empathy with the sleeping figure in
the foreground."*

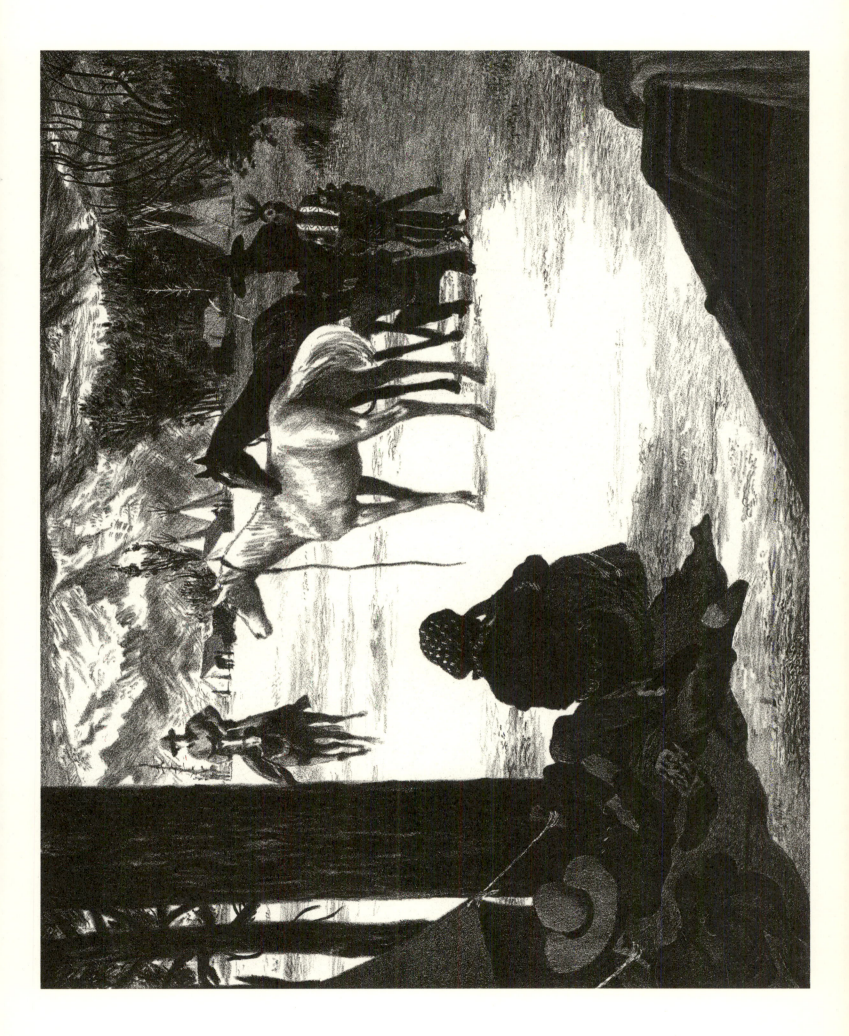

20 *Seneca Greencorn*
10⅜ × 12⅞
1941 / Edition 24

Represented here is the Sun Dance, performed as part of the annual thanksgiving celebration of the Oklahoma Seneca-Cayuga. Wilson put himself in the picture, appearing in a hat at upper left with a sketchbook in his hand.

"Seneca-Cayugas call it their 'Thanksgiving.' I think of it as a fertility ceremony, as this is the time, late August, when they name the new babies and share with each other a sample of the season's crops. There is no superstition about my pencil, and I've drawn all the things they've never let anyone photograph."

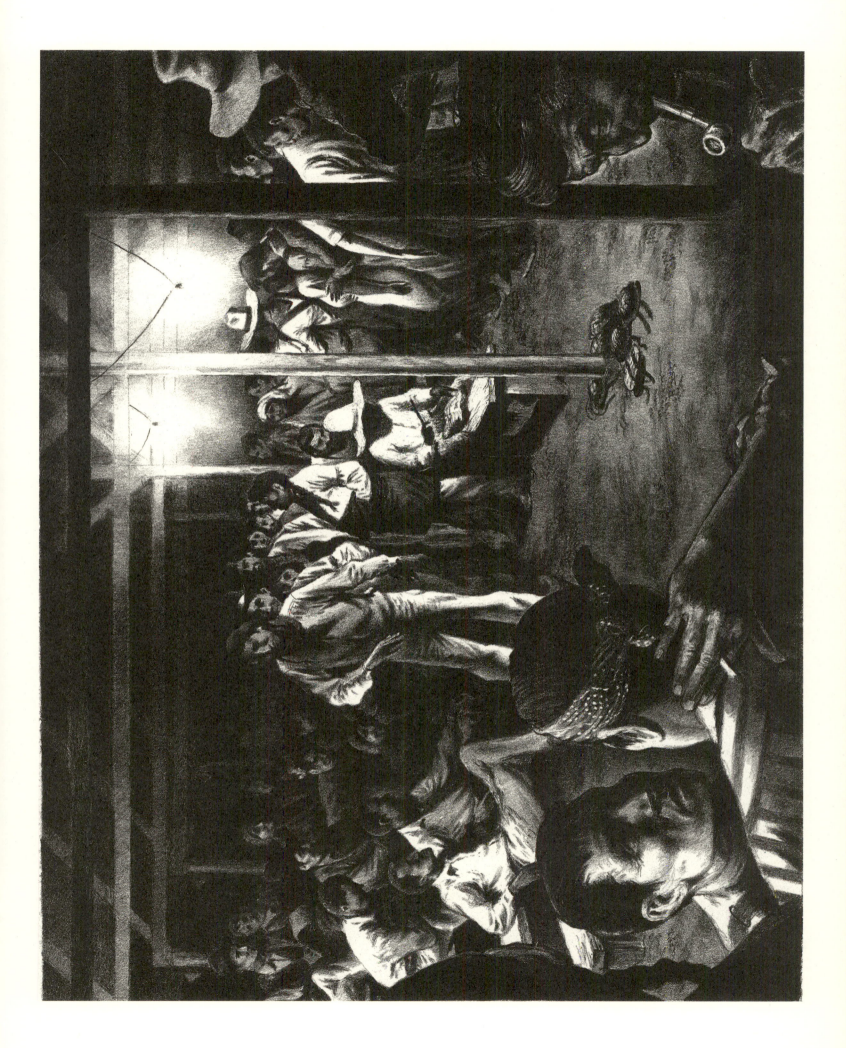

21 *Handgame Feast*
9 × 15¼
1941 / Edition 30

Reproduced in *Collier's* in 1952, *Handgame Feast* was exhibited at the National Academy of Design, the Library of Congress, and in several midwestern shows. A later print, *Handgame* (see plate 33), depicts the handgame itself.

"Uncle Alex Beaver's longhouse was the setting and the handgame the central activity of an evening that included all manner of country games. Afterward, the food that everyone had brought for the occasion was carried in from the cooking fires outside. What wasn't eaten was divided up and taken home—a satisfying climax to an evening of fun, not ceremony."

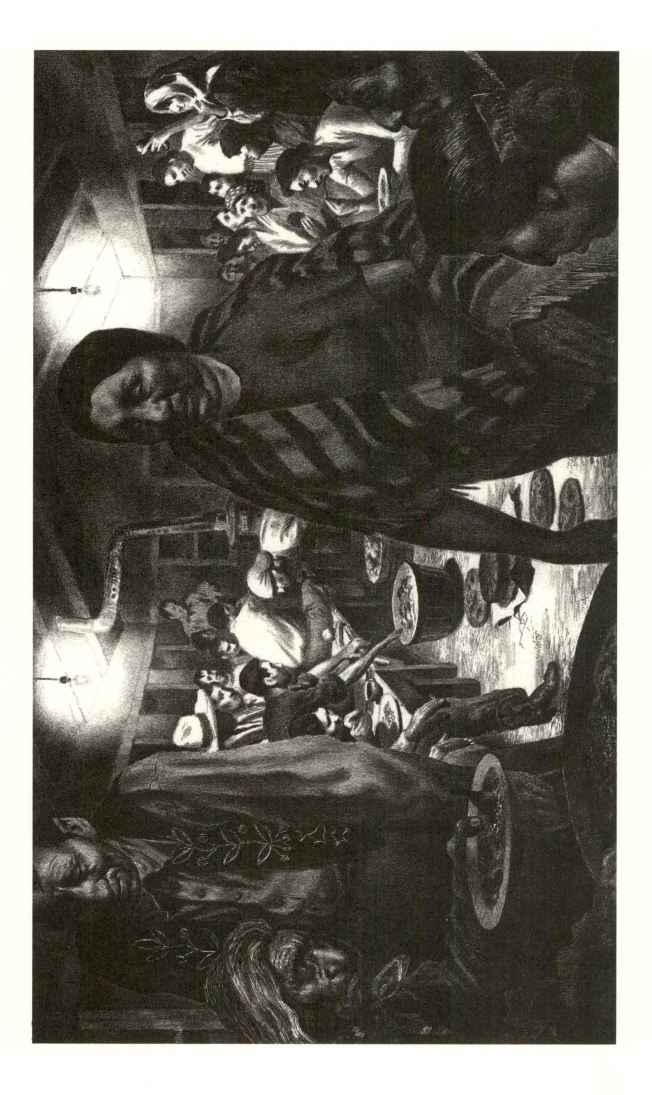

22 **Visiting Indians**
9⅝ × 13
1941 / Edition 30

Another print published by *Collier's* in 1942,
Visiting Indians again depicts behind-the-scenes
activities at a powwow. In the background is
the camp. In the foreground men and women
have gathered to gossip and joke.

*"The old car got the visitors to the powwow—but
would it get them back home? I had intended to
concentrate on the young boy practicing for an after-
noon of ceremonial dancing but soon realized there
was more to the scene than that."*

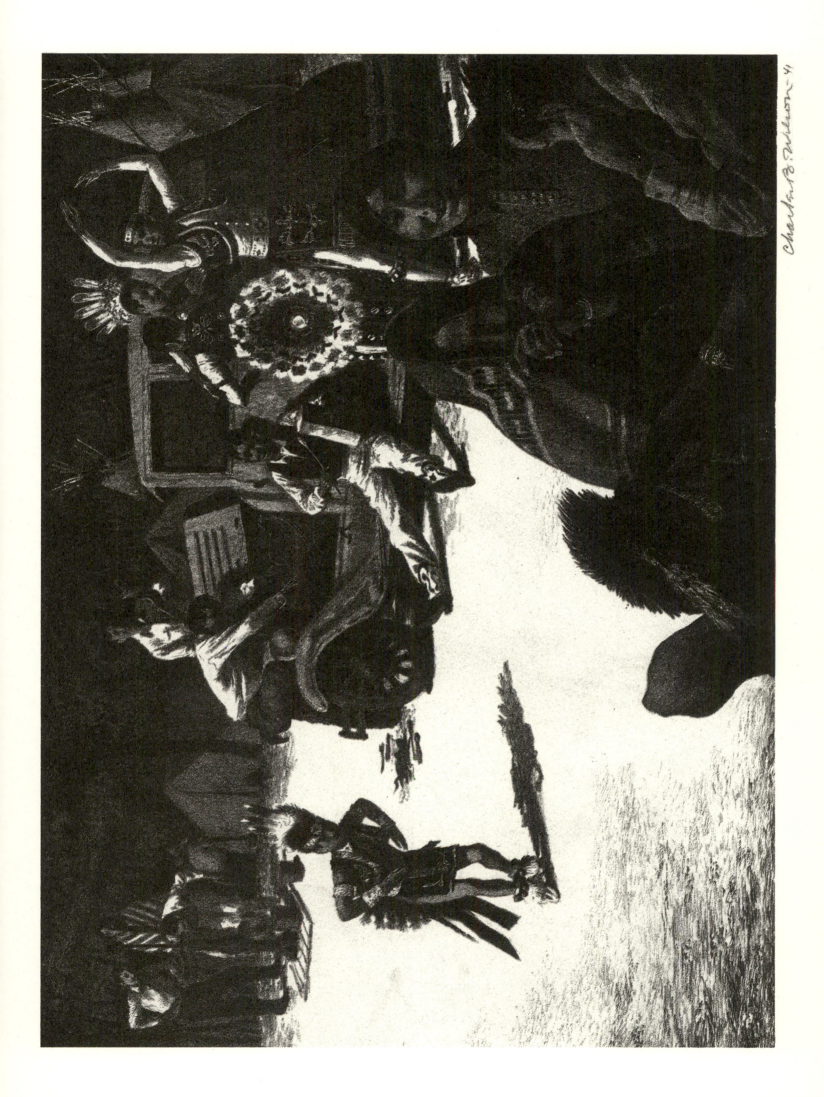

23 *War Dance for Little Indians*
10 × 12¾
1941 / Edition 16

The figures at the left are the focus of this lithograph, issued during Wilson's last semester at the Art Institute of Chicago. Today dances for children are common. The songs are not improvised, as many non-Indians suppose, but are intricate, prescribed arrangements of melody, word, and rhythm, which the dancers must know almost as well as the singers.

"Indians are very concerned with the importance of teaching their children the songs and dances. I did a number of prints that show this. Here, no doubt, the drummers play a slower beat for the young Indians."

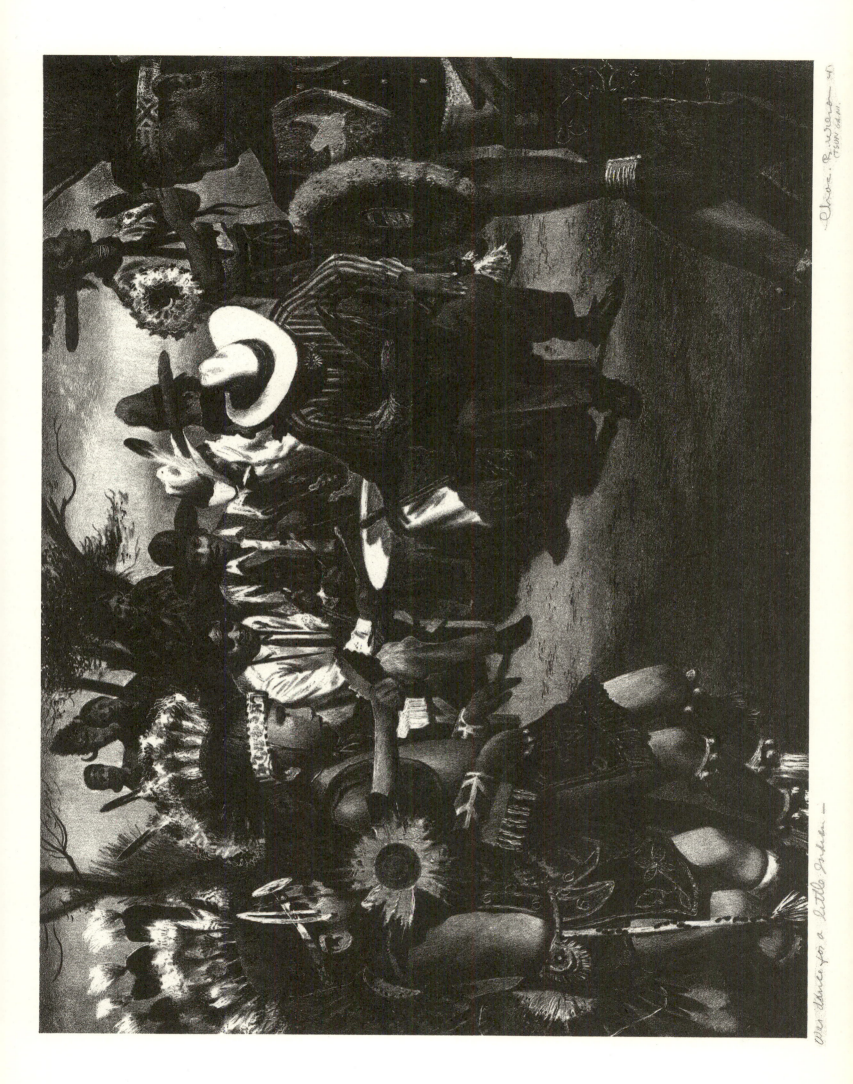

War dance for a Little Sister —

24 *Quapaw Powwow*
10 × 14
1941 / Edition 26

This subject represents a high point in Wilson's development as a printmaker. Concerned with spatial relationships, he composed the foreground in tones of black and gray, the middle ground in grays and white, and the background in shades of gray.

"Generally I was interested here in looking behind the scene. This stone, however, became a report of the powwow dance itself as well as an experiment for me in achieving a sense of space through tone."

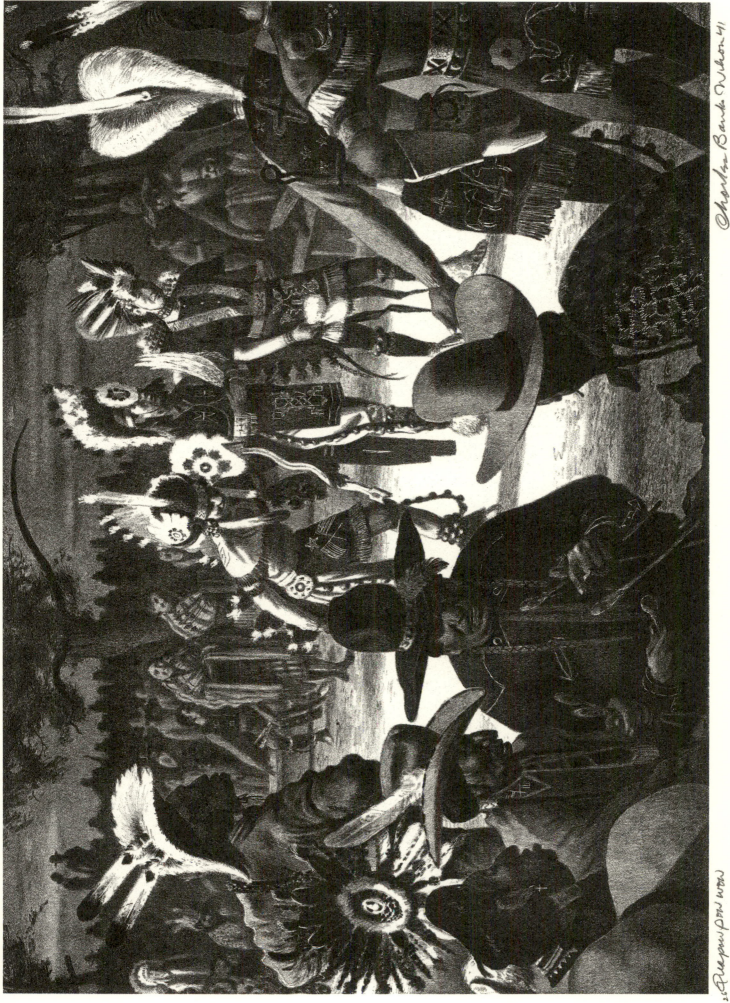

"Powwow Time"

Charles Banks Wilson 41

25 *Dancers Dressing*

14 × 8⅞
1941 / Edition 23

The design idea came before the subject matter in this print, published in *Collier's* in 1942 and later exhibited at the Pennsylvania Academy of the Fine Arts.

"It was inspired by the shape of a bentwood chair that someone had left out in a hotel hallway. As I fiddled with a composition using the chair, I added figures, which soon dominated the picture. Again they could be ballet dancers."

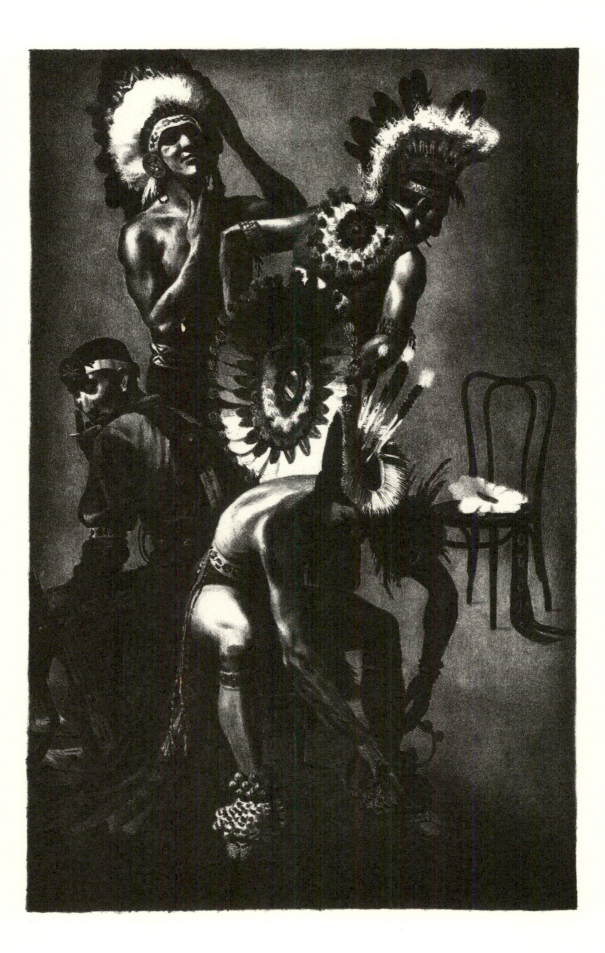

26 *The Chief, or The Celebrity*

7⅜ × 10¾
1941 / Edition 20

A young fan asks a powwow dancer for his auto-graph, forgetting that the dancer is really an Indian and not an actor playing a part. The Eagle Dance of the Hopi places the scene in context.

"This was my final attempt at satire!"

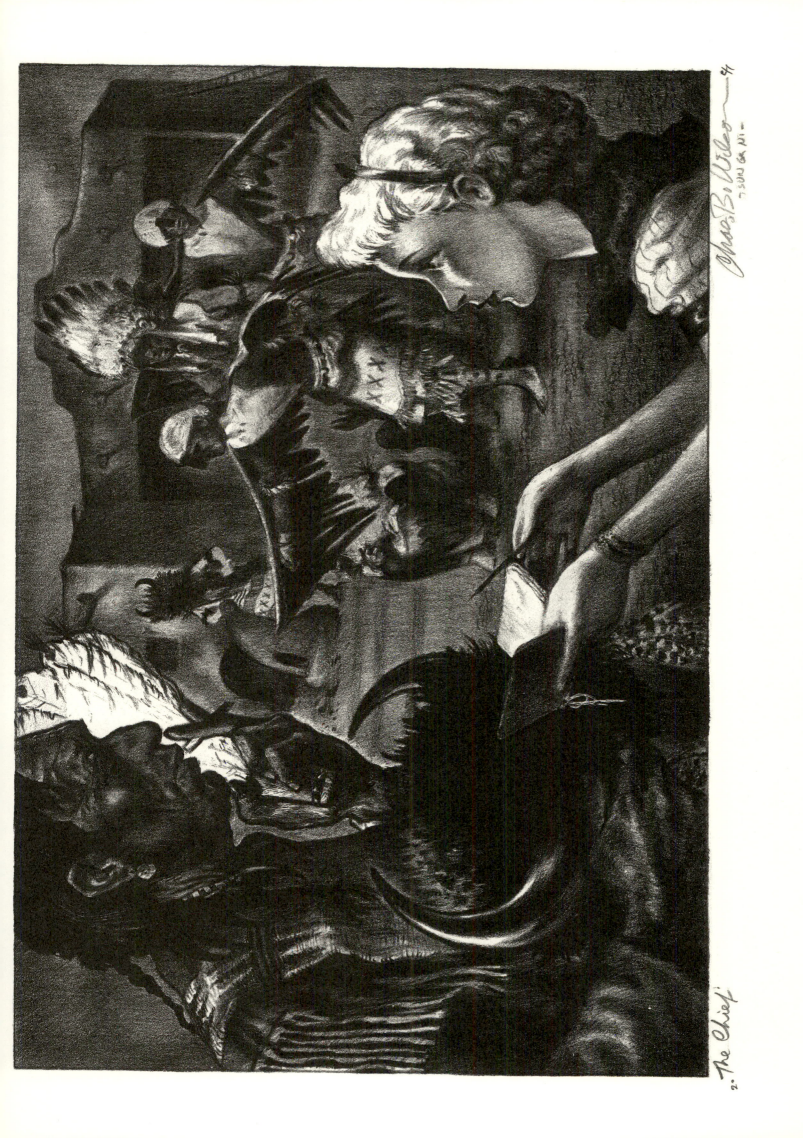

2. The Chief

27 *Indian Peyote Music*
9⅞ × 13
1941 / Edition 35

In this drawing the central figure sings to the accompaniment of a gourd rattle. The subject at left plays a water drum. The man at right holds a cigarette made of tobacco leaves and dogwood bark wrapped in a corn shuck. Its smoke, along with the smoke of the fire in the center of the enclosure, carries the prayers of the singers to God through an opening in the ceiling.

"I sat flat on the ground in a tipi for ten hours one October night to get material for this print. For me the privilege of being at this meeting will be the closest I'll ever come to having a religious experience while making a drawing."

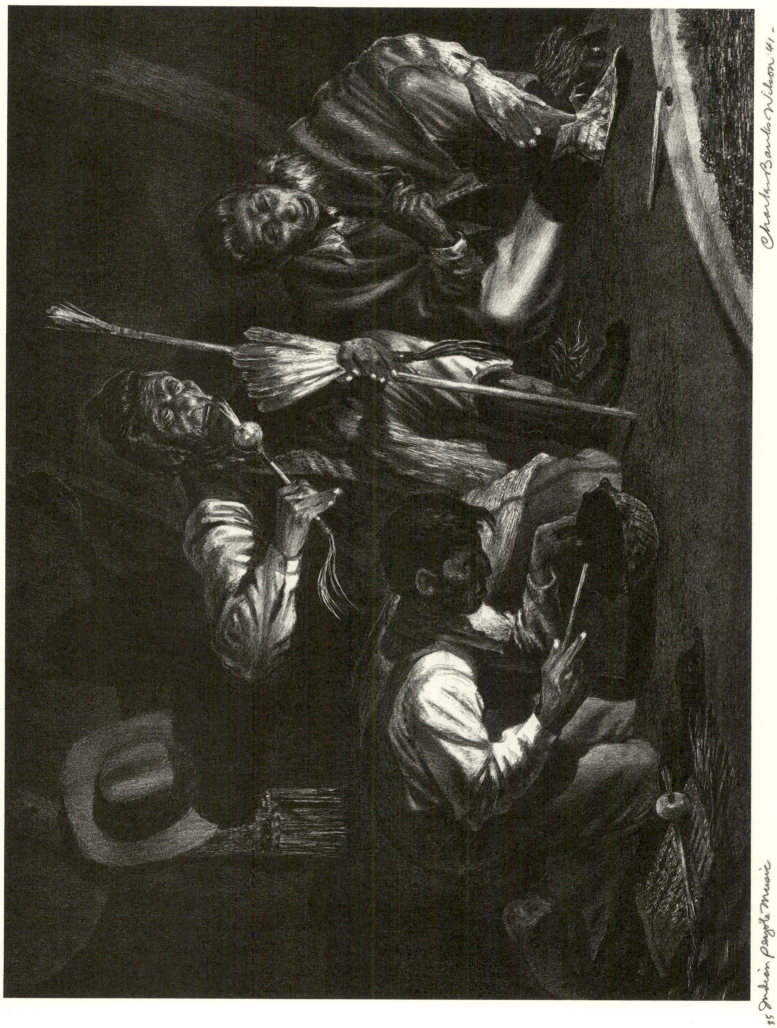

"Indian People Music

Charles Banks Wilson '41

28 *Old Medicine Singer*
8⅞ × 13¼
1941 / Edition 34

Based on another of his Peyote ceremony sketches, *Old Medicine Singer* was the last print Wilson produced as a student in Chicago.

"The average viewer might hesitate to look at him closely in the flesh. As this is only a picture, you have the courage to look the old patriarch straight in the eye. No stone I've ever done was better printed by me."

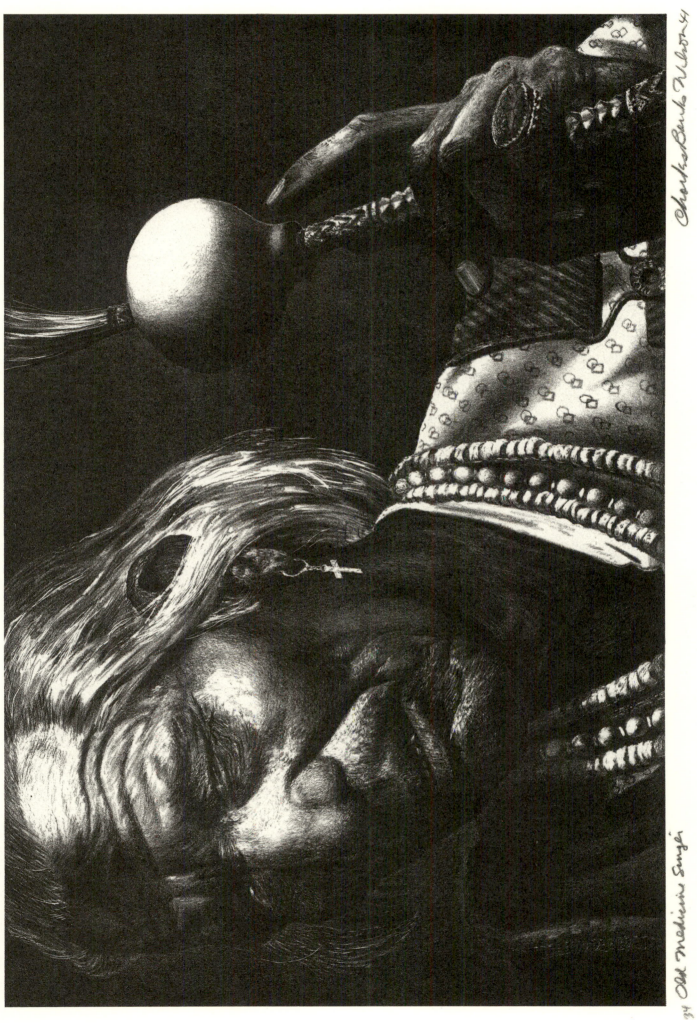

34 Old Medicine Singer

ChaukaBanks Wilson 4

29 *Comanche Portrait*
10¼ × 14½
1941 / Edition 200

George Miller printed this lithograph, the first of five prints that Wilson produced for Associated American Artists.

"They wanted me to repeat the earlier Henry Turkey-foot composition. I substituted an old Comanche man I had drawn that summer. It was on the basis of this commission that I found the courage to get married and move to New York City in the fall of 1941."

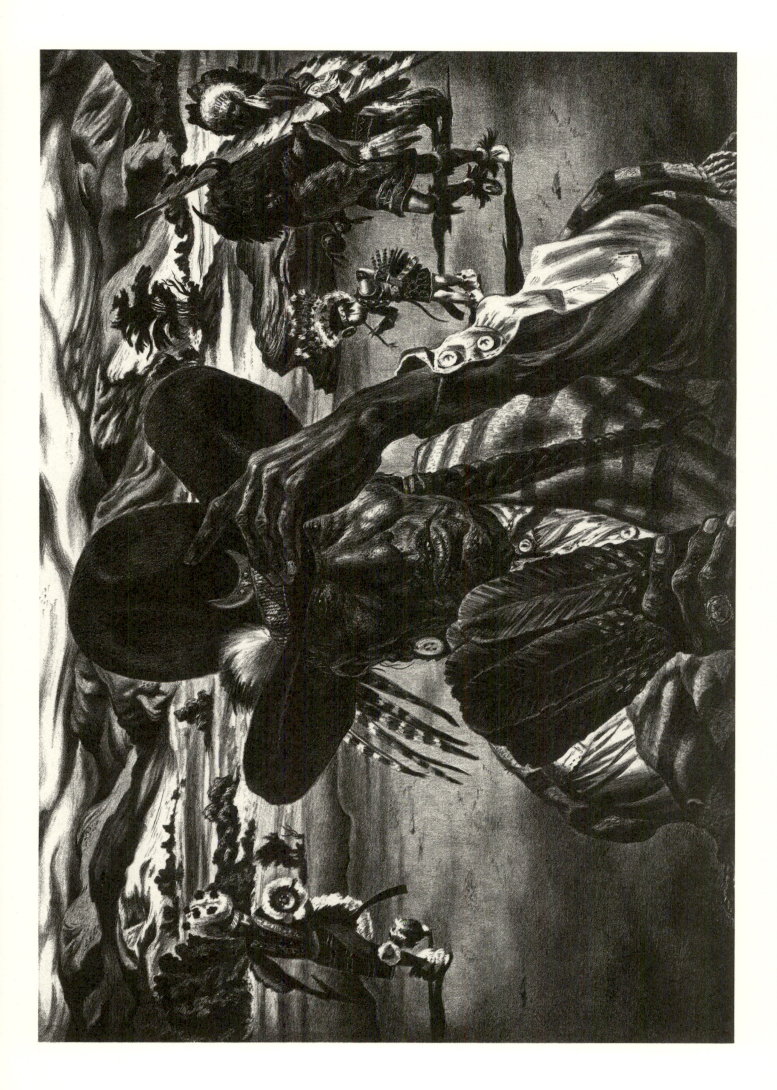

30 *Ozark Summer, or The Swimmin' Hole*
10 × 13½
1942 / Edition 200

Associated American Artists published this print as *The Swimmin' Hole*. Purchased by several museums, it has proved to be one of Wilson's most popular subjects, capturing what he feels is "the essence of boyhood."

"This is not a specific place, even though my father said that he 'remembered it well.' The Metropolitan Museum of Art had copies made for distribution to GI training camps everywhere. Louis Untermeyer called it 'America's best loved print.'"

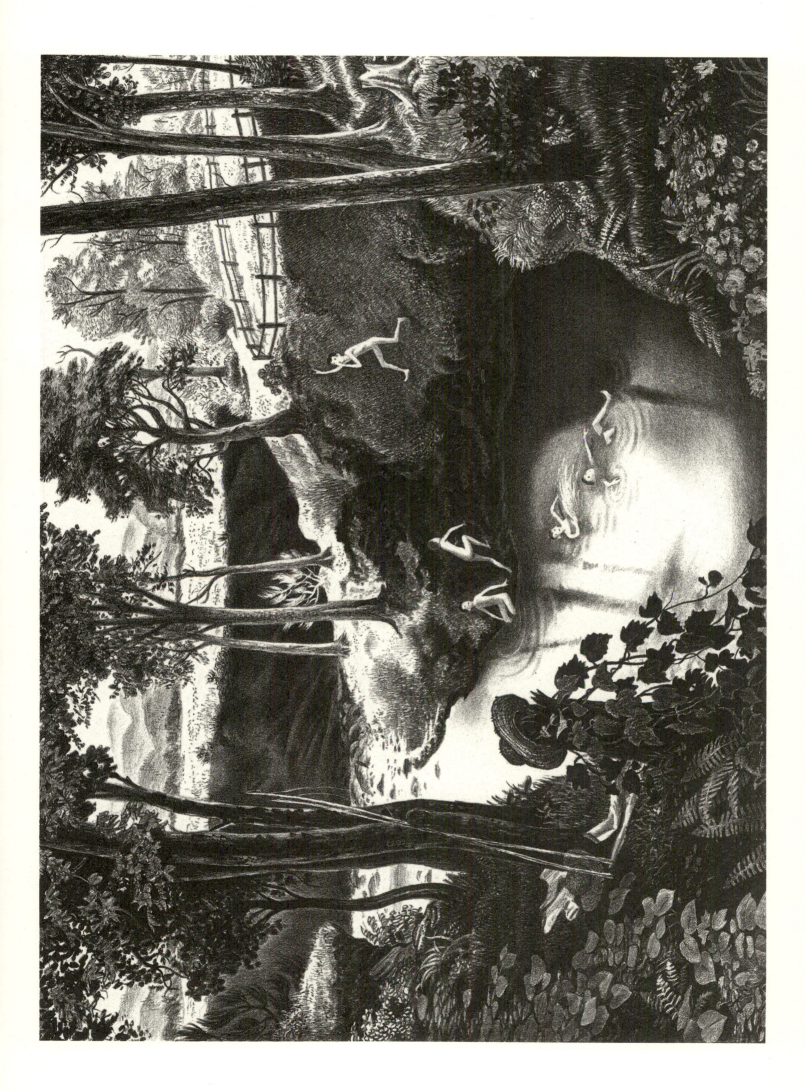

31 *Ozark Snow*
9¾ × 13¾
1942 / Edition 25

First reproduced by Associated American Artists as a Christmas card, *Ozark Snow* later appeared with *The Swimmin' Hole* in Hal Borland's *American Year: Country Life and Landscapes Through the Seasons*, published by Simon and Schuster in 1946.

"I came in for criticism about the location of the windmill, but it was there when I drew it, and I didn't tell those folks in the cabin that their mill was in the wrong place! I recall a traveling salesman who brought me a few dollars regularly toward the purchase of this print. He said he felt an affinity with the man 'bringing home the bacon.'"

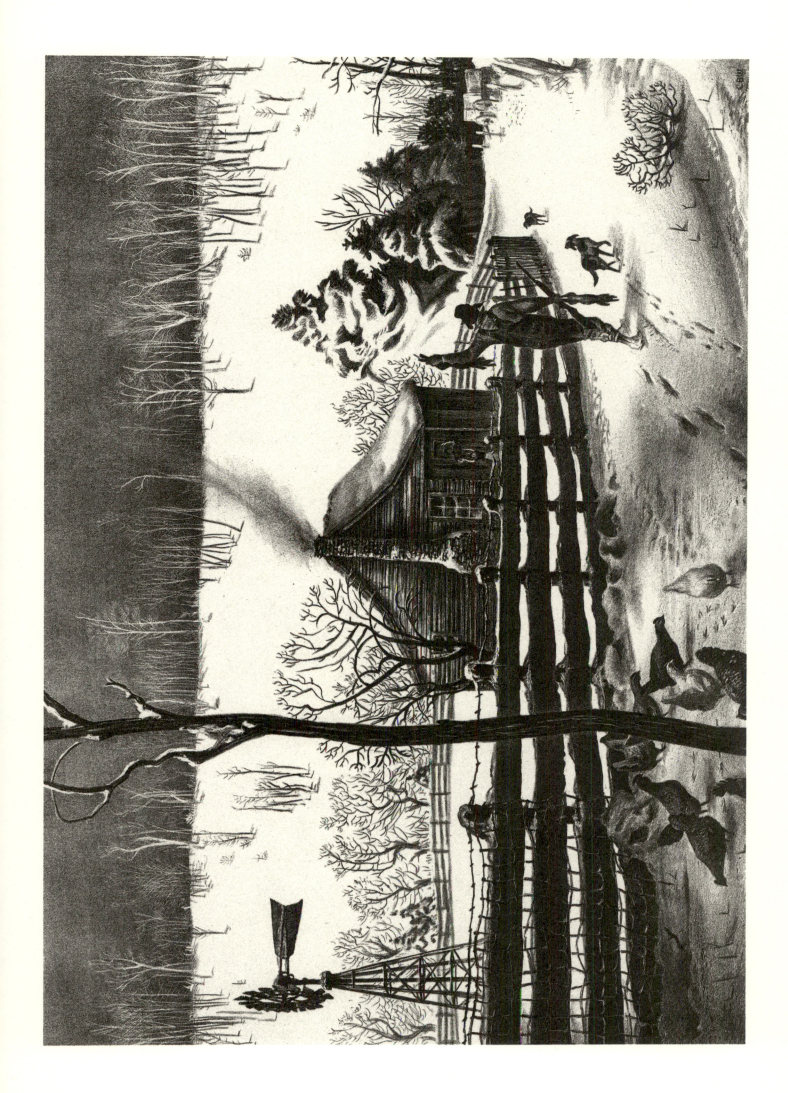

32 *Judge Roy Bean*
10¼ × 12⅝
1942 / Edition 25

This print, based on a drawing made to interest the publisher of a book on the subject, was exhibited in 1942 in the display window of Doubleday's Broadway bookstore, in New York City, surrounded by a group of Daumier lithographs depicting French jurists in white wigs and long, black robes.

"The 'Law West of the Pecos' had one lawbook, but a six-shooter there to enforce it! I selected the bar patrons as jurors. The viewer is on trial, and the man on the right has a rope in hand, so I figure you've been found guilty."

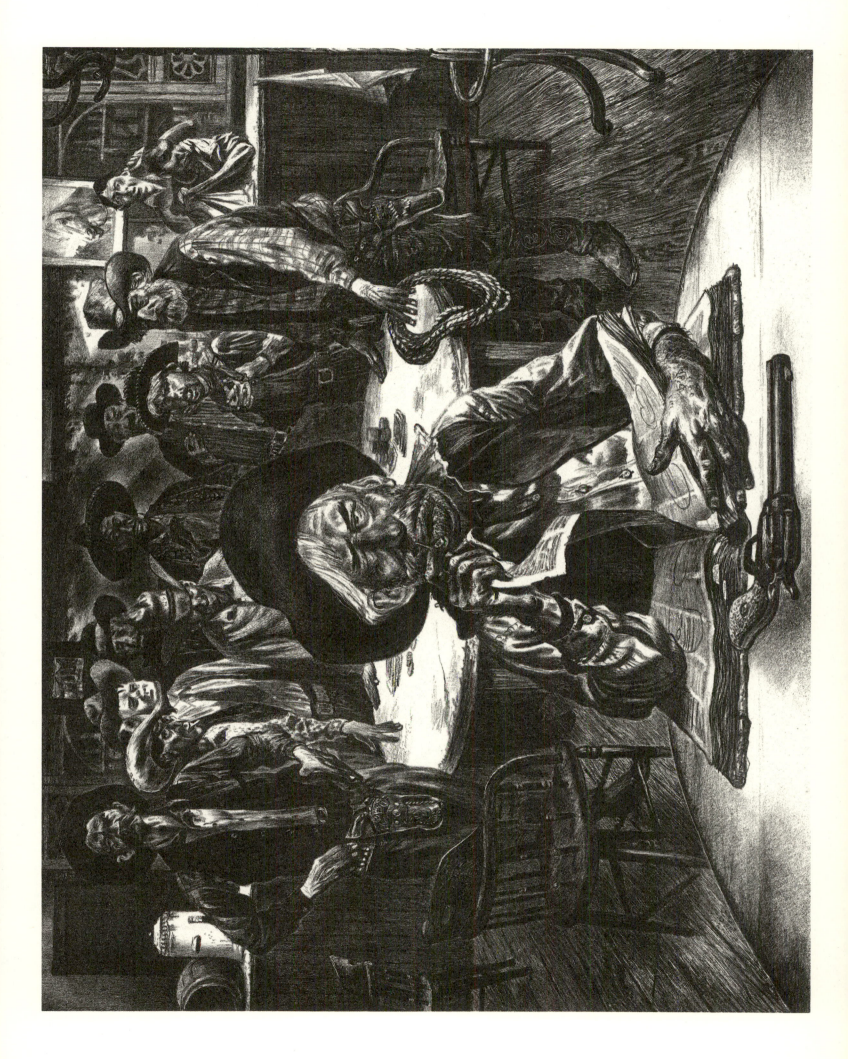

33 *Handgame*

9⅞ × 7⅞

1942 / Edition 25

Printed by George Miller for *Collier's* magazine, *Handgame* describes a popular pastime among Indians in Oklahoma. Here the central figure takes a turn at guessing in which hands the players at left hide beans or small pieces of bone, while another member of the opposing team at right attempts to confuse him.

"Many Indians I know enjoy games with gambling possibilities, and in recent years the handgame has become a high-stakes favorite. At the time I did this drawing, however, I only knew of it as being played just for fun."

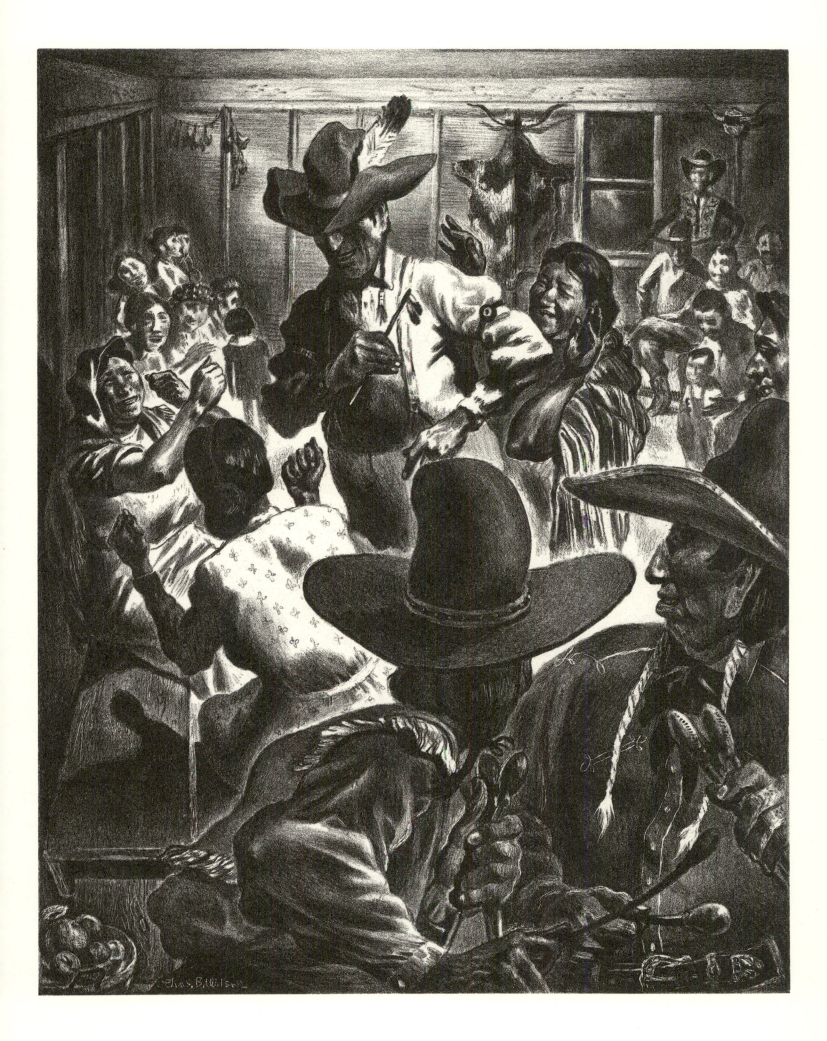

Chas. B. Wilson

34 *The Interrogation*
10 × 13½
1942 / Edition 25

This small edition, printed by George Miller, gave Wilson the chance to use a finely grained stone. A light etch achieved the soft, delicate tones that would have been lost in a larger edition.

"The art editor of Collier's magazine at the beginning of World War II, before GI helmets were changed, wanted to see how I might handle a non-Indian subject. Heretofore I had done only western pictures for him."

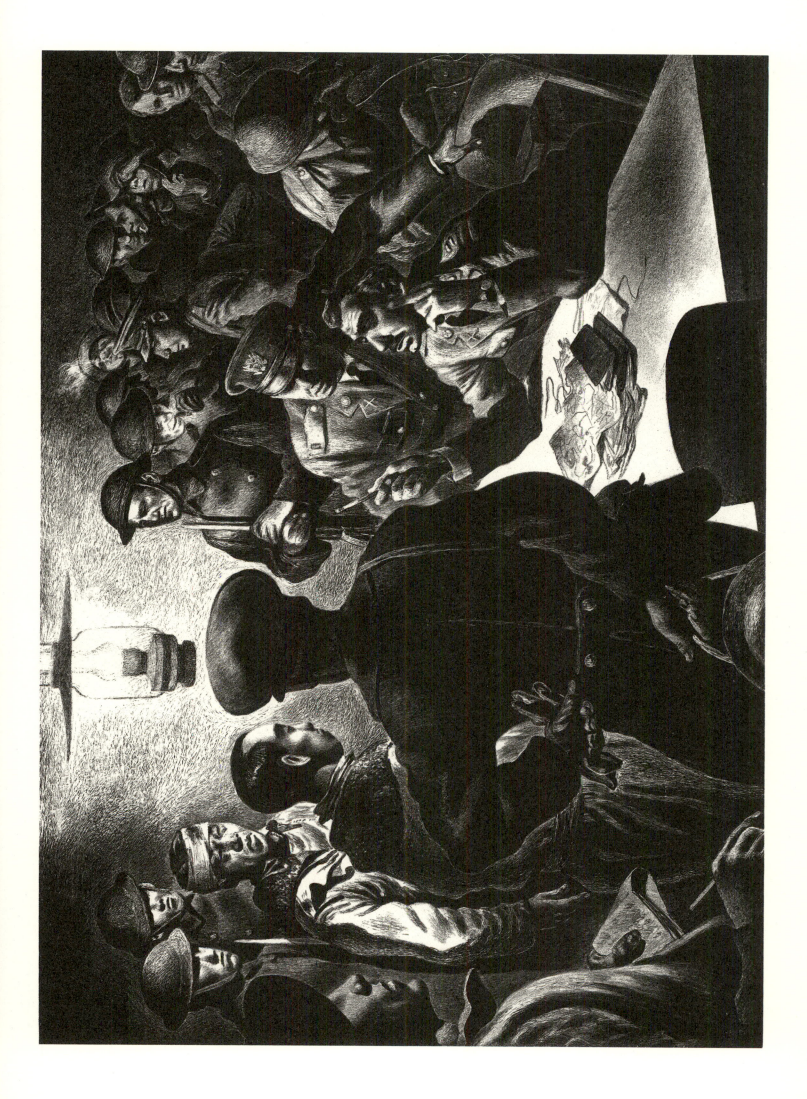

35 *Freedom's Warrior*

10 × 13¾

1943 / Edition 50

First published in *This Week* magazine, *Freedom's Warrior* was included in exhibitions organized by the Library of Congress in support of the national war effort. Behind the modern Indian in U.S. combat uniform, Wilson described the shadowy figures of warriors of the past: at left are Chief Joseph, Sitting Bull, Tecumseh, and Geronimo; and at right, Powhatan, Blackhawk, Pontiac, and Osceola.

"This patriotic subject gave me an opportunity to point out that certain Indian chiefs were, in fact, military generals and, as such, were a part of the military heritage of the Indian soldier in World War II. Certainly no picture I have ever done so appealed to Indian people as this one."

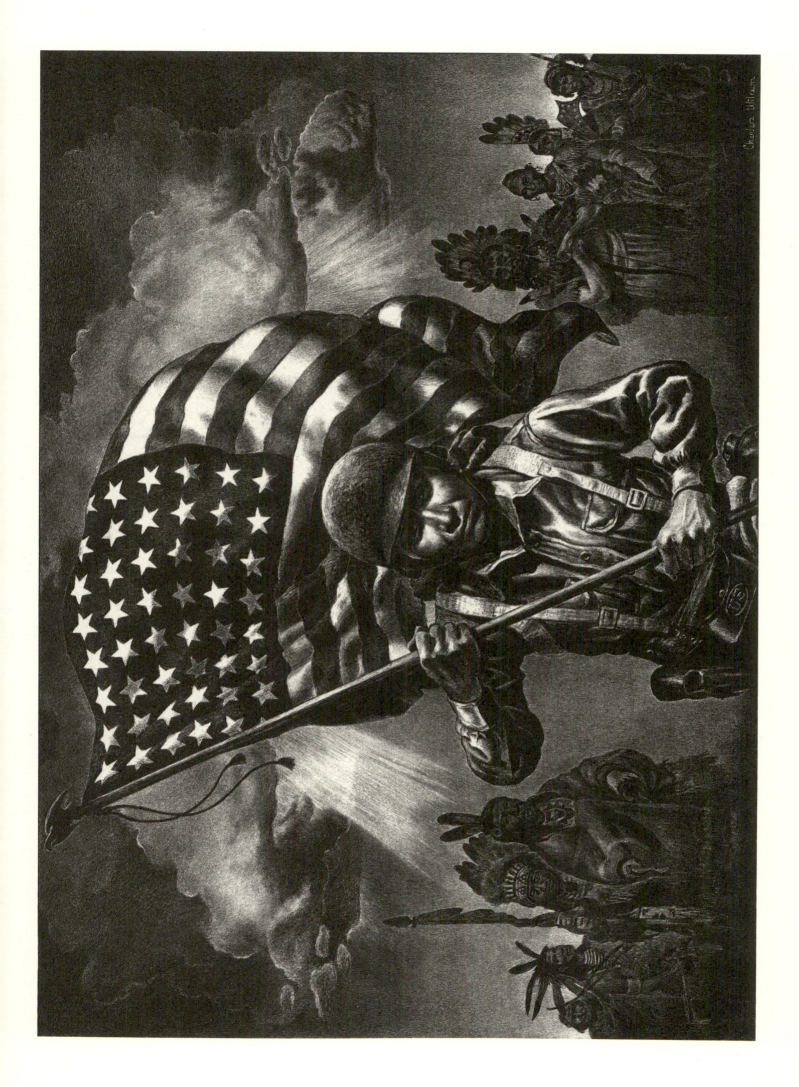

36 **End Man**
9⅞ × 14
1943 / Edition 25

Expressing the artist's nostalgia for days gone by, this print won awards at both the Brooklyn and Seattle art museums in 1943.

"Some critics think this is my finest lithograph. It's interesting that it is neither an Indian nor a land-scape. It is a recollection of the old-time minstrel shows I enjoyed as a boy. The clowns sat at opposite ends of the front row and were called the 'end men.' Here they are shown center stage."

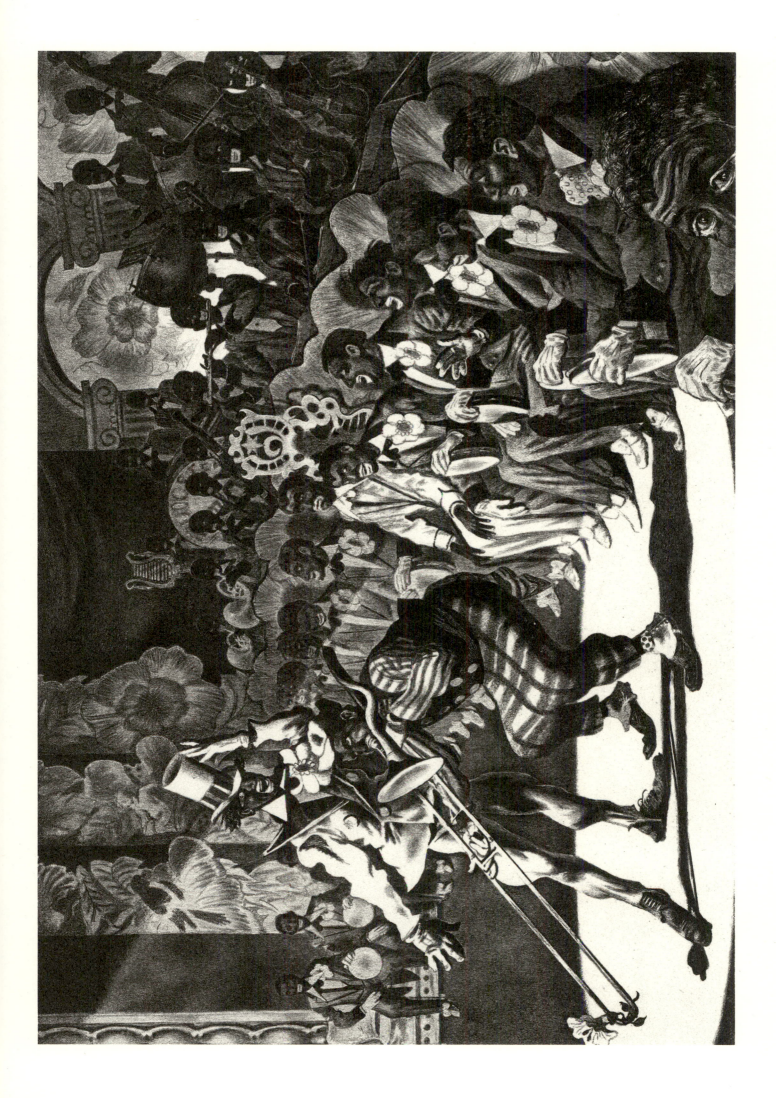

37 *Hardrock*
13¾ × 9¾
1943 / Edition 25

Wilson sketched this "hardrock" miner in 1941, before leaving Miami for New York City.

"I did a lot of drawing underground in the lead and zinc mines of Oklahoma and Kansas. The men down there, except for the Indians—there were no blacks underground—became snow-white from lack of sun. The skin covering this miner's large bicep appeared so thin that it seemed hardly able to contain all the power I knew was there. I have contrasted that against the rugged surroundings of the shaft."

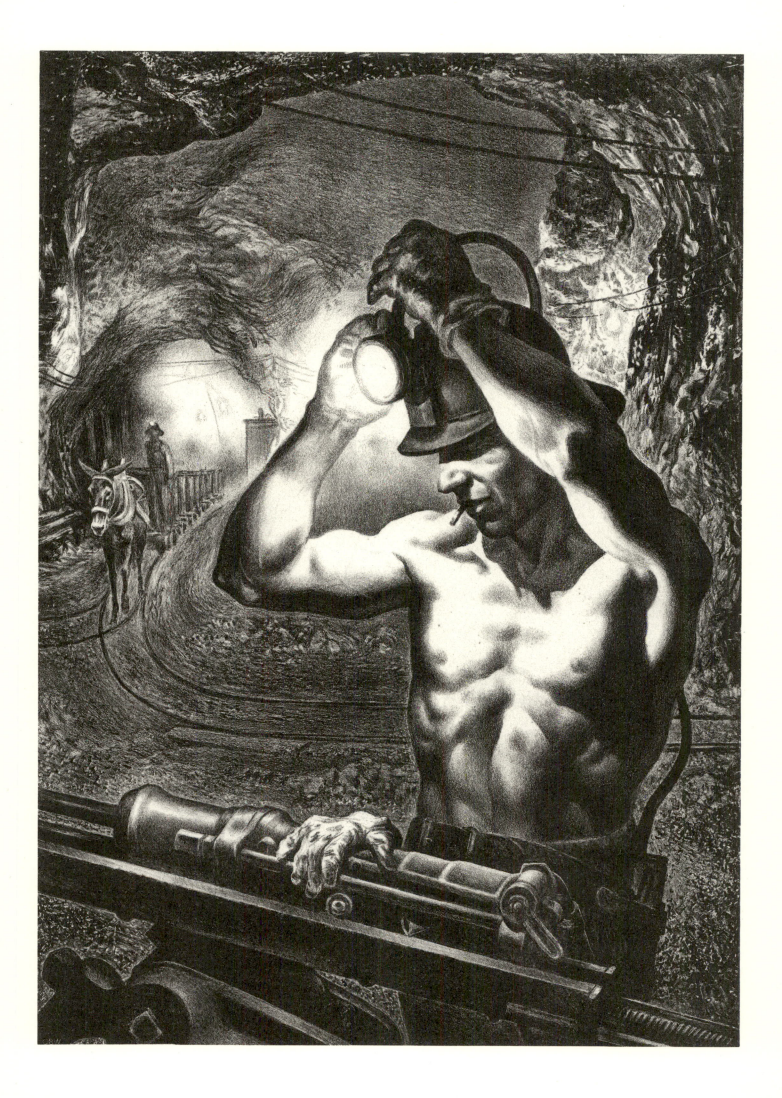

38 *Shawnee Ribbon Bets*
9⅜ × 13½
1947 / Edition 25

Based on an oil painting later acquired by the Gilcrease Museum, in Tulsa, *Shawnee Ribbon Bets* was the first lithograph Wilson produced after his return to Oklahoma in 1943. It was printed in New York by George Miller.

"Brightly colored hair ribbons were often worn by the women. Here they are being gathered as bets before a contest—a ribbon against a ribbon, or a shirt, or even money. I find that most Indian games somehow involve gambling."

39 *Old Injun*

11⅞ × 8¾

1950 / Edition 200

The Seneca-Cayuga man featured in *Pete Buck* (see plate 8) appears again as the subject of *Old Injun*, another lithograph printed by George Miller.

"The Associated American Artists group in New York City wanted me to do something similar to the earlier Pete Buck, *so this was commissioned. Here I have added the figures of the women going about their work, continually cooking."*

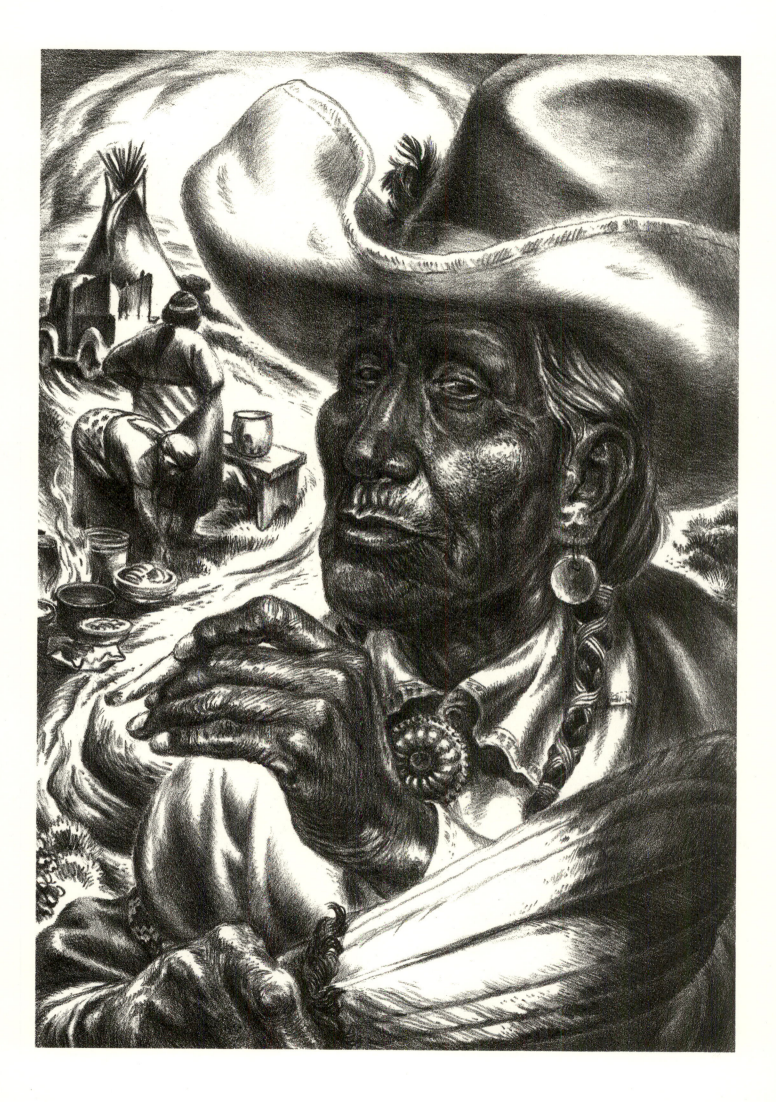

40 *The Intruder*
13¾ × 9⅛
1952 / Edition 50

Based on one of the illustrations for J. Frank Dobie's book *The Mustangs*, this subject appeared again in a reverse drawing as *The Challenge*, a print commissioned by Associated American Artists.

"This was the first stone printed after I had my own press, and the first I had printed myself since leaving the Chicago Art Institute in 1941."

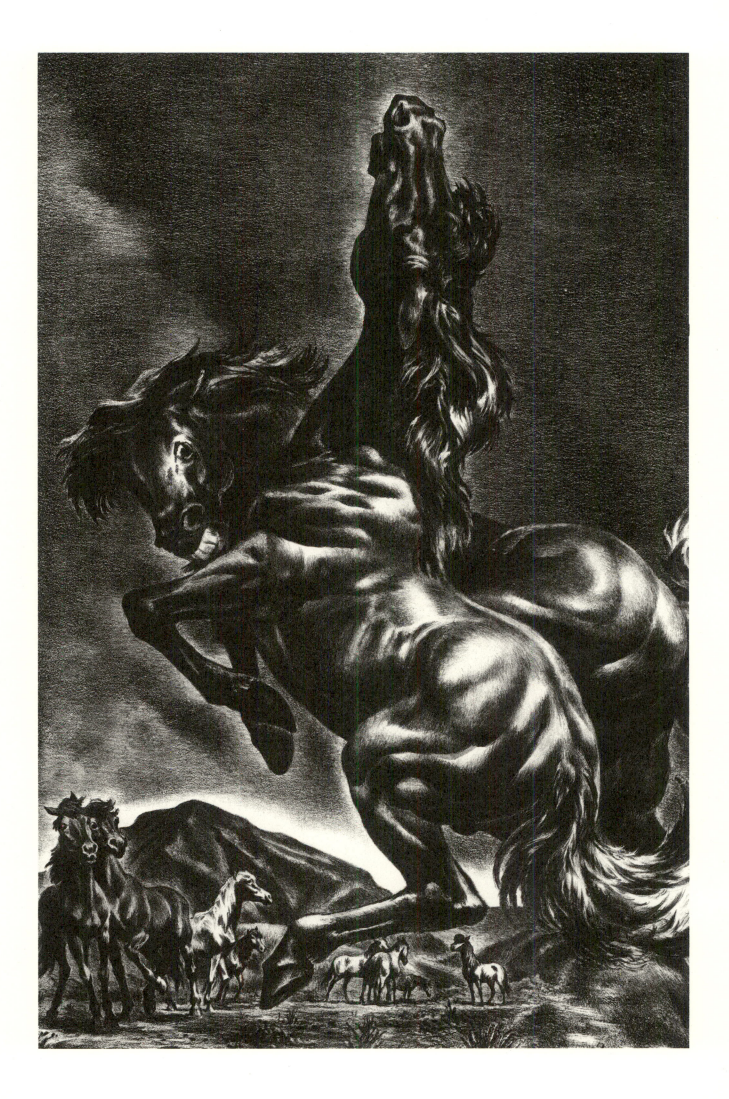

41 **Small Operator**
10¾ × 14
1952 / Edition 50

Drawn from a sketch made at the Smoky Hill
Mine, near Miami, *Small Operator* depicts an old
"hardrock" miner salvaging lead or zinc from the
refuse of a former mining operation. After World
War II many mines in northeastern Oklahoma
were abandoned and men such as the one shown
here went about making an uncertain living.
Wilson executed fifty watercolors but only two
lithographs of mining activity in this region.

"The man separated the metal from the rock by
hammering it into small pieces and then shaking it
all in his hand jig. The heavier metal sank to the
bottom, leaving the waste rock to be scraped off and
discarded. This work was carried out amid old con-
crete mill foundations and forsaken ore bins."

42 *Shawnee Indian Cooks*
9 × 5½
1953 / Edition 24

Wilson created the images of these smoke-blackened pots by rubbing a silk stocking on a soft litho crayon and then rubbing the stocking on the stone to produce the feathery, gray tones he wanted.

"I've shown a variety of kettles, some of which have been used for perhaps a hundred years. Most of them are copper. The women are preparing food for a memorial dinner. I'm often struck by the idea that women do more than anyone in keeping the Indian heritage alive."

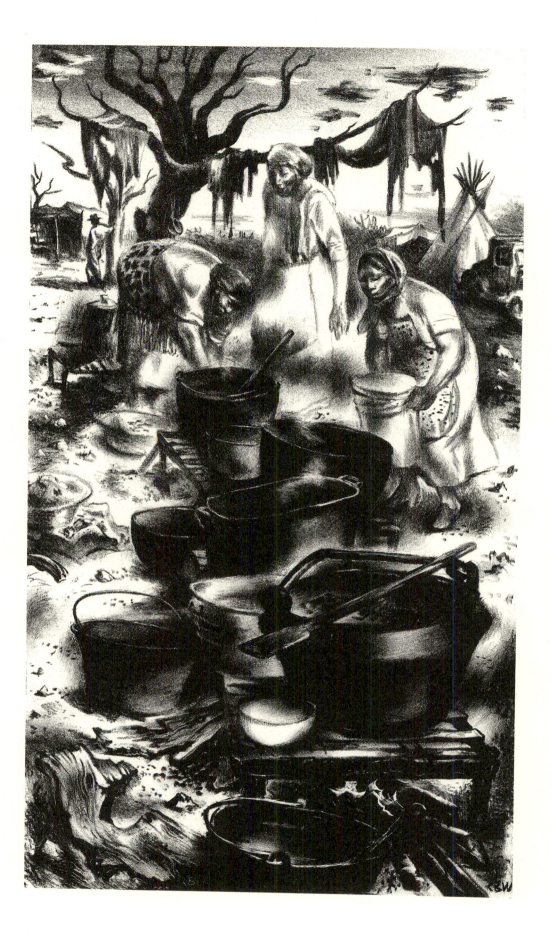

43 *Prince Esquire, or Royal Breed*
10⅝ × 14⅞
1954 / Edition 200

An unusual subject for a portrait is this prize
Angus bull, considered by many at the time as
the finest example of his breed.

*"I drew this bull at Sunbeam Farms, near Miami.
The two of us had some reputation there, for differ-
ent reasons, and I thought we ought to collaborate.
However, when I tried to draw him he acted surly
and narrowed his usually large, intelligent-looking
eyes. The herdsman perked him up by parading
a fine cow in front of him just across the fence."*

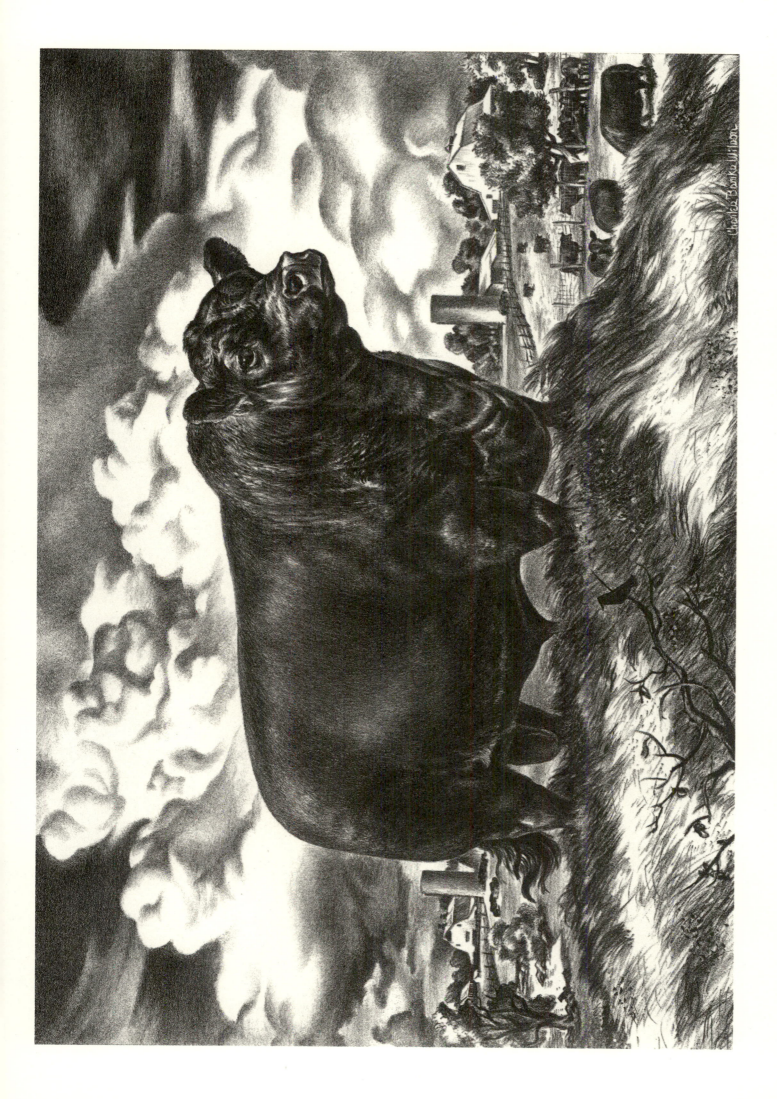

44 *Boxholder*
13 × 8¼
1954 / Edition 43

According to the artist this drawing represents "a kind of adventure in abstract realism." It takes its name from what the man holds in his hand: the kind of circular that in the city is addressed to "Occupant" and in the country to "Boxholder."

"Rural mailboxes along a country road may be a popular subject with artists, but they are seldom done as I did these. At the time I was teaching 'pure' design at the local college."

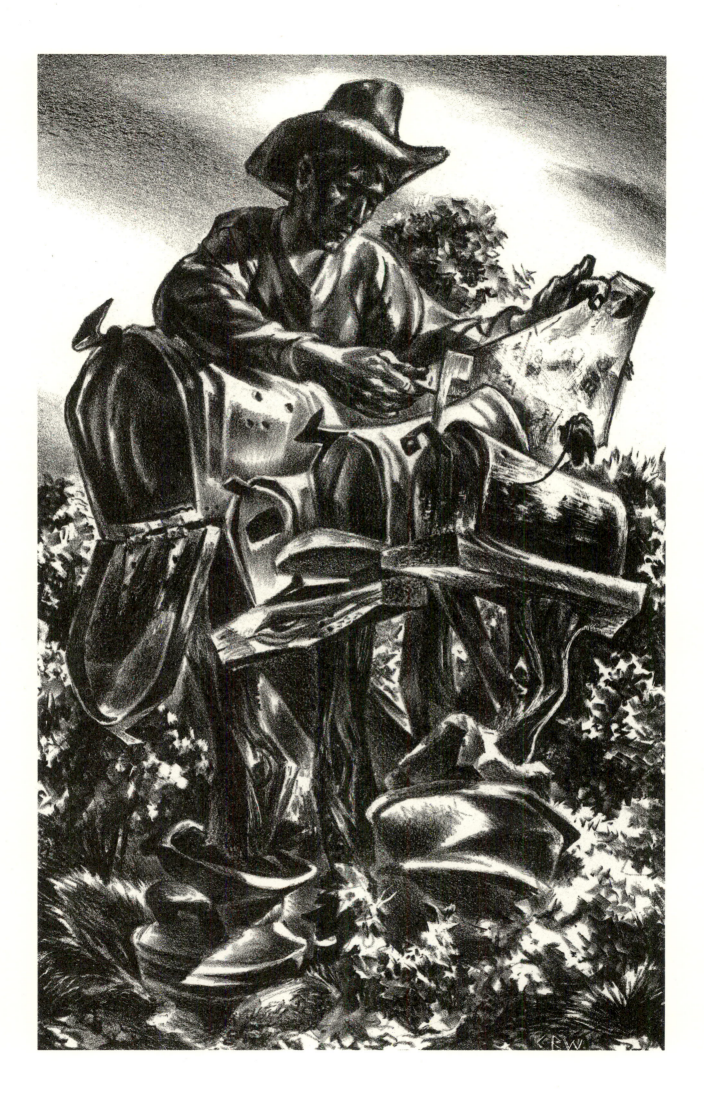

45 **Pigeons, or *Pinnacle***
12 × 6¼
1954 / Edition 50

In terms of printing technique, Wilson considers this lithograph one of his finest.

"From my studio window I look across Main Street at the pigeons strutting and preening around the ornaments atop the theater. Aside from the obvious concern here for design, I identified with the pigeon coming in for a landing but unsure of his footing. I sometimes feel that way myself."

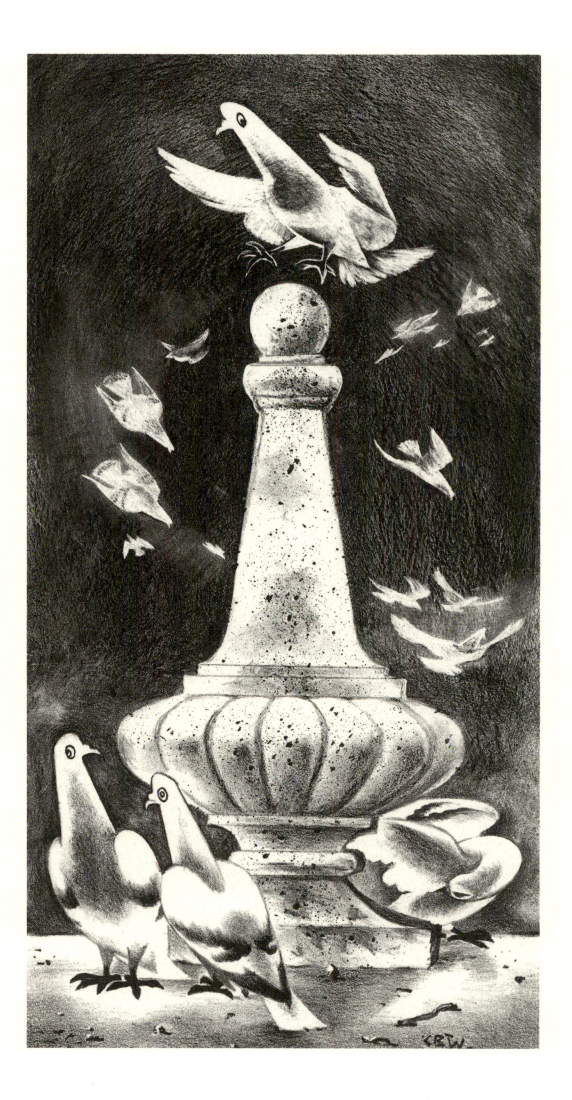

46 *Edge of Town*
7¾ × 15
1954 / Edition 50

Picturing the local icehouse near the railroad yard, *Edge of Town* was included in the Twelfth National Exhibition of Prints at the Library of Congress in 1954. A watercolor version was shown in the Oklahoma Artists Annual Exhibition, at the Philbrook Art Center, that same year. The Library of Congress later purchased the print for its permanent collection.

"Miami's ice plant hinted at the growth of the town in its structural additions, beginning with the limestone wall in the center. Its textures and patterns tempted me as much as walking the rails did the passersby."

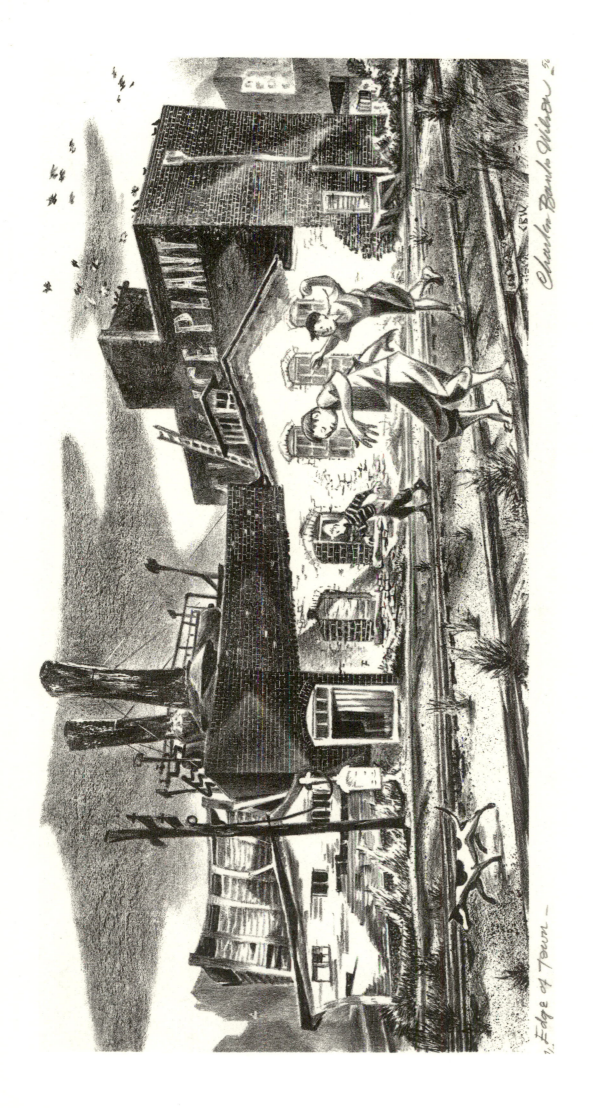

"Edge of Town" — Charles Banks Wilson

47 *The Oklahoman*
13¾ × 9⅝
1956 / Edition 25

Suggesting one of Oklahoma's most famous sons, this lithograph was printed in New York City by George Miller.

"I developed this from a painting I did of Will Rogers from sketches I made when he appeared at a local theater in 1934, when I was sixteen. I wasn't trying to do a portrait, only a Rogers-like character."

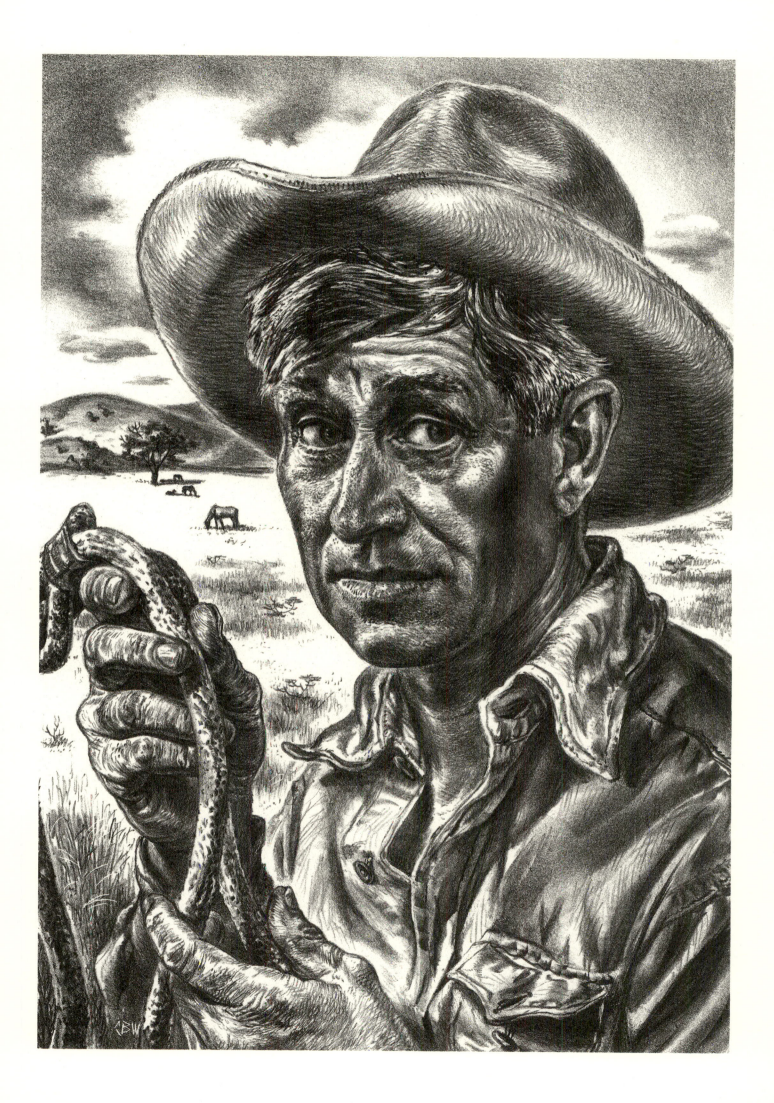

48 **Roadside Willows**

11⅛ × 14

1956 / Edition 40

Wilson finds most of his subject matter close at hand and combines observation with imagination to create his own visions of the everyday world.

"Willows transform any place for me into one of enchantment, just as they have this weed-covered pasture."

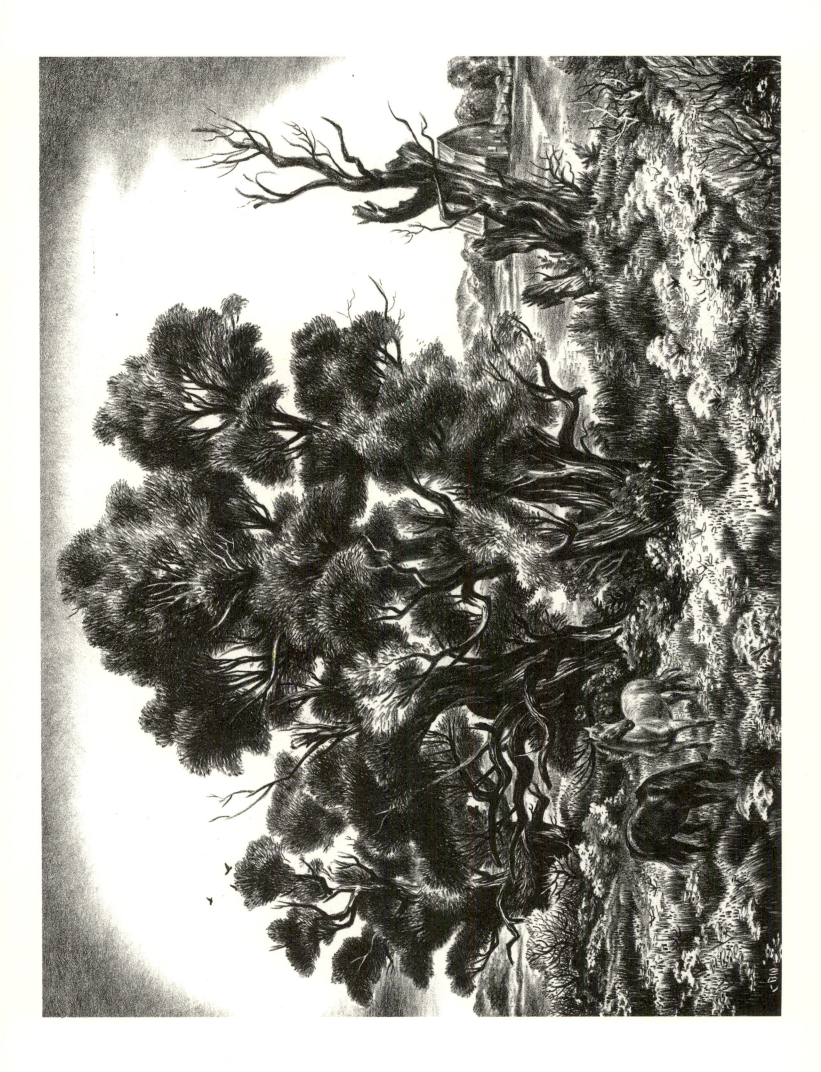

Ten Little Indians
Portfolio, 9 × 5
1957 / Edition 50

A sketch of an Indian dancer led to the creation of a series of lithographs published in 1957 as *Ten Little Indians*. When the first edition sold out, Wilson pulled additional prints and colored them by hand, later reworking the figures as colored decals for firing on ceramic cups, which were widely sold. The Ford Motor Company reproduced the original portfolio in the *Ford Times*. In 1965 Wilson redrew one of the two views of the figure entitled *Oklahoma Fancy Dancer* as well as *Osage Straight Dancer* and *Pawnee and Shawnee Girls*. In 1967 he reissued *Comanche Girl*.

"I had originally intended to show the various kinds of costumes worn by dancers from different tribes. Then I decided to show them on children instead of adults; but the series was conceived as a portfolio of costume."

49 *Sioux Chief's Costume*
9 × 5
1957 / Edition 50

The eagle-feather war bonnet of the Dakota Sioux, shown on this dancer, has influenced the ceremonial dress of tribes throughout the United States and has always been popular with artists. This dancer also wears a buckskin shirt decorated with porcupine quills. His whistle is fashioned from the bone of an eagle's wing.

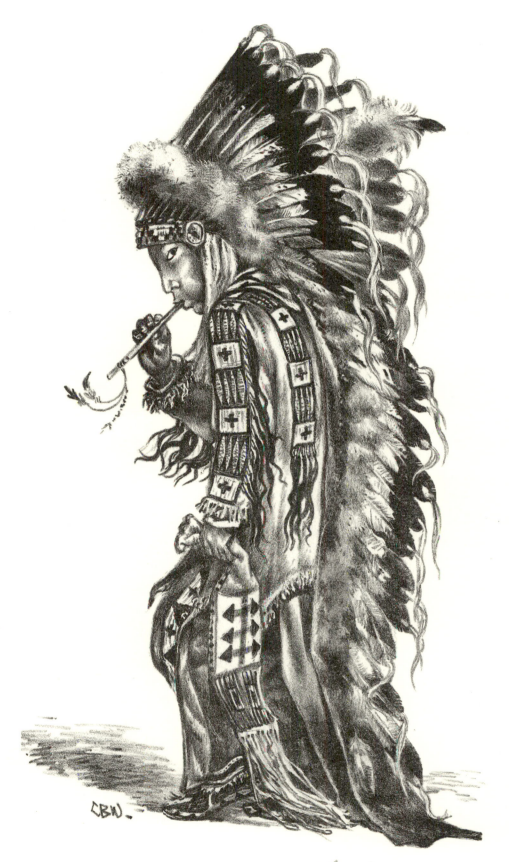

CBN.

Charles Banks Wilson

50 *Feather Dancer*
9 × 5
1957 / Edition 50

In Oklahoma the War Dance forms an impor-
tant part of the modern powwow. Although its
original purpose has been largely forgotten to-
day, the dance itself remains an art form. The
costume has been developed accordingly to create
an impressive display, gaining in color and vari-
ety what it has lost in meaning.

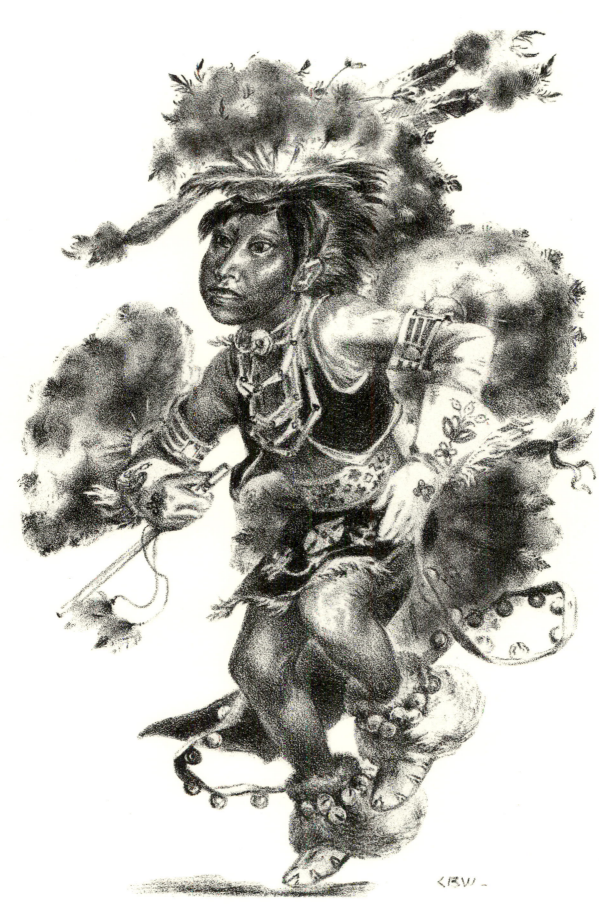

51 *Osage Straight Dancer*
9 × 5
1957 / Edition 50

Osage dance costumes show the influence of an early association with tribes such as the Comanche, with whom the Osages once traded. The dancer shown here is performing the "Straight Dance," an approximation of the Plains Indian dance style of the nineteenth century.

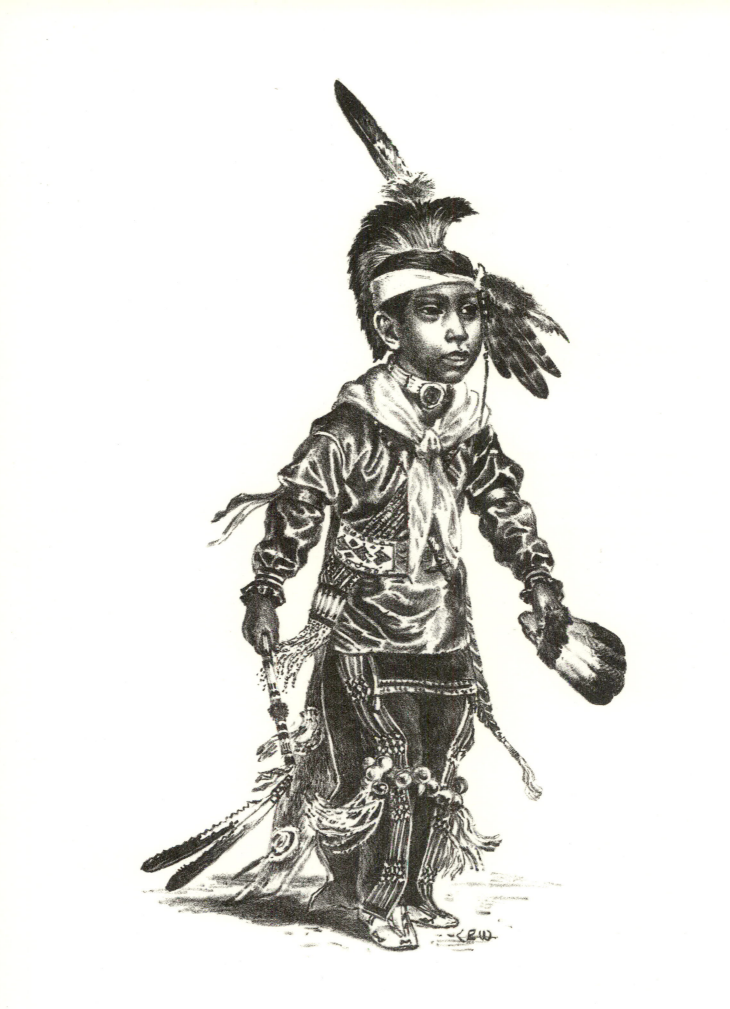

52 *Pawnee and Shawnee Girls*
9 × 5
1957 / Edition 50

The Pawnee girl, the taller of the two, is dressed
Osage fashion in a loose-fitting blouse, large
glass beads, and a broadcloth blanket skirt fea-
turing appliqued ribbon work. The little Shawnee
girl beside her wears a dress that shares many
features with the dresses worn by the Oklahoma
Seneca-Cayugas and represents a style that has
been in use for more than 150 years.

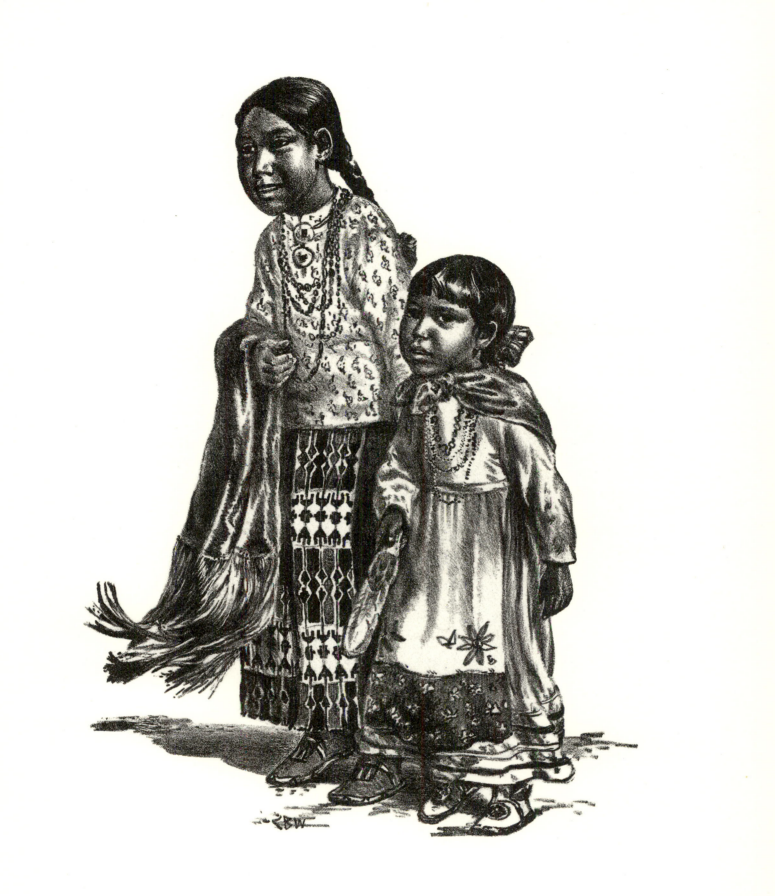

53 *Comanche Girl*
9 × 5
1957 / Edition 50

Of Plains origin, this costume is difficult to trace
to any one tribe. It consisted originally of a buck-
skin skirt with a short, fringed cape. Different
tribes adopted individual patterns for the cut of
the sleeve. Abstract geometric designs were the
traditional decoration for such garments, as they
still are today.

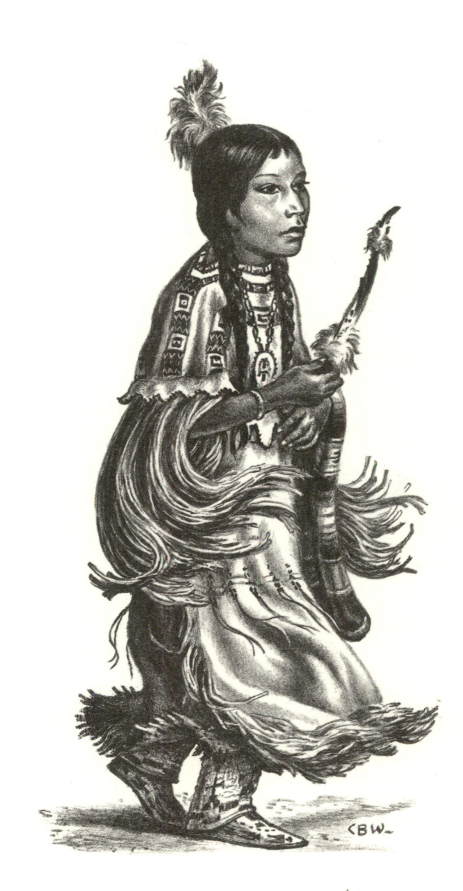

Charles Ban

54 *Cheyenne Dress*
9 × 5
1957 / Edition 50

Although the style of dress shown here has been
known for more than a century, this example,
made of a heavy, blue broadcloth, is a more re-
cent design. The moccasins represent an impor-
tant feature of the costume, Cheyenne moccasins
being regarded today as the most beautiful of
those made by any American Indian tribe.

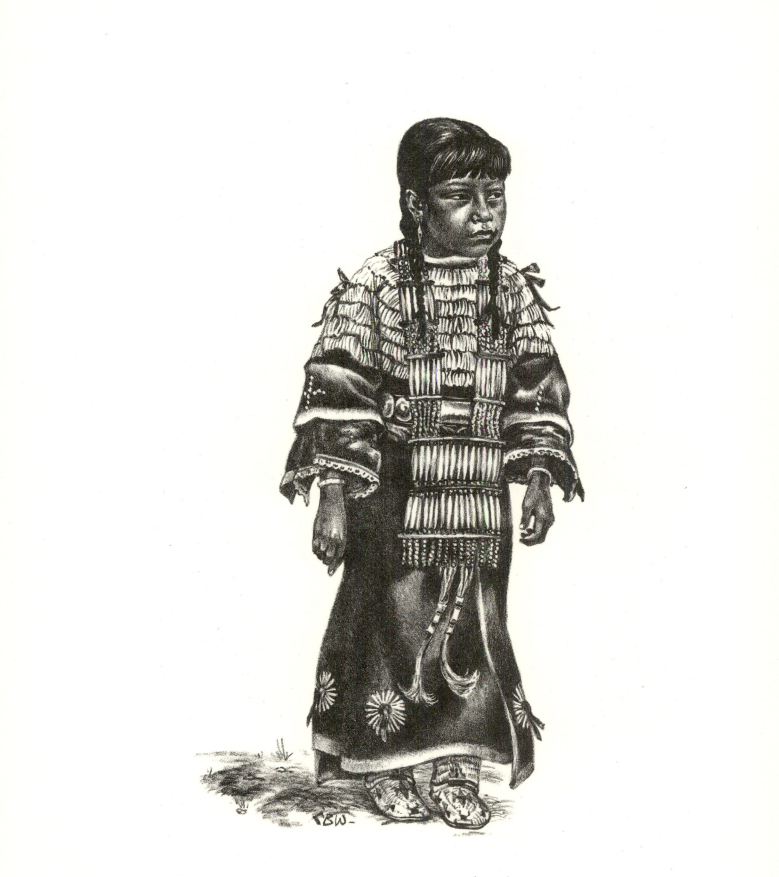

Charles Banks Wilson

55 *Oklahoma Fancy Dancer*
9 × 5
1957 / Edition 50

Presenting another view of the costume featured
in plate 50, this drawing shows to better advan-
tage the feathered bustle worn by the dancer.
Originally each feather held a particular, per-
sonal significance to the wearer. Today the War
Dance dress is designed to take into account the
dancer's body movements and the total visual
effect on the viewer.

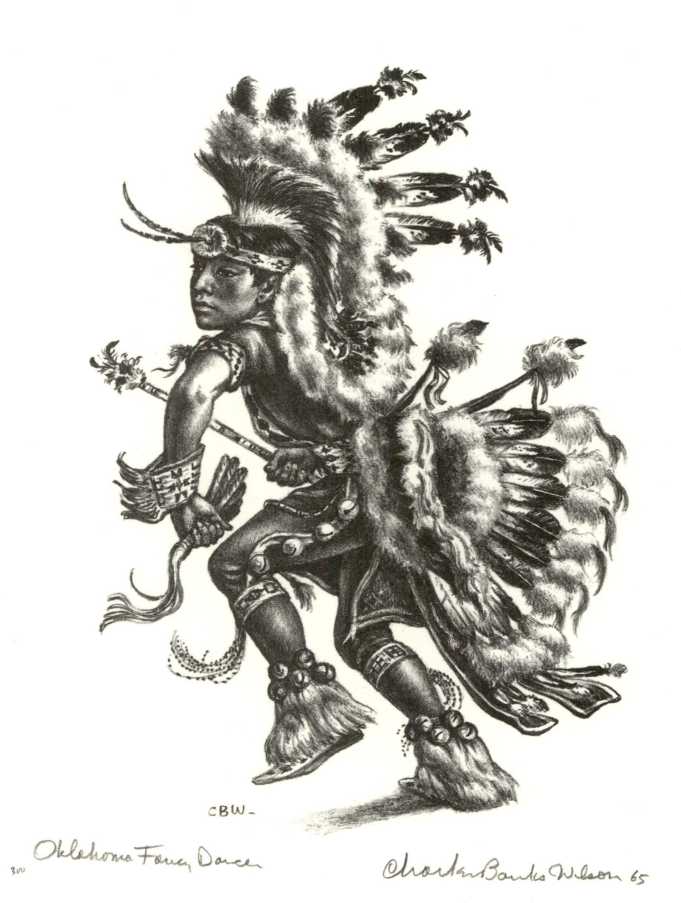

CBW–

300 Oklahoma Fancy Dancer Charles Banks Wilson 65

56 *Seneca Boy with Mask*
9 × 5
1957 / Edition 50

This figure wears leggings covered by a
breechcloth and a skirt decorated with designs
showing an early French influence. He holds a
wooden mask of the kind formerly used by the
Senecas to chase away evil influences from a
house or village. This dancer uses it effectively
as a dramatic element in his performance.

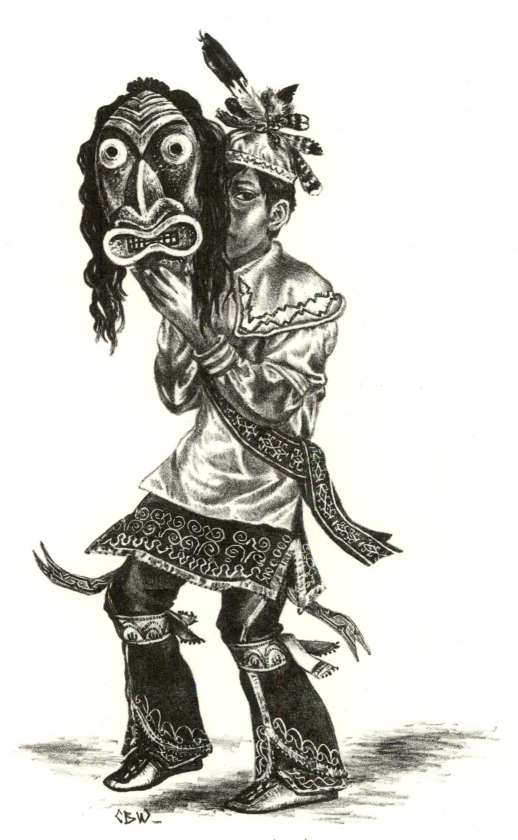

Charles Banks Wilson

57 *Plains Indian Eagle Dancer*
5 × 9
1957 / Edition 50

Originating in the American Southwest, the Eagle Dance, with its distinctive costume, shown in front view here and in back view in plate 58, has been adopted by American Indian dance groups everywhere. Its form is intended to represent an eagle in flight. Two men always perform this dance, accompanied by as many as six drummers and singers. Among Plains tribes, dancers usually are accompanied by a single singer.

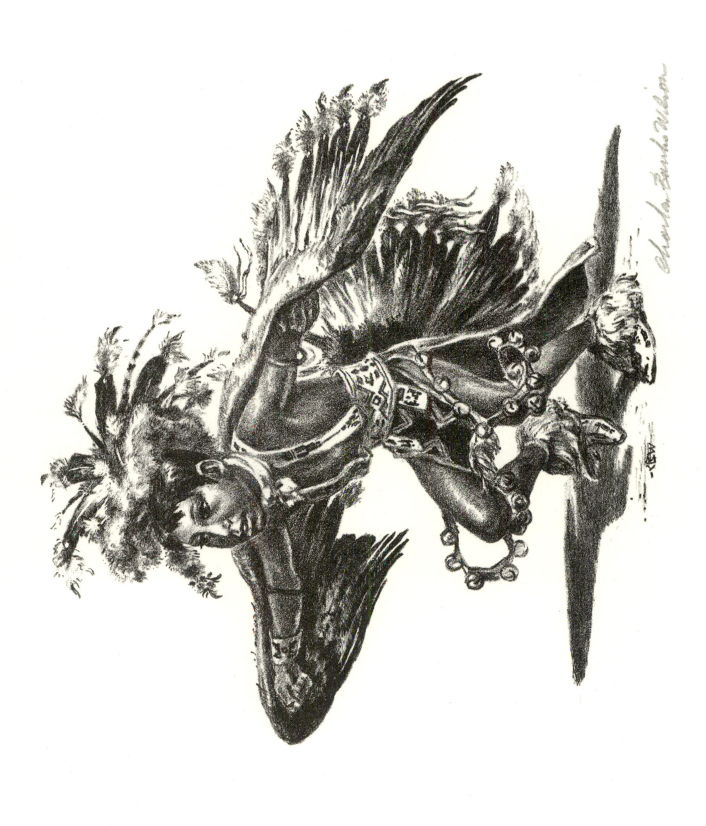

58 *Plains Indian Eagle Dancer*
5 × 9
1957 / Edition 50

Among the Pueblo, the headdress simulates
the eagle's head and beak, and the front of the
dancer's body may be painted white to resemble
the breast of the bird he imitates. Among the
Plains tribes, the costume, except for the wings,
is the same as that worn for the War Dance.

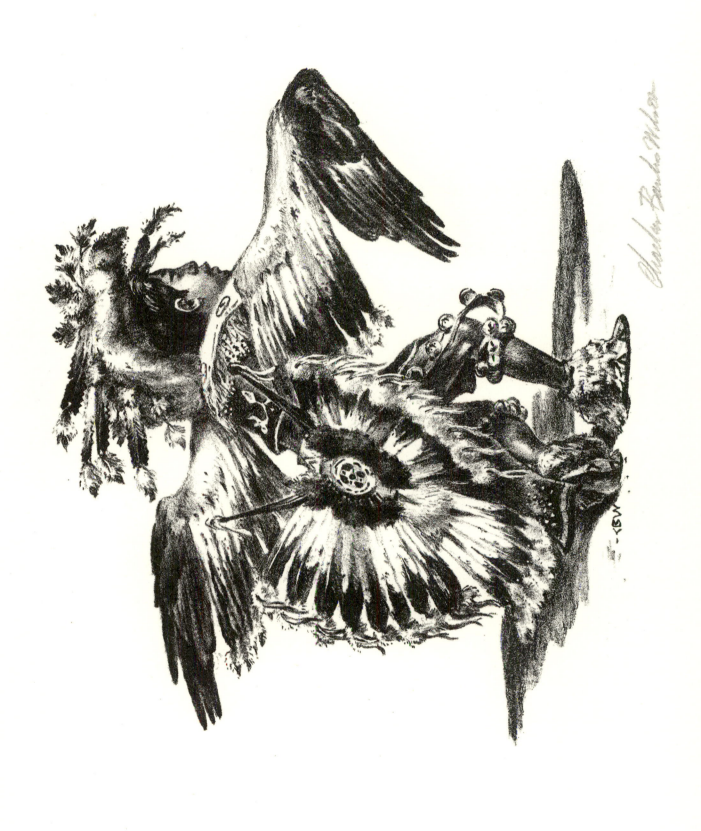

59 *Indios,* or *Arapaho Man*

9⅝ × 6⅝
1958 / Edition 20

Wilson used sandpaper to achieve the rough texture of this print. The result is suggestive of a Mexican woodcut.

"I sketched this on a trip into western Oklahoma with Thomas Hart Benton, who used the Arapaho as a figure in his Truman Library mural. I based my lithograph on a watercolor I did that day. The bumps and hollows of his coarse face had the character of a western landscape."

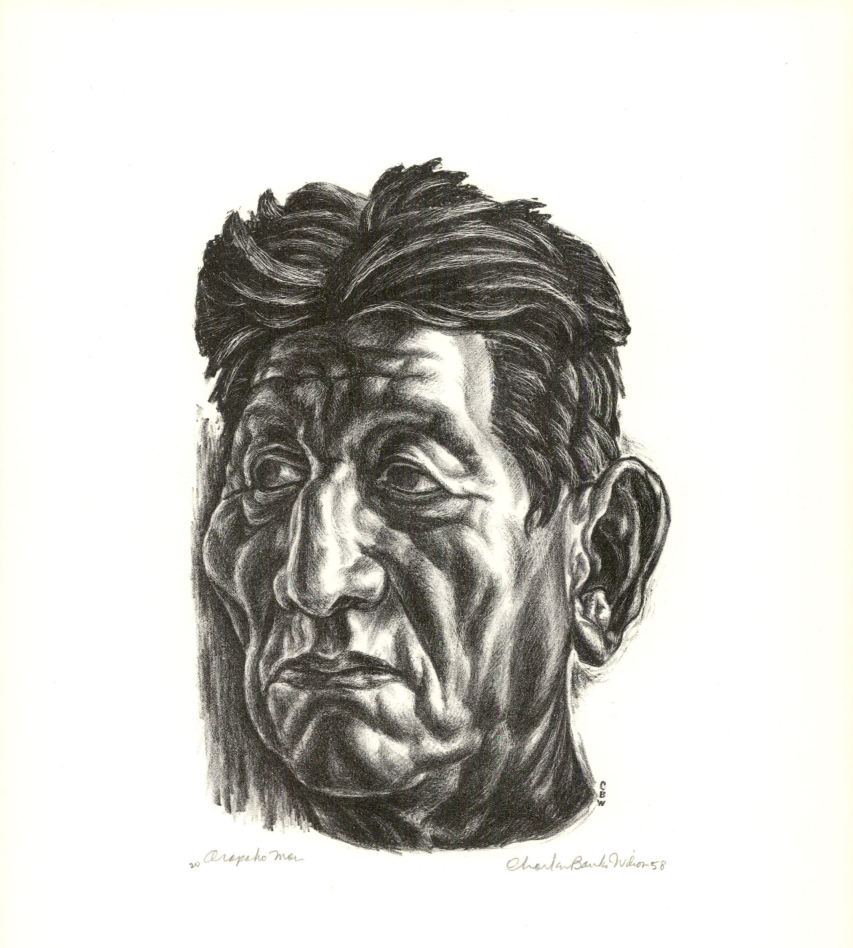

20 Arapaho Man Charles Banks Wilson 58

60 *Smiling Cowboy*
12¾ × 9¼
1961 / Edition 20

A man named Jim Archer provided the subject for this lithograph. Problems in printing resulted in a limited edition. Wilson again issued lithographs of Archer in 1969 and 1979.

"Jim's friends were responsible for this portrait by insisting that I draw him. He was a horseshoer and a cowboy whom everyone loved, including the horses. I found that his nose and his hat had similar shapes. The hat still hangs in my studio, and I see it every day."

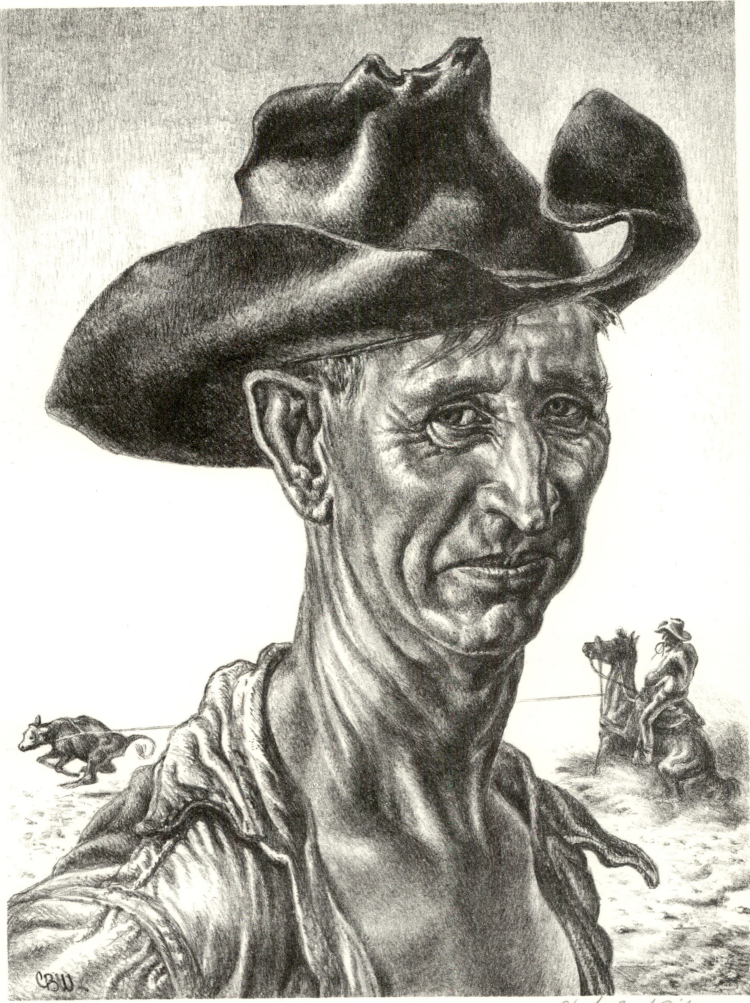

Smiling Cowboy — Charles Banks Wilson '61

61 *Adventure*
9¾ × 12⅛
1961 / Edition 25

Wilson based this composition on a wash drawing he made one Saturday morning along the Oklahoma-Kansas border north of Miami.

"While I was concentrating on the drawing, a large black snake had stretched out beside me, warming himself in the early spring sun. I knew he wouldn't bother me, but I recall how difficult it was to keep my mind on my work! Adventure doesn't have to be a trip to the moon. It can be a Saturday morning walk with your dog."

62 **Wild and Free**
11¼ × 14⅝
1962 / Edition 50

The original painting of this subject illustrated
the cover of J. Frank Dobie's book *The Mustangs*.
A later version of the print suffered technical
problems, and only eight impressions were pulled.

*"I was inspired by Dobie's description of wild mus-
tangs—'sentinels of alertness in eye and nostril, free
of all confines of time and flesh.'"*

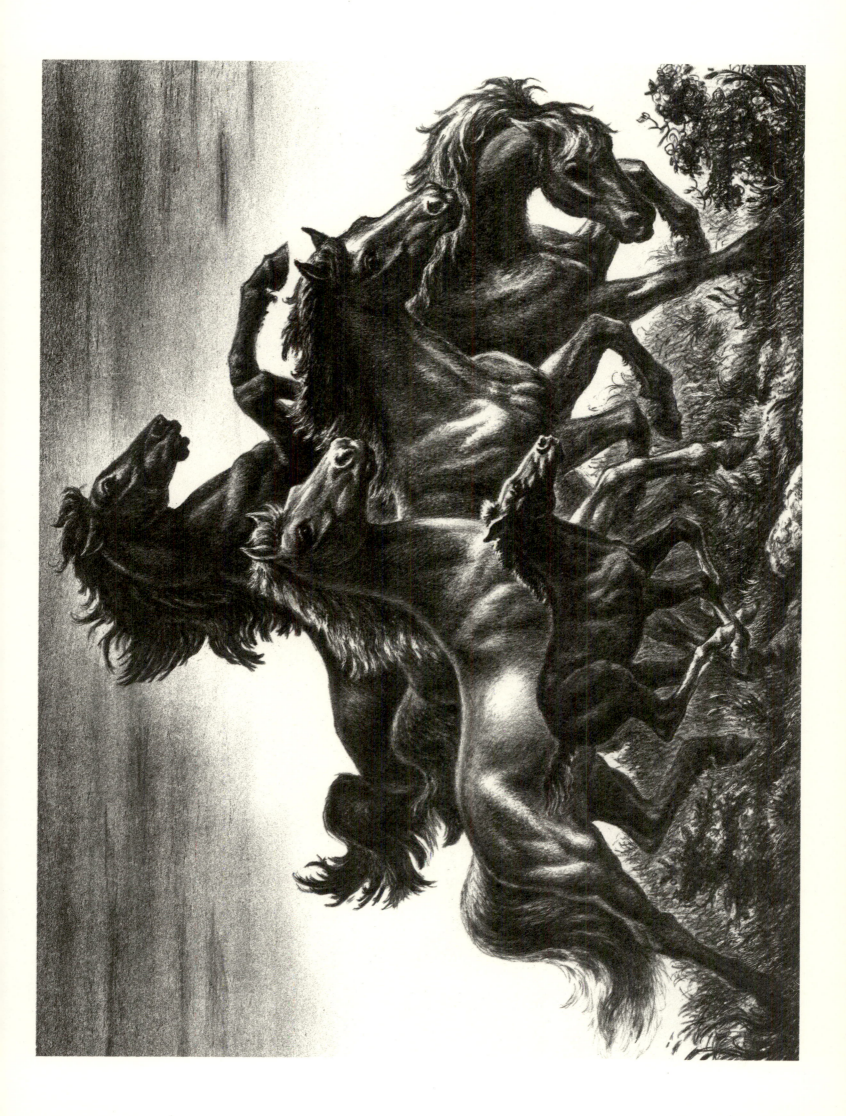

63 *Rhythm of the War Dance*
8 × 16⅞
1963 / Edition 55

Originally conceived as a design for a mural,
Rhythm of the War Dance contains less specific
description than most of Wilson's lithographs.

*"The details in this print are not of beadwork, bells,
and feathers, but rhythms. I got caught up in the
experience of the War Dance and wanted this pic-
ture to reverberate like the drum beat."*

64 **The Champion**

8¼ × 12½

1963 / Edition 45

This is the first of two prints of the same subject and composition. The larger version, entitled *New Champion*, was issued in 1972.

"The drummers are singing a special song for the winner of the War Dance contest. Contests are held at nearly every powwow I attend, with prize money and trophies offered to induce the better dancers to be there. I find the dances are not so much a ceremony these days as they are an art form."

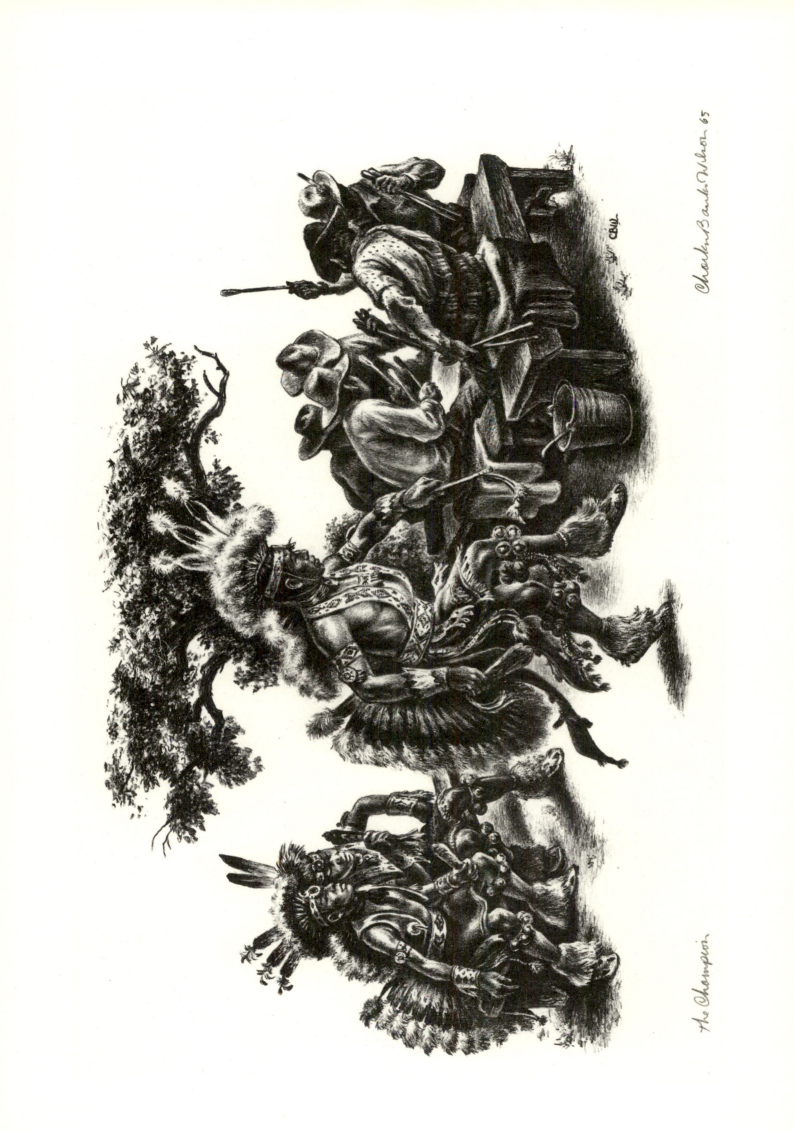

The Champion

Charles Banks Wilson 65

65 *Tom Benton*
9⅝ × 7
1963 / Edition 45

Although Wilson never was Thomas Hart Benton's student, the two were close friends and traveled together. Benton later insisted that Wilson was the only artist who ever painted him from life.

"In drawing Tom six times, I feel I discovered the secret of his pictorial design: there in his face were the same interlocking patterns of his pictures. The intensity of his concentration was best seen by those who posed for him. When he posed for me, however, he complained that I made him work too hard. I told him I was making him pay for all the discomfort he had dealt to his sitters over the years."

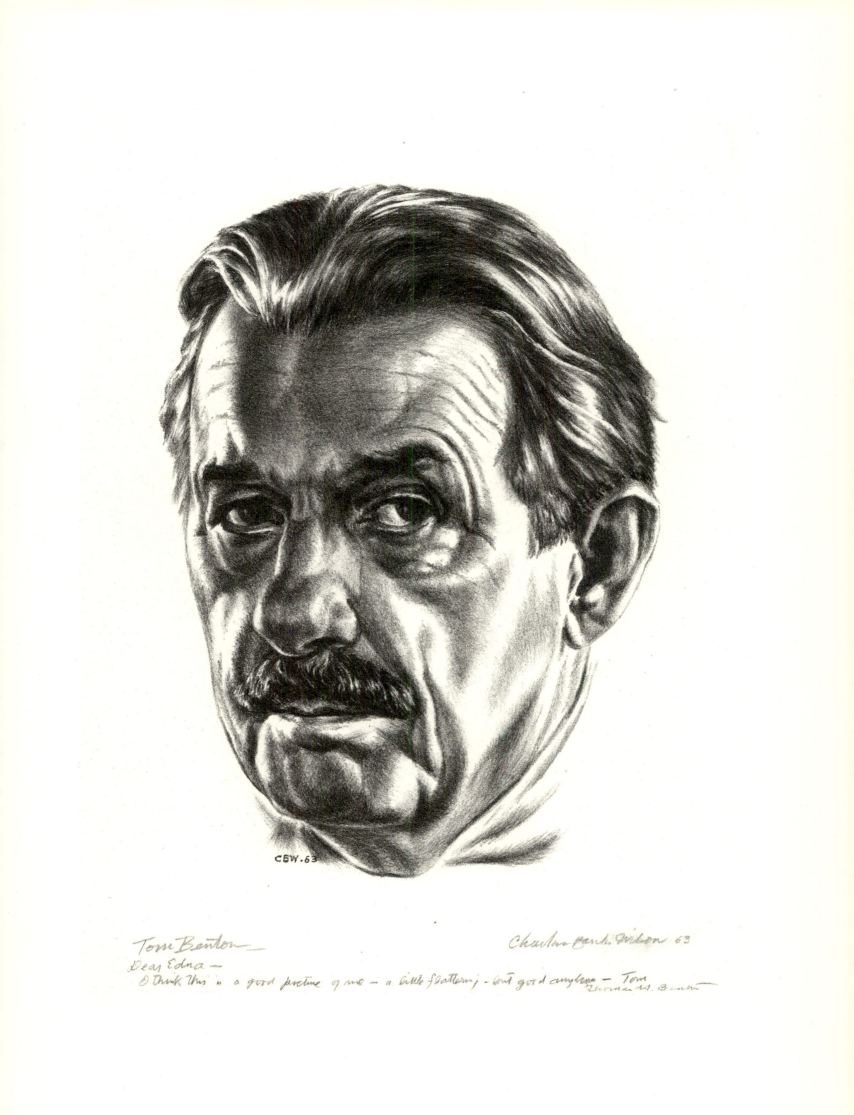

CBW. 63

Tom Benton

Charles Banks Wilson 63

Dear Edna —
I think this is a good picture of me — a little flattering — but good anyway — Tom
Thomas H. Benton

66 *Morning on the Creek*
14⅛ × 9⅝
1967 / Edition 50

This subject is repeated as a horizontal composition in *Boy Fishing* (see plate 69). In 1981 Wilson redrew the figure for another print, entitled *Tar Creek Boy.*

"Tar Creek, where I drew this, was a place that offered an endless supply of pictures. As a boy I enjoyed fishing, swimming, and exploring its lazy water and shady banks. Many a homemade raft was launched here for a summer adventure."

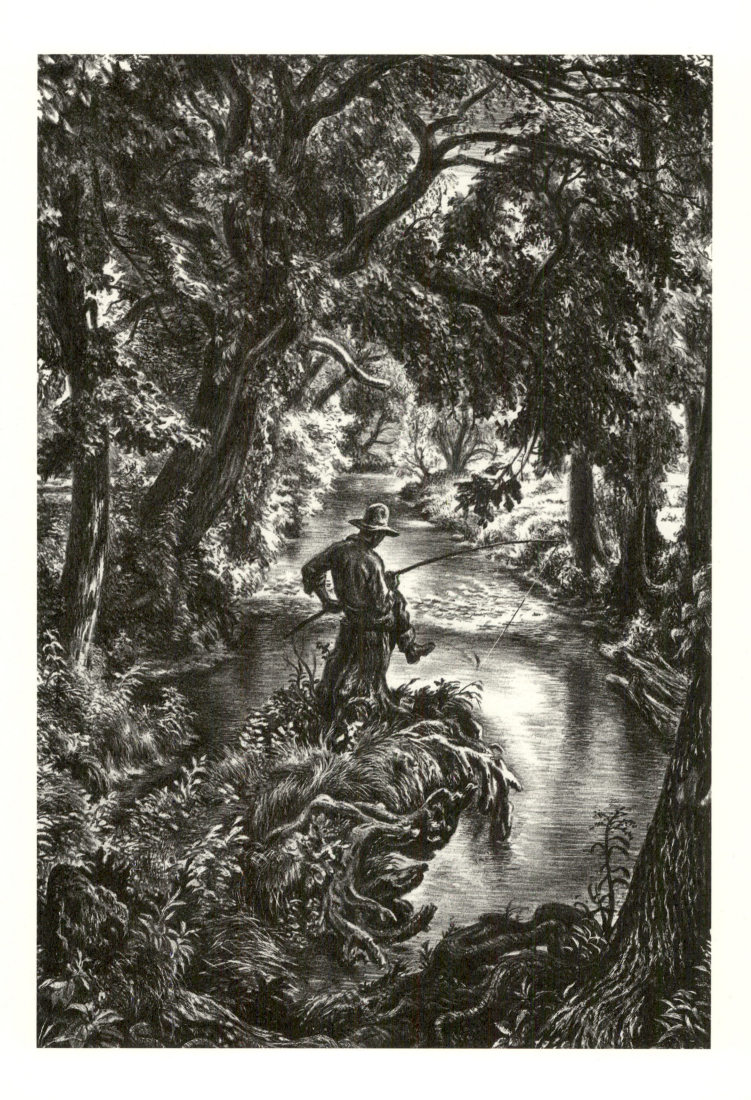

67 *Any Summer Afternoon*

10¼ × 12¾

1967 / Edition 45

The setting here is Coal Creek, or Joe's Creek, named after a man who once had a cabin there. President Truman's daughter, Margaret, bought this lithograph for her husband, because it reminded her of their four boys.

"Most good swimming holes feature a tree such as this, and when I run across one, a decision has to be made—to sketch or go swimming."

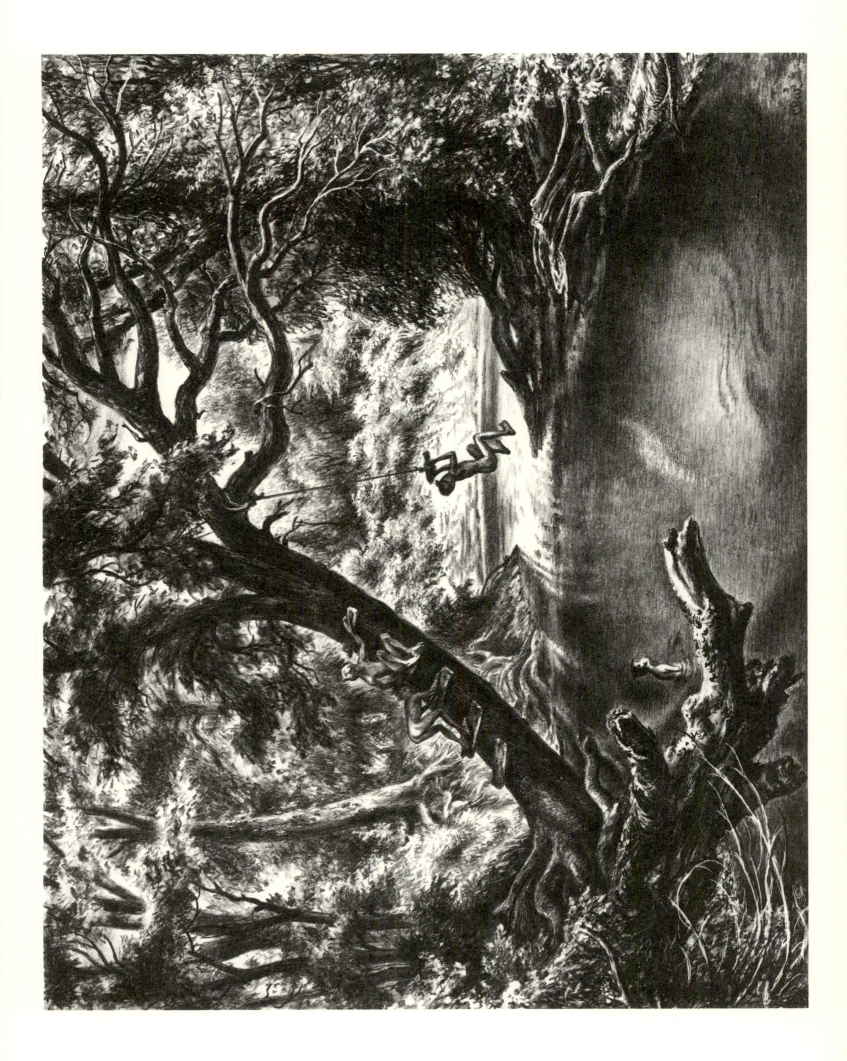

68 **Blackowl**
7¾ × 6
1967 / Edition 30

For this portrait of Archie Blackowl, Wilson covered the surface of the stone with touche, a carbon-black fluid, and scraped out the white areas with a blade.

"Archie is one of America's finest Indian artists. I've used him often as a model, drawing him as a young dancer in 1945, as a middle-aged singer in 1964, and again in 1973. I guess we've both grown old together."

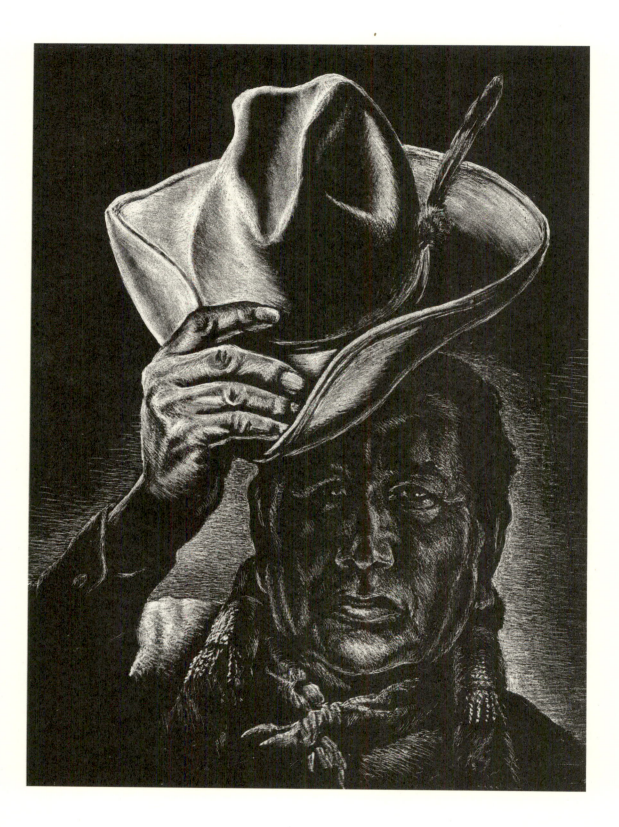

69 **Boy Fishing**
10¼ × 15¾
1968 / Edition 50

Represented here is the same general area pictured in plate 66.

"Again this is Tar Creek, but I moved a few feet up the bank from the spot where I did the studies for Morning on the Creek. Here the litho crayon was more freely used."

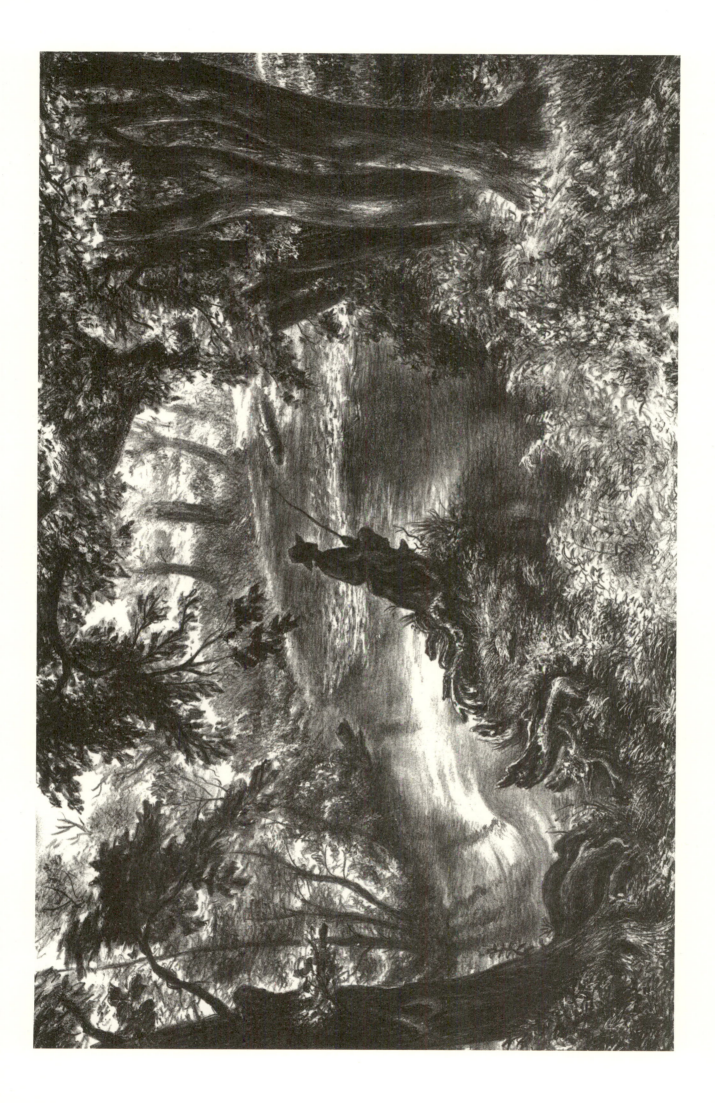

70 **Boys in Summer**
10¼ × 15¾
1968 / Edition 45

Cave Springs, near Miami, provided the setting
for this scene.

*"Girls enjoyed this swimming hole just as much
as the boys. It had the required tree and very cold
water, right out of a spring. It was sparkling clear
and inviting, if you were a teenager. I painted!"*

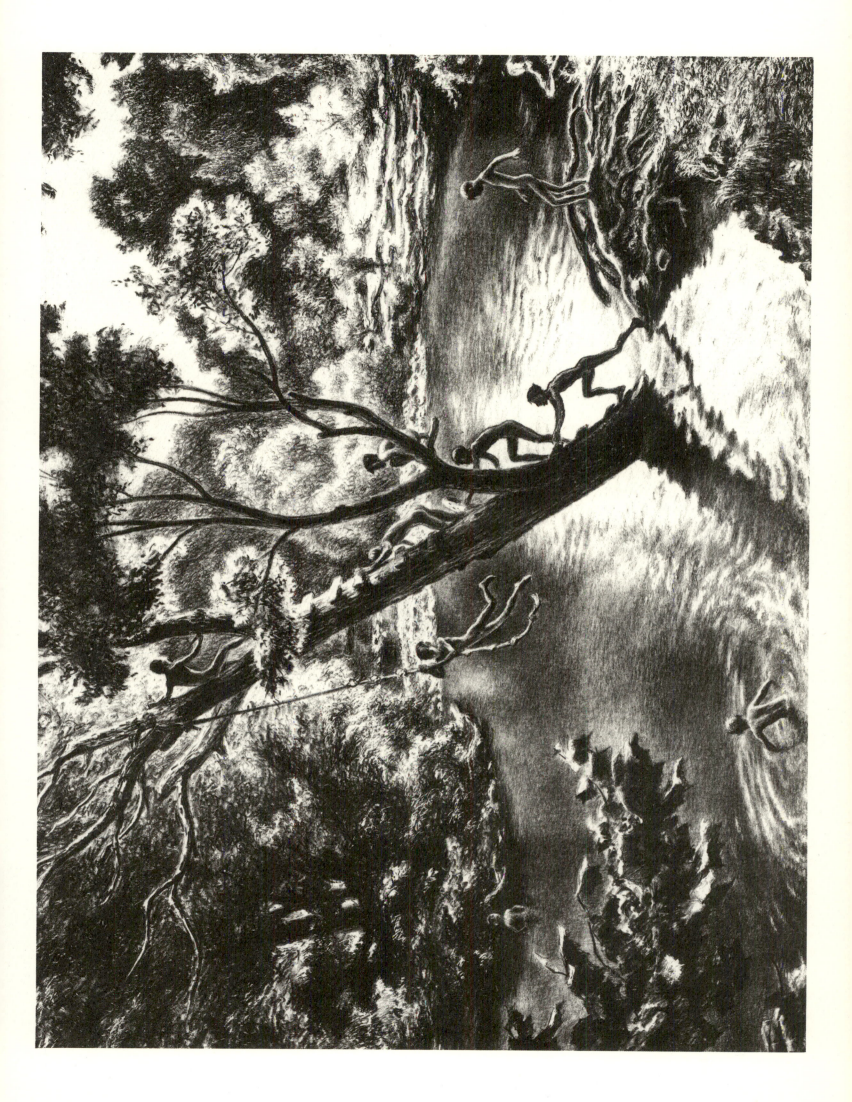

71 *Sugar in the Gourd*
12¾ × 17¼
1968 / Edition 45

Printed by George Miller, *Sugar in the Gourd* was inspired by an earlier painting. Wilson visited the subject at his home to make detailed studies for this lithograph, which in turn served as the basis for a second painting.

"This gets its name from an old fiddling tune. I was giving a painting demonstration for my college art class, using this man as a model holding a fiddle as a prop. During rest period he tuned it up and entertained the students—an enjoyable surprise!"

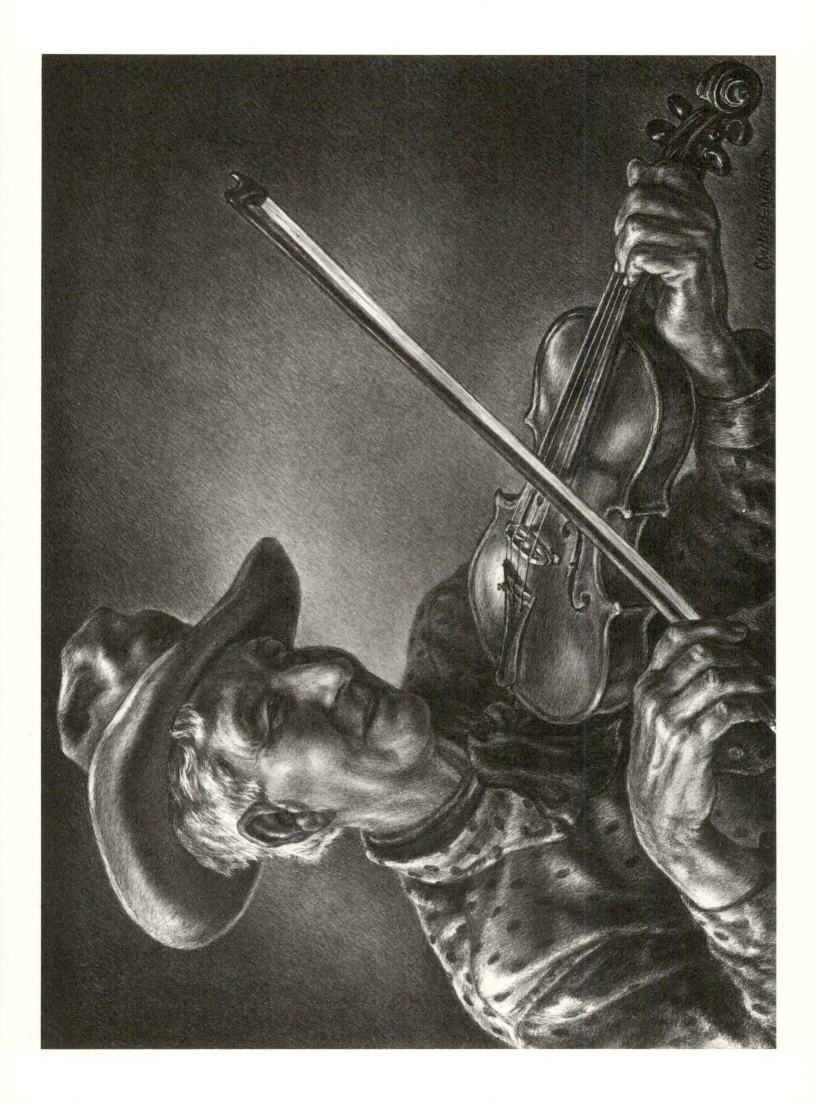

72 *Fishing Joe's Creek*

10⅞ × 14¼
1969 / Edition 45

Fishing Joe's Creek proved to be one of Wilson's most personally satisfying lithographs. It is based on an earlier watercolor.

"I found this place with my daughter, Carrie. She came here to catch turtles, and I came to catch pictures."

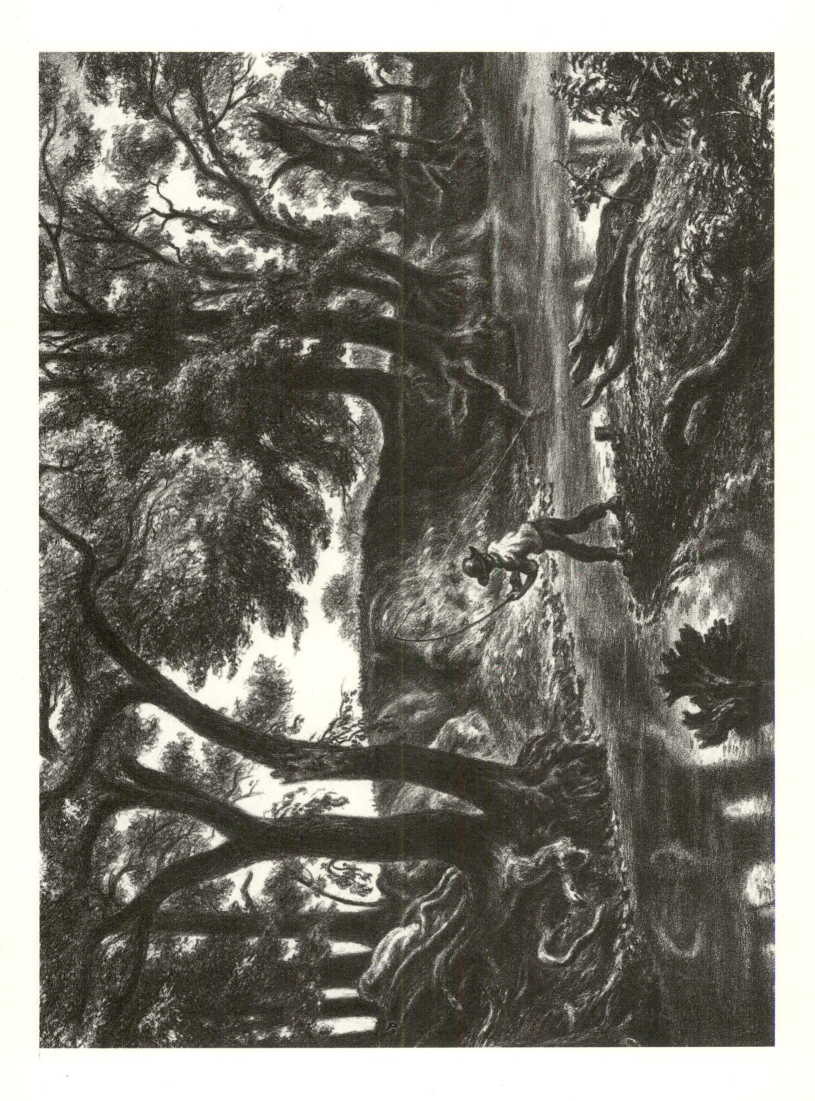

73 *Powwow Dancers*
12 × 10
1969 / Edition 45

Although dance dress styles have become highly individualized and can no longer be strictly classified as tribal, these dancers might be said to wear the "Oklahoma" dress, in contrast to styles worn by Indians in other parts of the country.

"Every piece of the feather dancer's dress is designed to express the movement of the figure. This print shows that it is equally decorative front and back. Some costumes are masterpieces of texture as well as color and design."

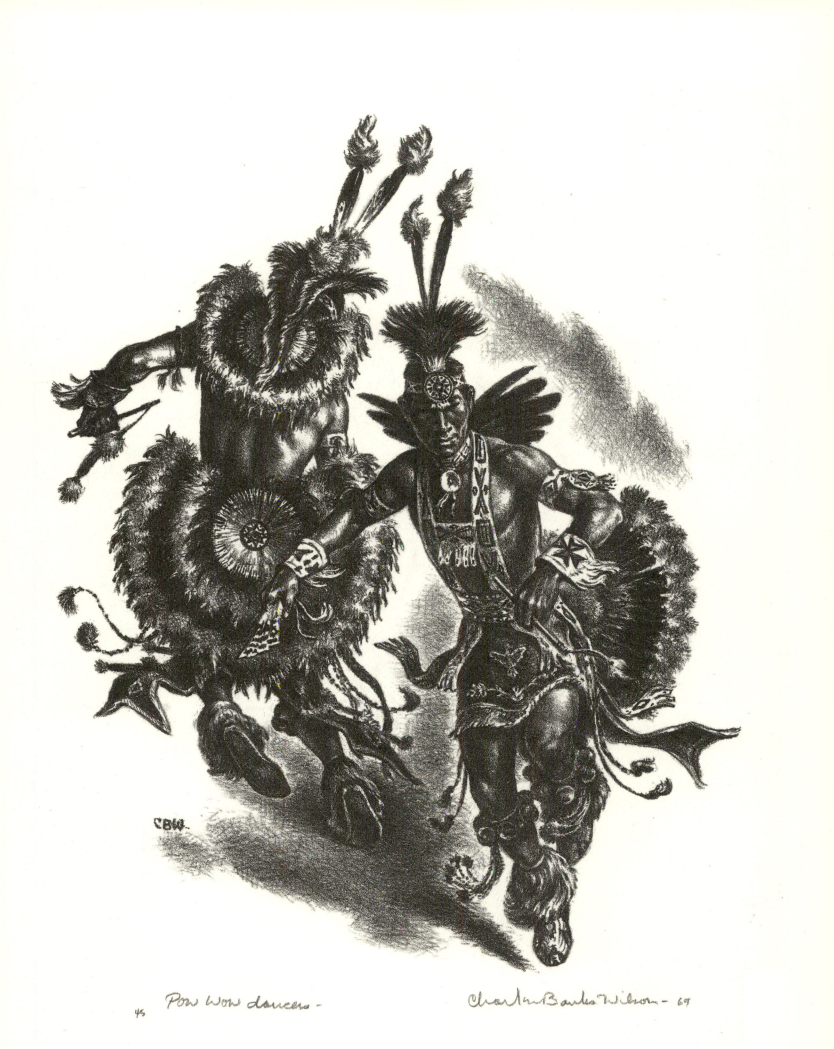

45 Pow Wow dancers. Charles Banks Wilson - 69

74 *Powwow Singers*
12 × 10
1969 / Edition 45

Similar in composition to *Powwow Dancers* (plate 73), this print also incorporates a diagonal at left and a sweeping curve on the right. In the artist's opinion, these common features relate the two prints even more closely than their subject matter.

"Singers are the hub of the powwow, and I did this lithograph as a companion to Powwow Dancers. *In the back, the 'chorus girls,' as the women singers are sometimes called, protect themselves from Oklahoma's hot July sun."*

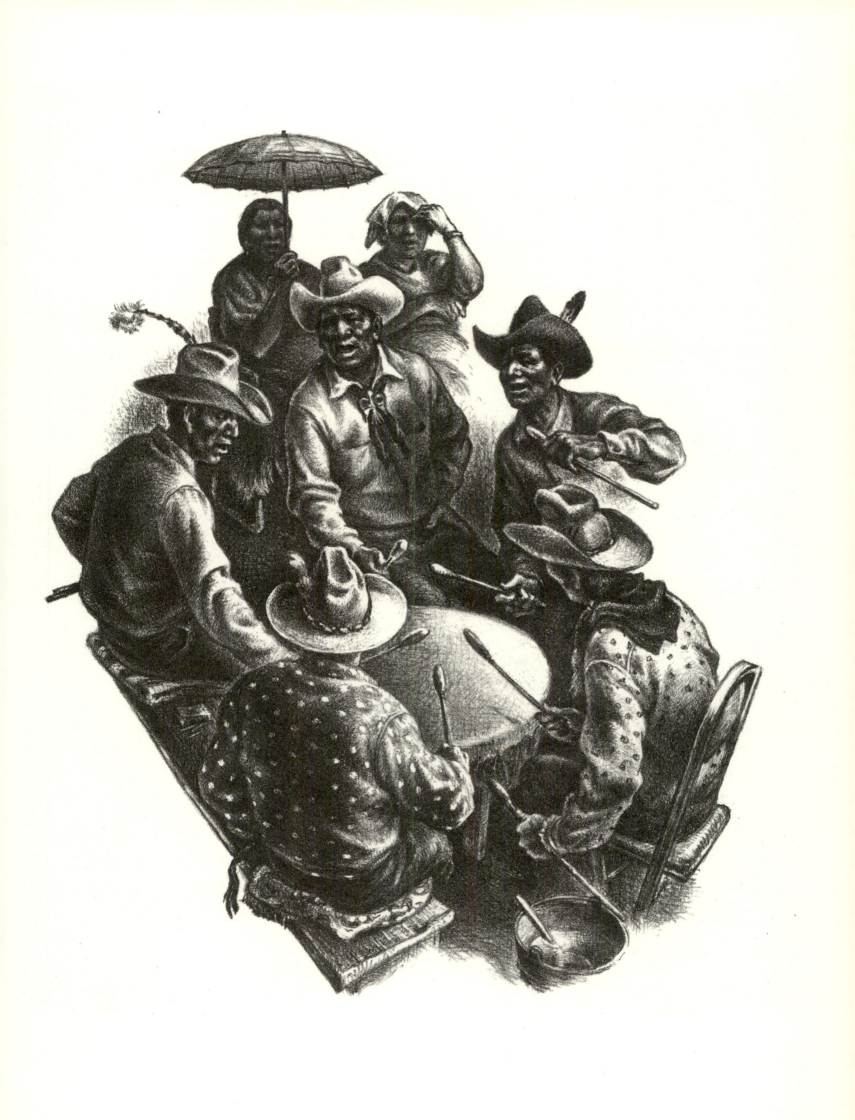

75 *Indian Profile*
15⅝ × 10
1969 / Edition 75

This print had no title until collectors insisted
on a name for it. Wilson used his own shoulder,
observed in a mirror, to complete the figure.

*"My daughter, Carrie, suggested that for a change I
just draw an Indian without telling a story or making
a social comment. As a result, this noncontempo-
rary, historical Indian was a first for me. These are
the only Indian features I ever based on an old photo
instead of on live models."*

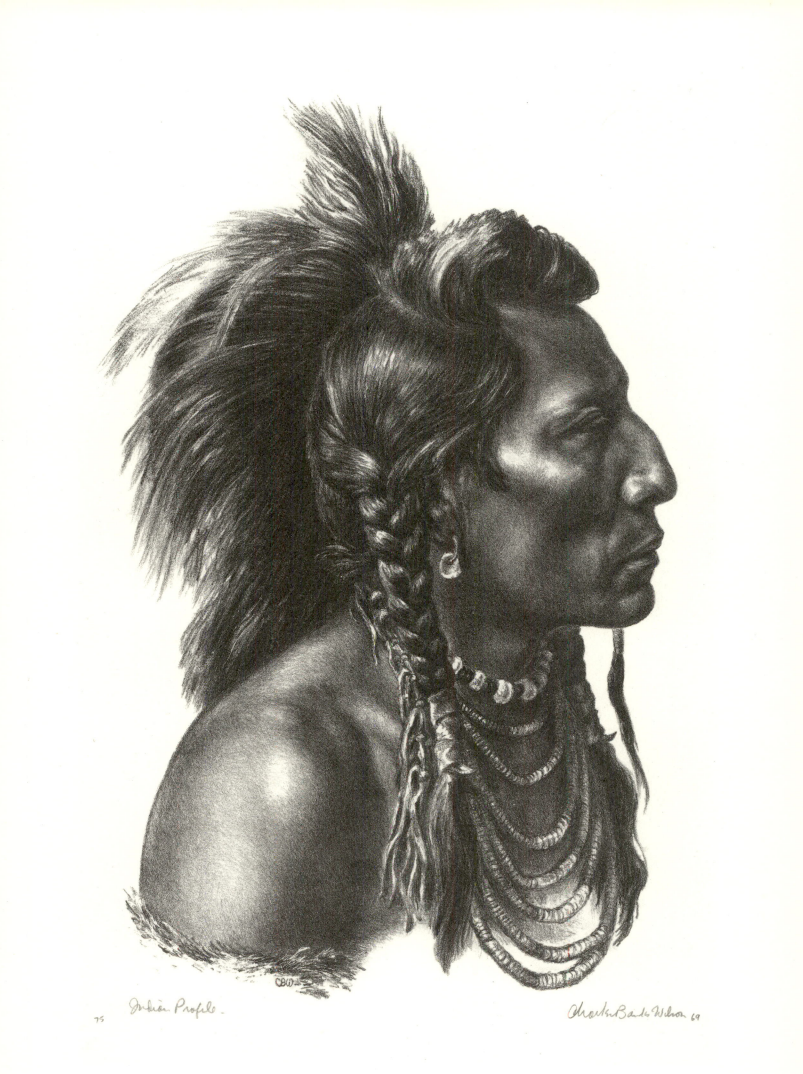

75 Indian Profile. Charles Banks Wilson 69

76 **Trail's End**
9¼ × 10⅞
1973 / Edition 150

In developing this drawing, which is based on James Earle Fraser's sculpture *End of the Trail,* Wilson employed a new model for the rider and placed him on a small western pony instead of on the larger horse represented in the original work.

"I can't take credit for this one. It had tugged a lot of heart strings before I came along. My drawing was intended as the design for a bas-relief plate to be produced in England. The plate never was made, but I published this print."

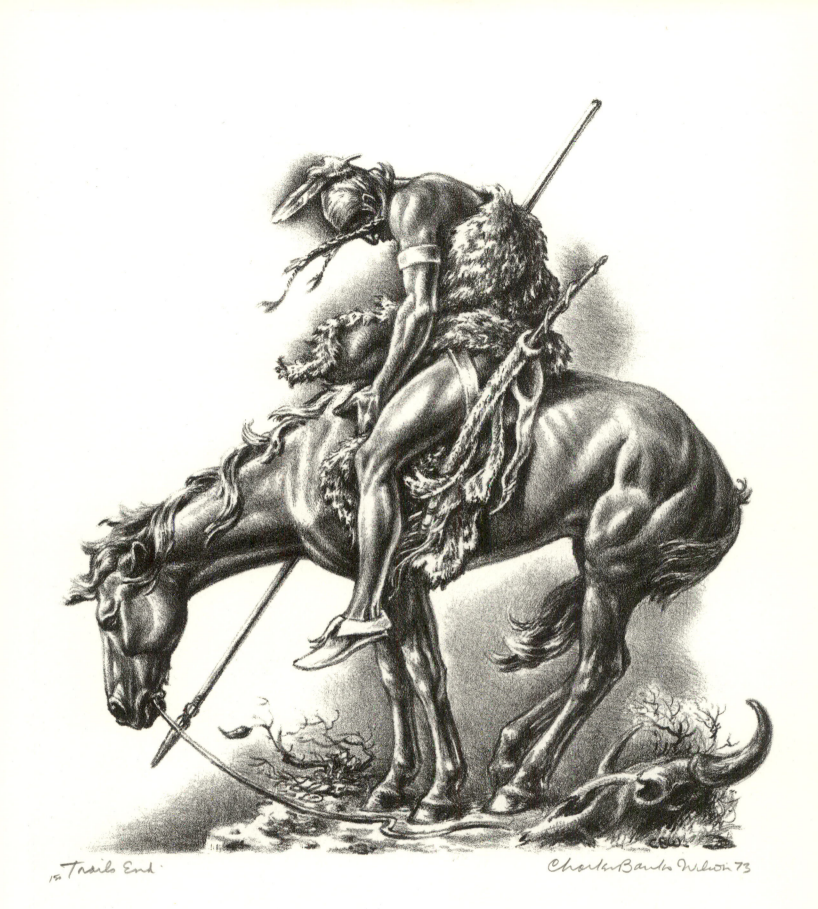

"Trails End" · Charles Banks Wilson 73

77 *Wet Weather Spring*
15¼ × 10¼
1974 / Edition 50

The title refers to a seasonal spring formed during rainy weather when the ground becomes saturated and moisture seeps out of the soil.

"Sometimes it seemed that a place was just waiting to be painted. For years I noticed this little valley and the trees the spring fed. Now only the valley remains. I made a watercolor and this drawing."

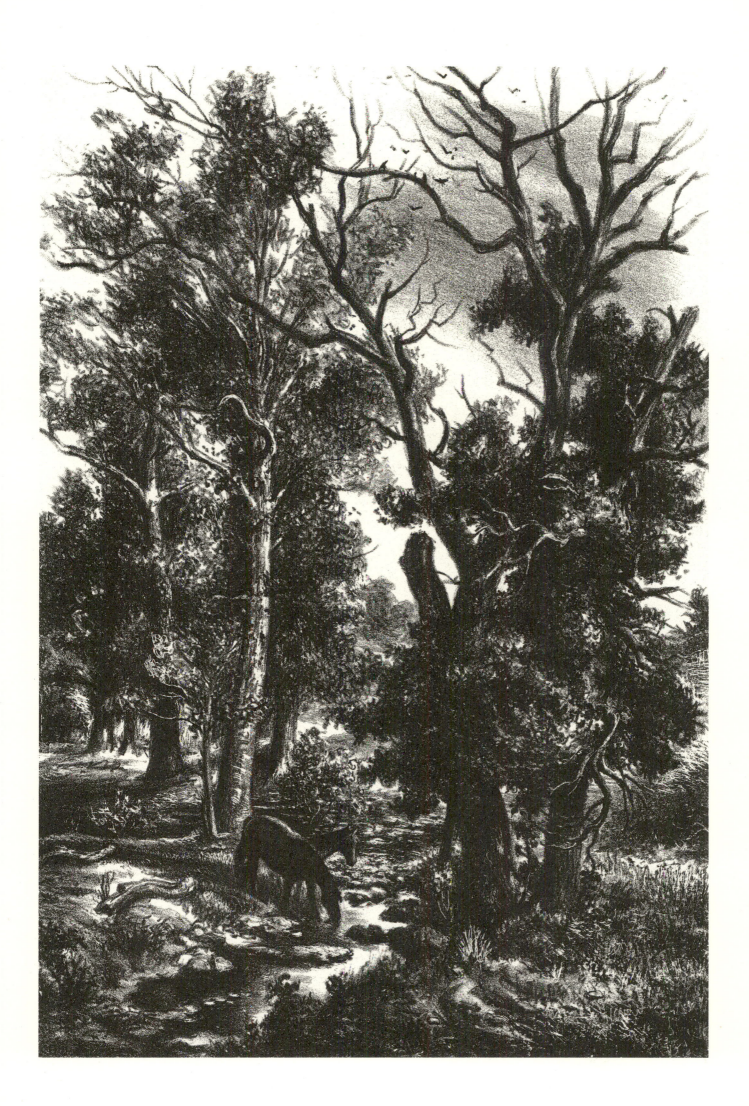

78 **Indian Sketches**
16¼ × 10¾
1975 / Edition 25

The delicacy of these drawings, which were done during the development of *Powwow Dancers* (plate 73), allowed for only a small edition of prints.

"While composing figures for the Powwow Dancers *print, I had made a lot of action doodles. In this lithograph I combined several of them with a more finished study."*

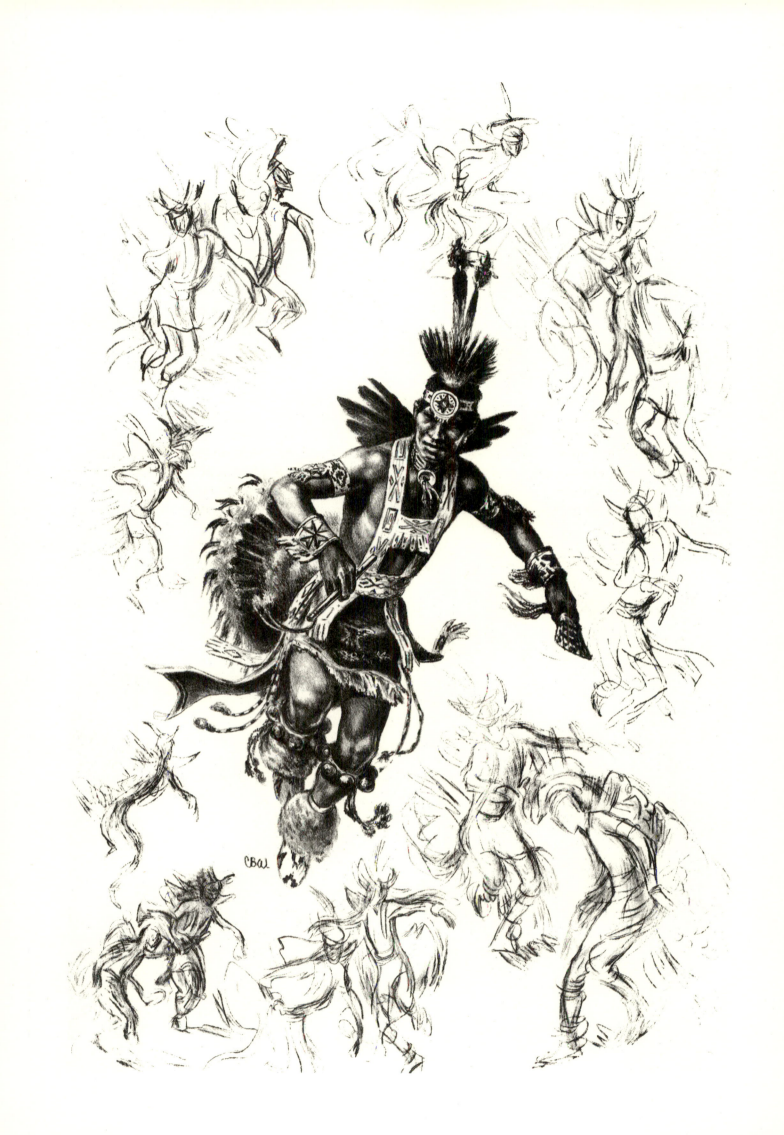

79 *Superstar*
10½ × 6¾
1975 / Edition 60

Based on earlier studies, this portrait of Jim Thorpe shows him as he appeared at the age of twenty-six, at the Olympic Games in Stockholm, Sweden, where he was acclaimed as the greatest athlete in the world.

"In painting the Oklahoma capitol portrait, I gave special attention to the muscles of his great body. Now, however, when I see the painting hanging in the rotunda, all I look at is his strong face."

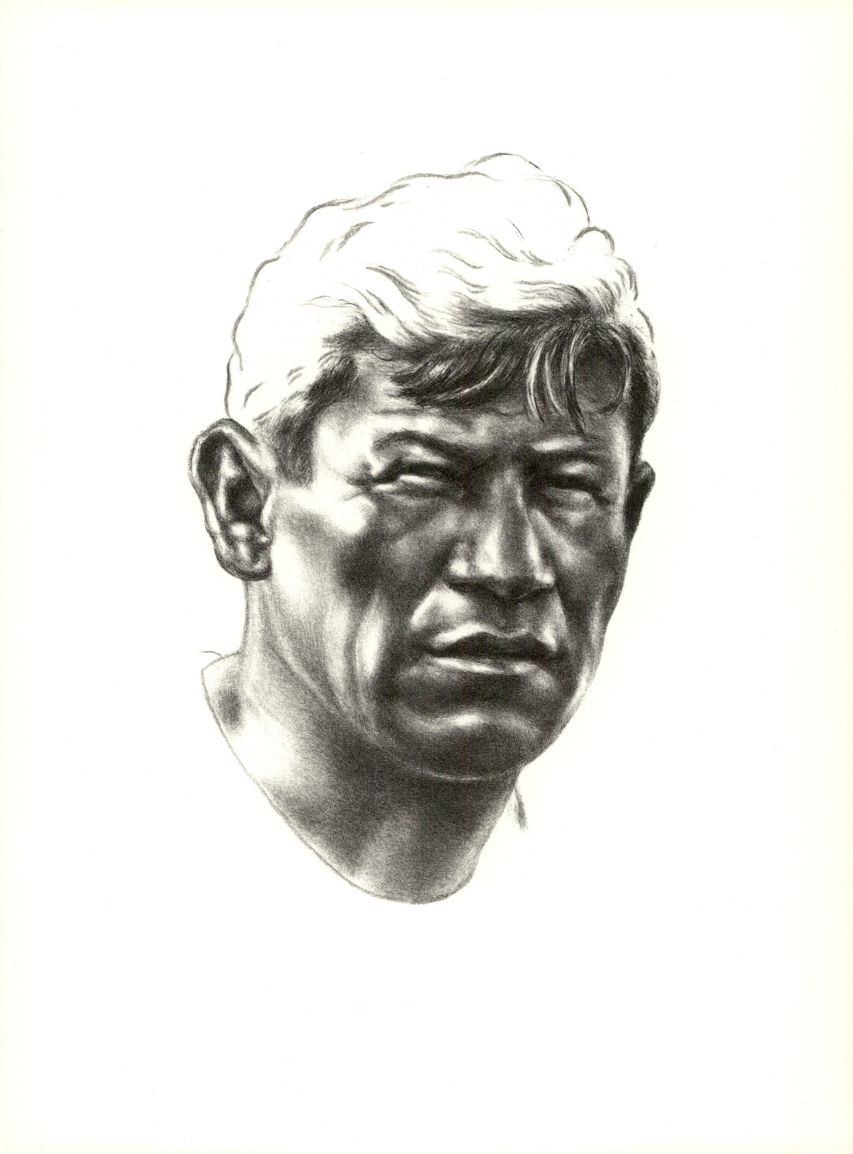

80 **Sorghum Time**
11 × 17
1975 / Edition 75

This print, redrawn from an earlier stone, is based on a painting commissioned by the Ford Motor Company. It shows the traditional process involved in making molasses from sorghum, a low-grade sugarcane.

"I am amazed at how many people tell me of their experiences in making sorghum molasses. One fellow set me straight when he told me, 'It ain't picturesque, it's damn hard work.' I found this old mill south of Bentonville, Arkansas, not far from my birthplace. The boy here keeps the horse moving by kicking him in the ribs. Mules are better—they don't get bored."

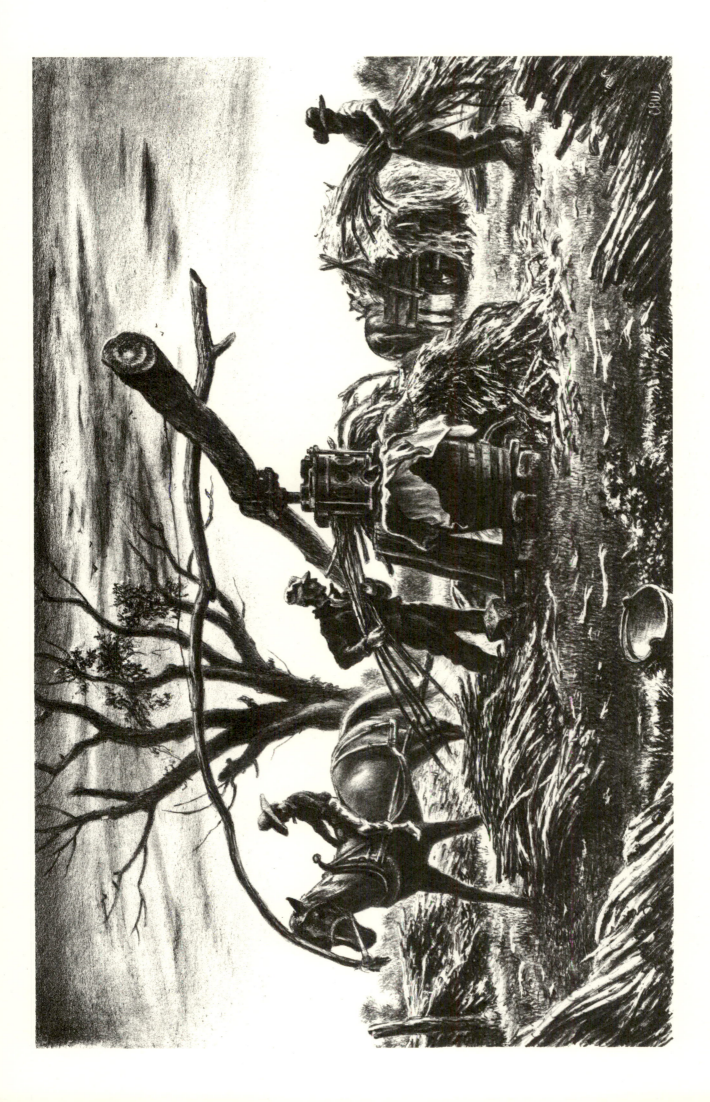

81 *Bull Rider*
15 × 10¼
1976 / Edition 200

Freckles Brown was the first man to ride the famous bull Tornado, which had thrown all previous riders, for the required eight seconds in the National Finals Rodeo in 1975. Brown was in Miami for another rodeo when he sat for his portrait in Wilson's studio. He later signed some of the prints in this edition.

"Freckles had been busted and battered from head to toe by the time he posed for this. He is the only cowboy I ever knew about whom no other cowboy had a bad word to say."

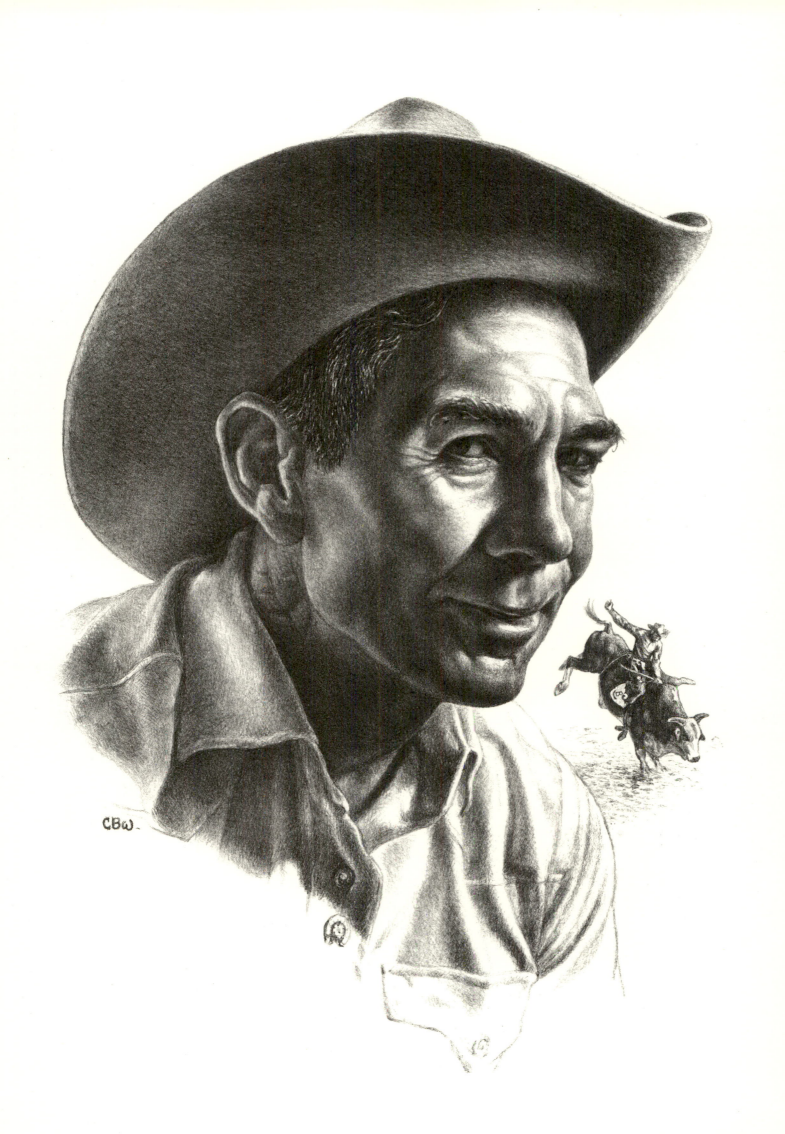

82 *Boy on the Creek*

8¾ × 6⅛
1976 / Edition 120

Featuring an enlargement of the central figure in *Fishing Joe's Creek* (see plate 72), *Boy on the Creek* appeared again as a reverse drawing in *On the Creek* in 1981.

"This Huck Finn of Oklahoma is 'every mother's boy and every man's memory,' someone once told me."

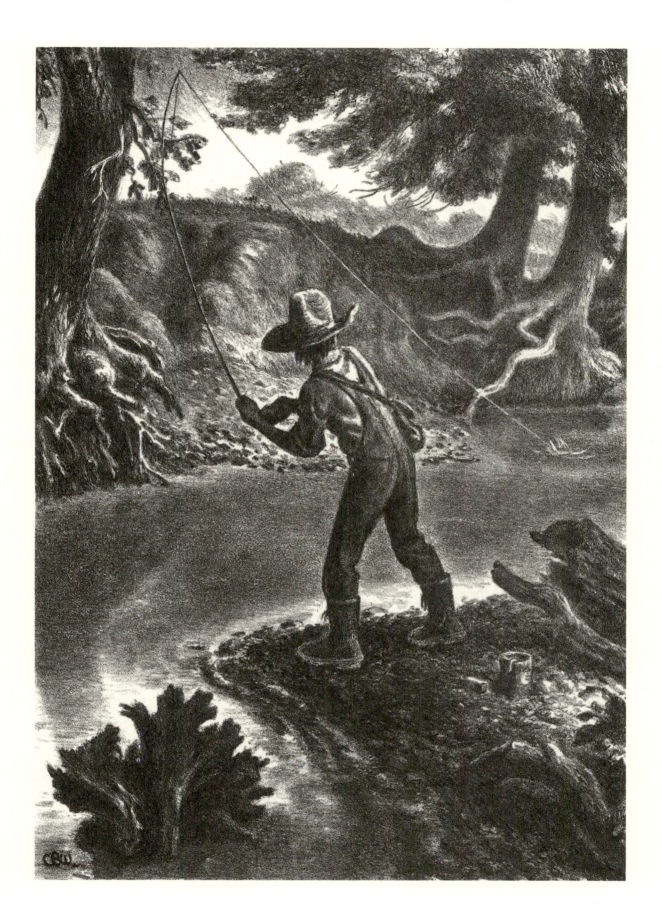

83 *Young Fisherman*

8¾ × 6¼

1976 / Edition 45

Wilson extracted this figure from *Boy Fishing* (see plate 69), which in turn had been based on the lithograph *Morning on the Creek*. The three prints represent one of the artist's favorite sketching sites.

"Sometimes a section of a picture demands more attention and shouldn't be lost in its surroundings. In this case I enlarged the figure of Boy Fishing *on Tar Creek.*

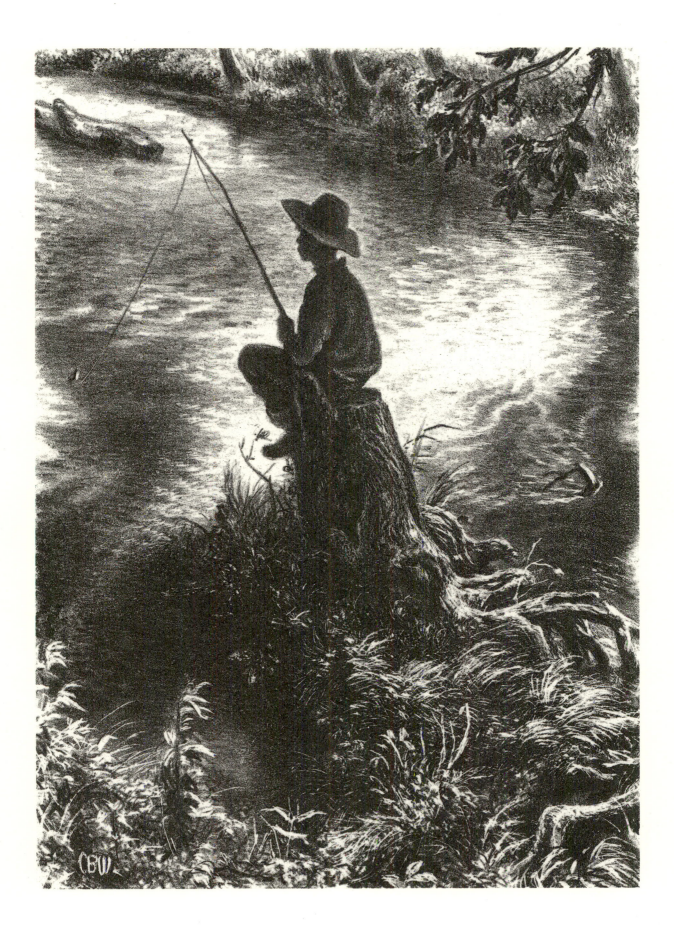

84 *The Race*
10⅝ × 14½
1976 / Edition 200

The first of six lithographs based on the state capitol murals in Oklahoma City, *The Race* takes its subject from the panel entitled *Settlement*.

"This print of the Oklahoma land runs—there were seven—portrays the 'Boomers' in the foreground urging the settlers of '89 and later to 'go forth and possess the promised land.' It has been very popular, partly, I think, because of the current interest in old steam locomotives."

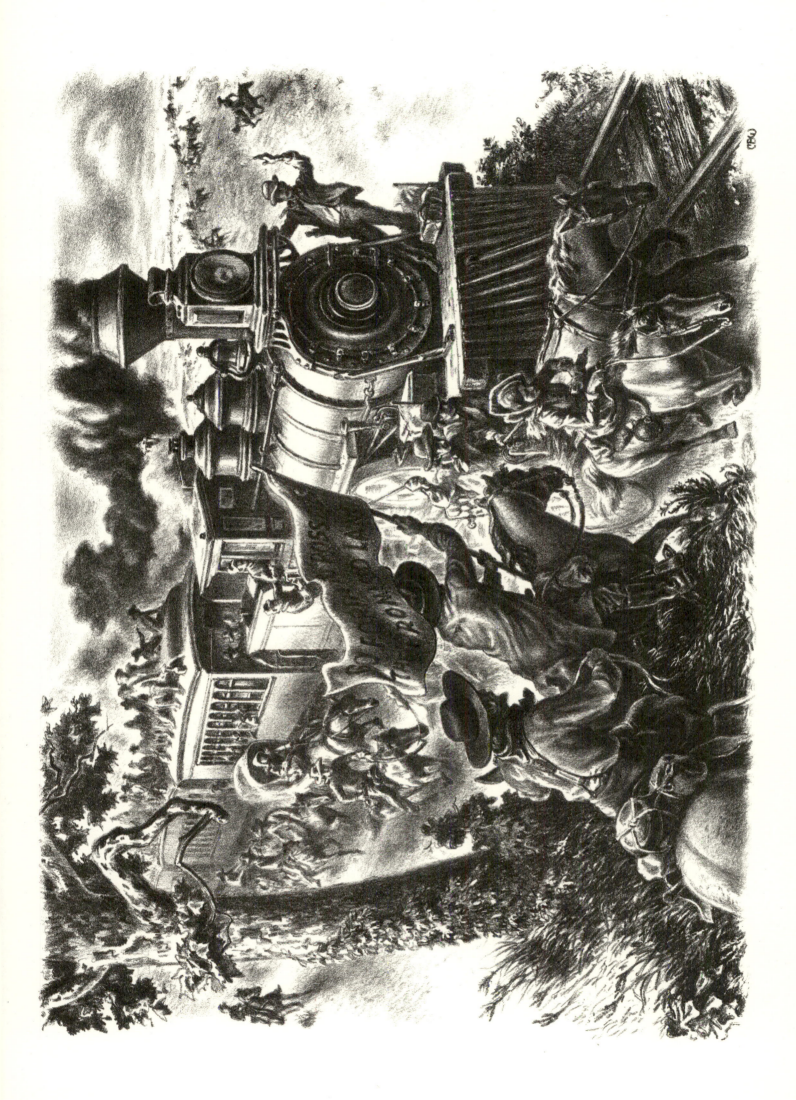

85 *Enter Coronado*
17½ × 11
1976 / Edition 100

Coronado, believed to have been the first European to explore parts of what is now Oklahoma, in 1541, is shown wearing the correct Spanish helmet of the period, the burgonet, rather than the later morion frequently misrepresented in books and films.

"I extracted this composition from my Oklahoma capitol mural Discovery and Exploration. *I posed for the figure of Coronado myself and sketched the Antelope Hills in western Oklahoma for the background."*

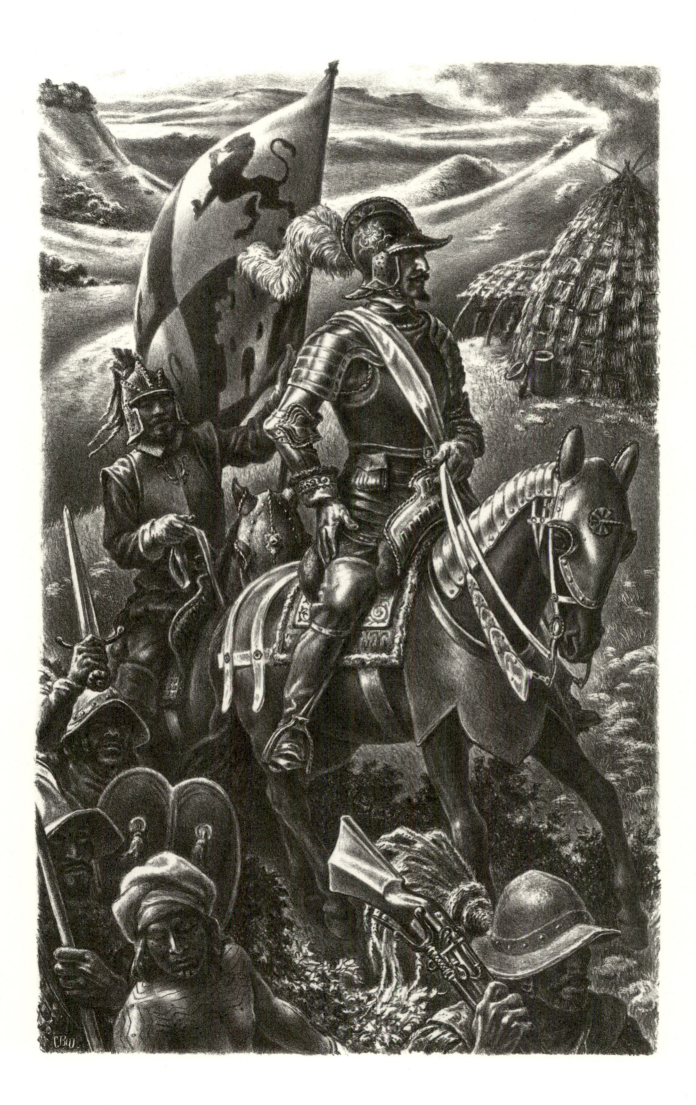

86 **Osage Trade**
13 × 16¼
1977 / Edition 250

Based on the *Frontier Trade* mural in Oklahoma City, this print depicts a group of white traders offering goods to an Osage chief in exchange for furs. Noted themselves as shrewd traders, the Osage were one of the wealthiest of America's Indian tribes long before oil was discovered on their reservation at the beginning of this century.

"Oklahoma's capitol murals are populated with my friends. For Indians I went in every case to the tribe I was to picture and drew a full-blood member from life. Joe Benny Mason, a pureblood Osage, posed for the central figure with the eagle-wing fan. Lennie Sky, brother of the model for my Plains Madonna, stands behind him. At right, the late professor Arrell Morgan Gibson, of the University of Oklahoma, leans on a long rifle."

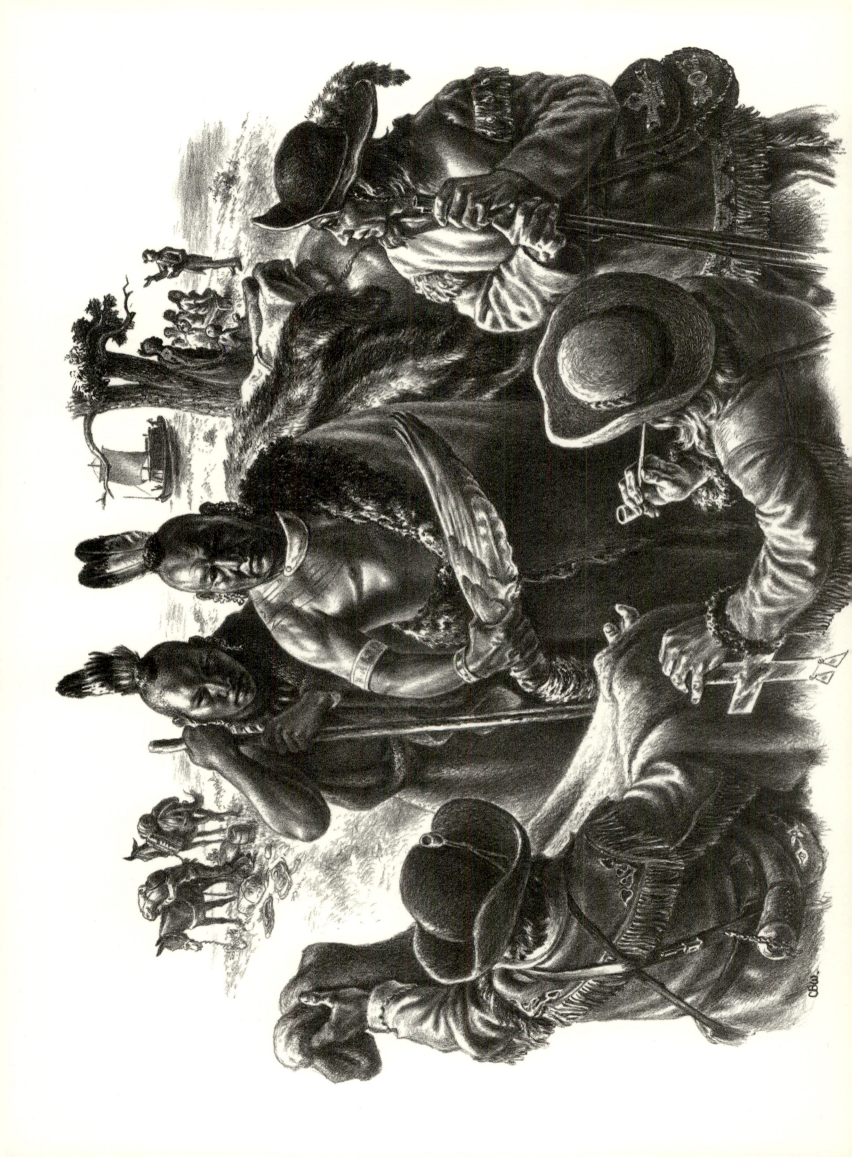

87 *Plains Madonna*
17 × 11½
1977 / Edition 300

The popularity of this lithograph, presenting an enlargement of one of the figures in the capitol mural *Indian Immigration,* prompted Wilson to repeat the subject in a painting that was reproduced as a color print and widely sold. The woman wears a Kiowa dress decorated with elk teeth. The original of the cradle that holds the infant is in the collection of the Field Museum of Natural History in Chicago.

"Osage author John Joseph Mathews wrote me that he thought I best expressed the 'royalty of the American Indian.' If this print succeeds in becoming my best-known work, it may be because it also expresses the nobility of motherhood."

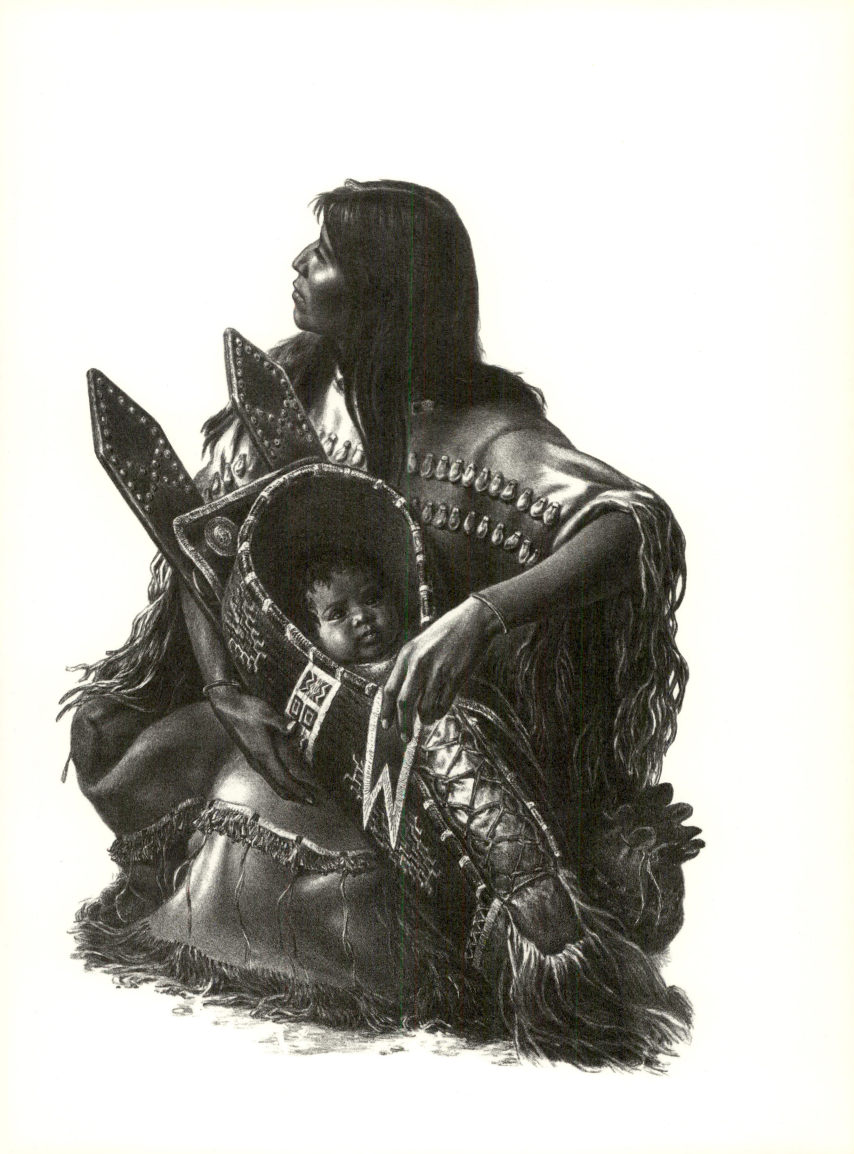

88 *Encounter, I.T.*

12 × 16½
1978 / Edition 175

The *Indian Immigration* mural also furnished the basis for this print, which describes the confrontation that occurred in the nineteenth century between opposing groups in what was then Indian Territory.

"I tried to picture another side of the story of Indian Removal: dispossessed Indians from the East being relocated in the West on land already occupied by tribes that had been living and hunting there for centuries. A young man who had just returned from Vietnam posed for the figure of the Comanche on the horse. The Plains Madonna figure can be seen at lower right."

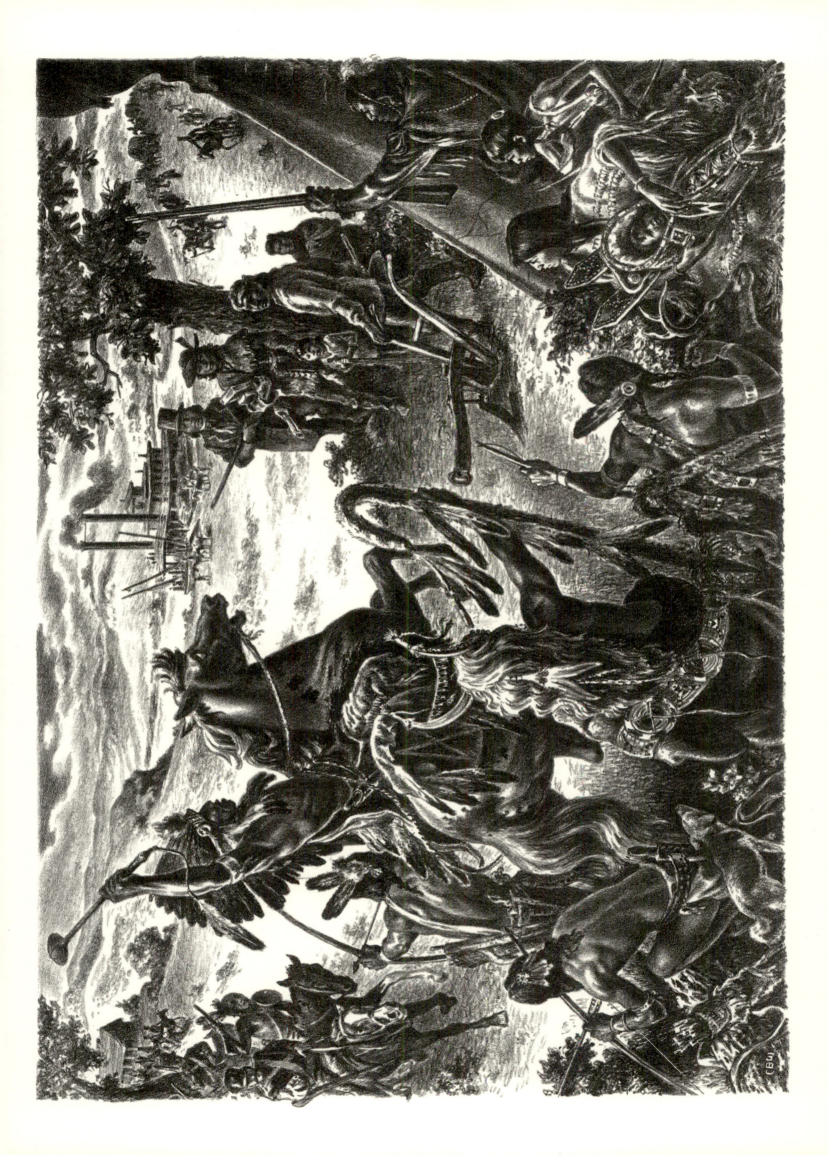

89 *Race to the Barn*
11½ × 16½
1978 / Edition 75

This subject was repeated in an oil painting done in 1981. Wilson says that he included the waving corn in the background to emphasize the forward movement of the composition.

"Inspired by my interest in that corner post and pasture, this lithograph grew into a recollection of my own boyhood. My horse never wanted to leave the barn lot, but ran like the wind going back home."

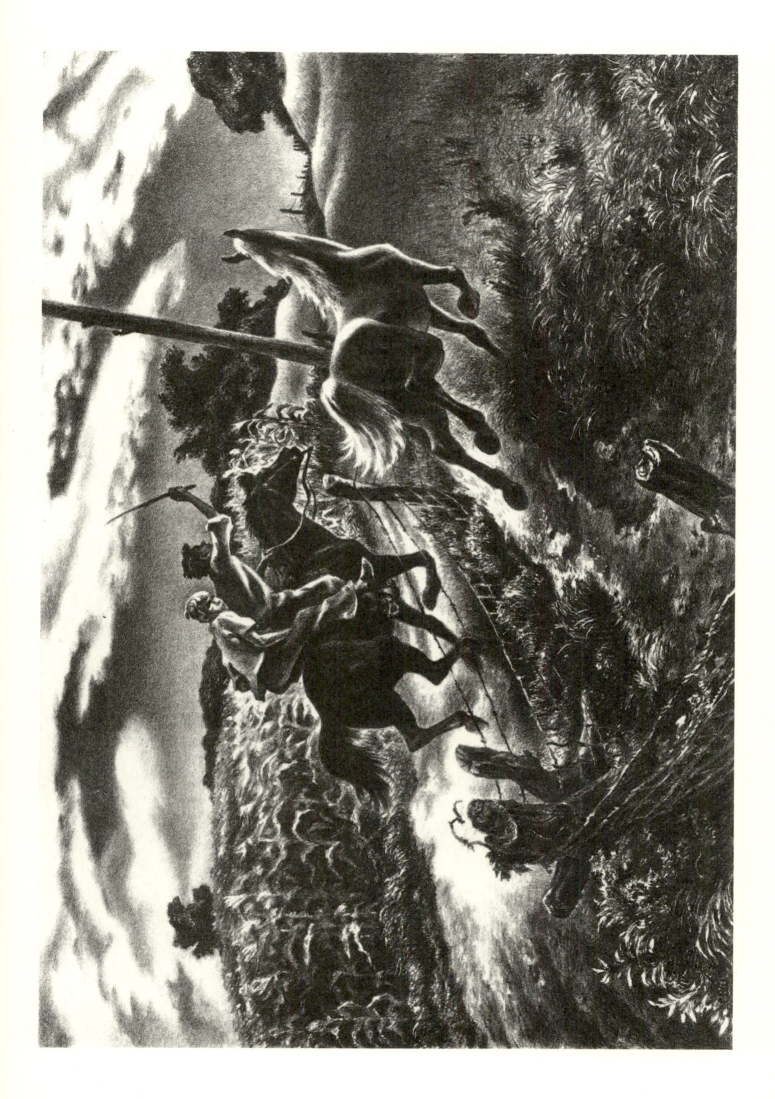

90 *Suzanna and the Elders*
16¼ × 8½
1978 / Edition 75

Representing a real-life experience in allegorical terms, *Suzanna and the Elders* derives its title from the story found in the Apocryphal book of Daniel.

"While driving late one afternoon on an isolated road through the cattle country of western Oklahoma, I zipped over a small hill and unintentionally intruded upon a young woman bathing in a stock tank. Both of us were surprised, but we waved, and I sped on to Buffalo. Hereford bulls remind me of watery-eyed, lecherous old men, so I made them the 'elders' of the story."

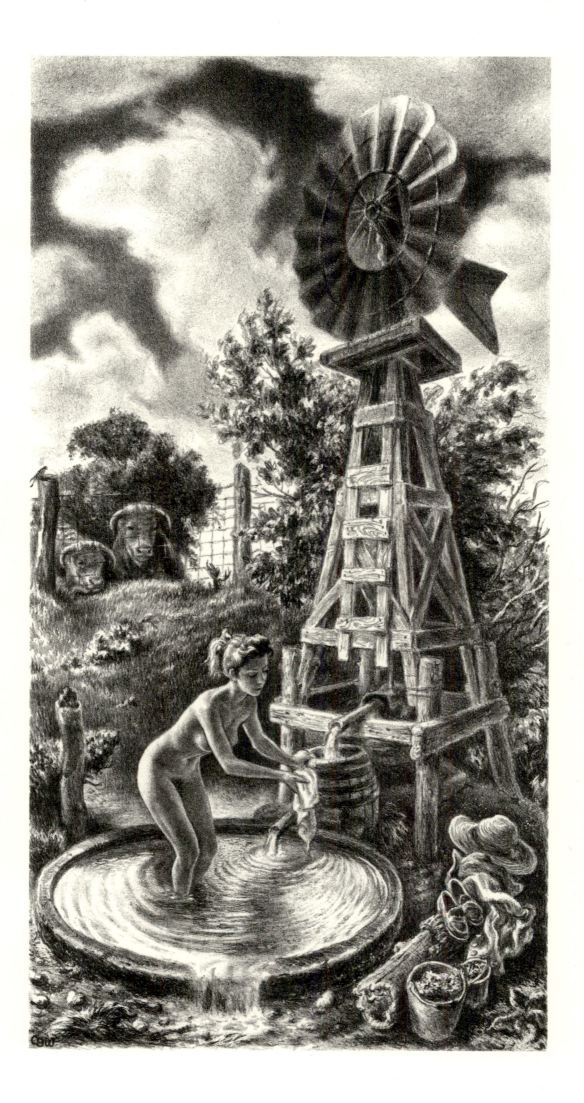

91 **The White Hats**
7⅞ × 17
1978 / Edition 200

The second of two stones produced this edition
of *The White Hats*, based on a charcoal drawing
Wilson made in 1952. He later hand-colored
some prints, and in 1985, he painted a full-color
version of the subject.

"A friend of mind who regularly saw this print dis-
played over the mantle in his son's living room told
me that it was years before he noticed the faces. He
had just written it off as 'modern art.'"

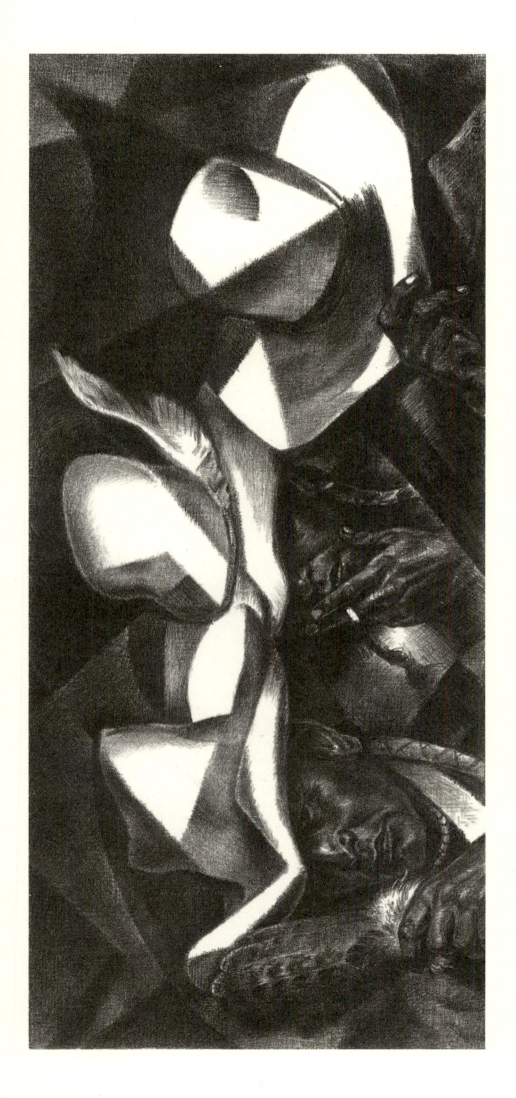

92 *The Humorist*
8 × 4¾
1979 / Edition 75

Will Rogers has been a favorite subject of
Wilson's for more than forty years.

*"This small lithograph has disturbed some people.
Recent generations have tended to regard Rogers al-
most as a deity. I admired him in every way, espe-
cially as a great stand-up comic, and hope that
viewers might look at this caricature and chuckle.
Will Rogers liked chuckles and would have enjoyed
that."*

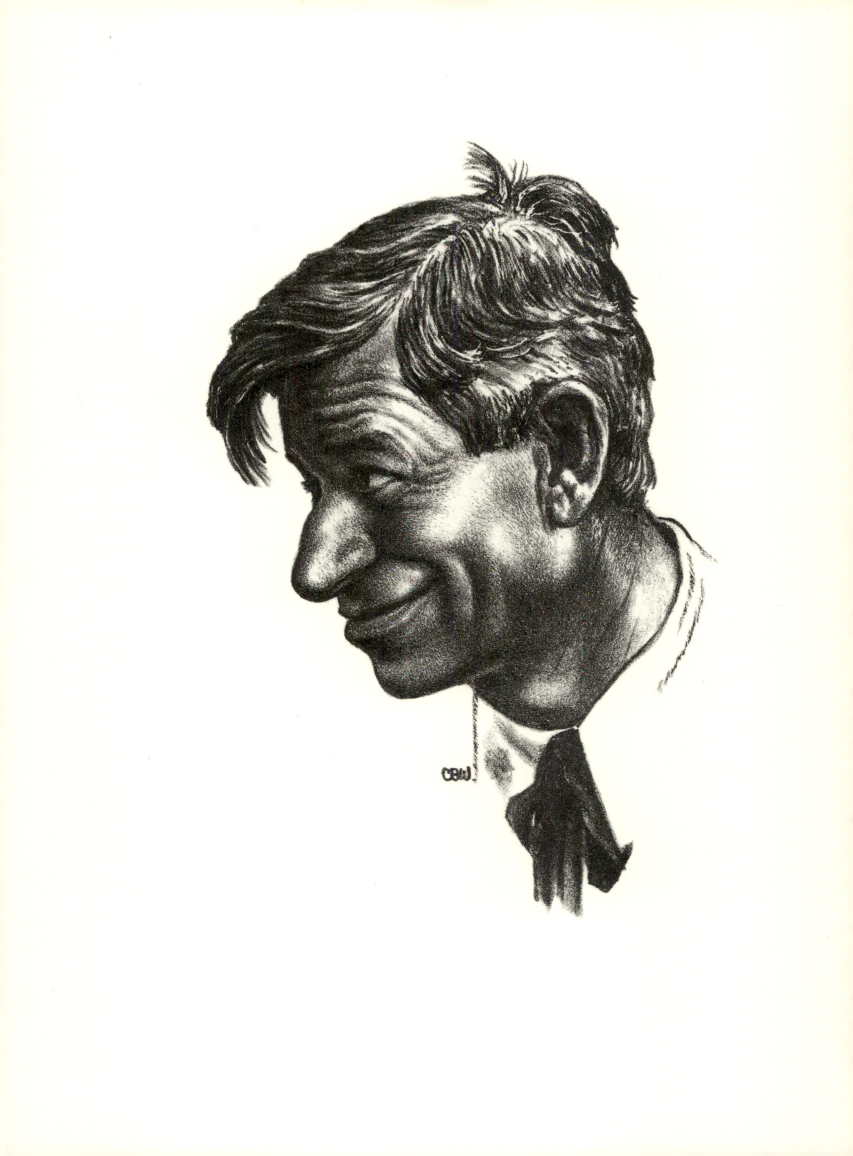

93 *Mural Buffalo*
11¼ × 17
1979 / Edition 150

Based on studies made from life for the *Discovery and Exploration* mural at the state capitol in Oklahoma City, this print depicts buffalo as described in his journal by a soldier who accompanied Coronado when he first entered what is now Oklahoma.

"It seemed that the safest way to draw these unpredictable animals was from the bed of a pickup truck. One large, red-eyed female found us between her and her calf and attacked!"

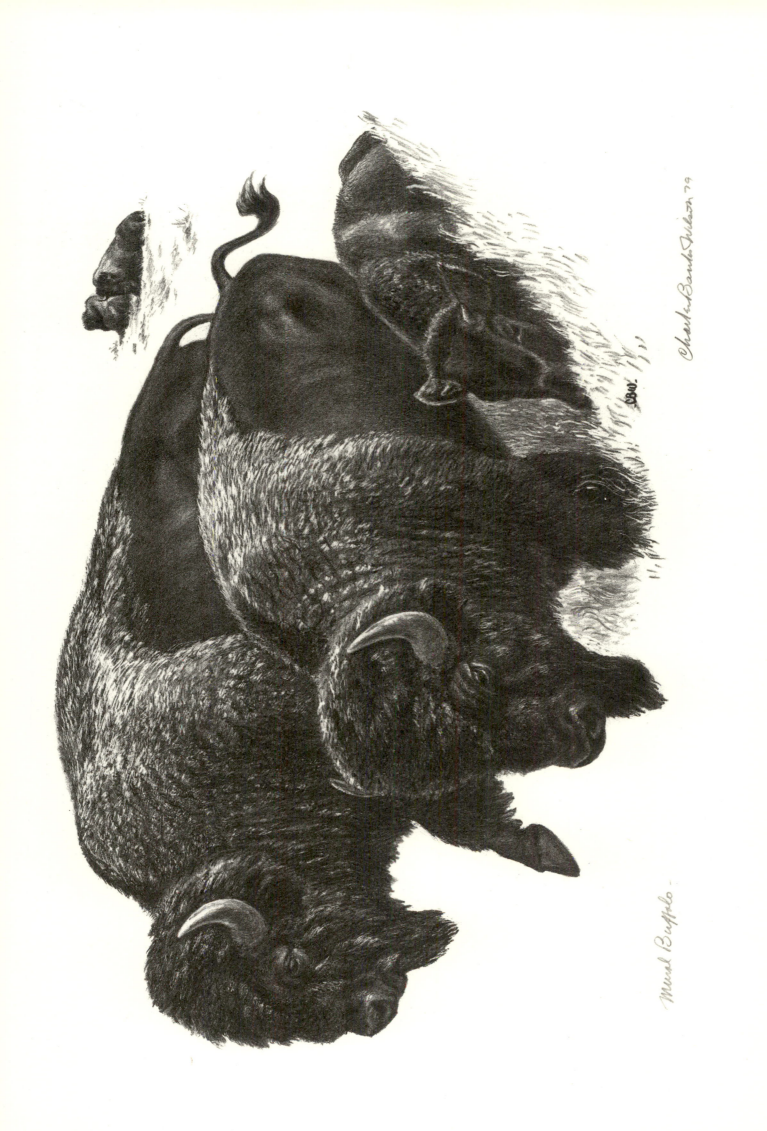

Mural Buffalo

94 *Tribal Elder*

7 × 4¼
1980 / Edition 100

From a pencil portrait in Wilson's "Search for the Purebloods" collection, this lithograph depicts an aged Otoe man who died a few weeks after the original drawing was made.

"Handsome in his youth, he was irritated by my request to draw him in his old age. It took three trips to Red Rock and much talk before he consented. I drew him at his kitchen table by the light of a small back-door window. He told me he didn't feel like posing, but I felt strongly that it was important to record him for future generations."

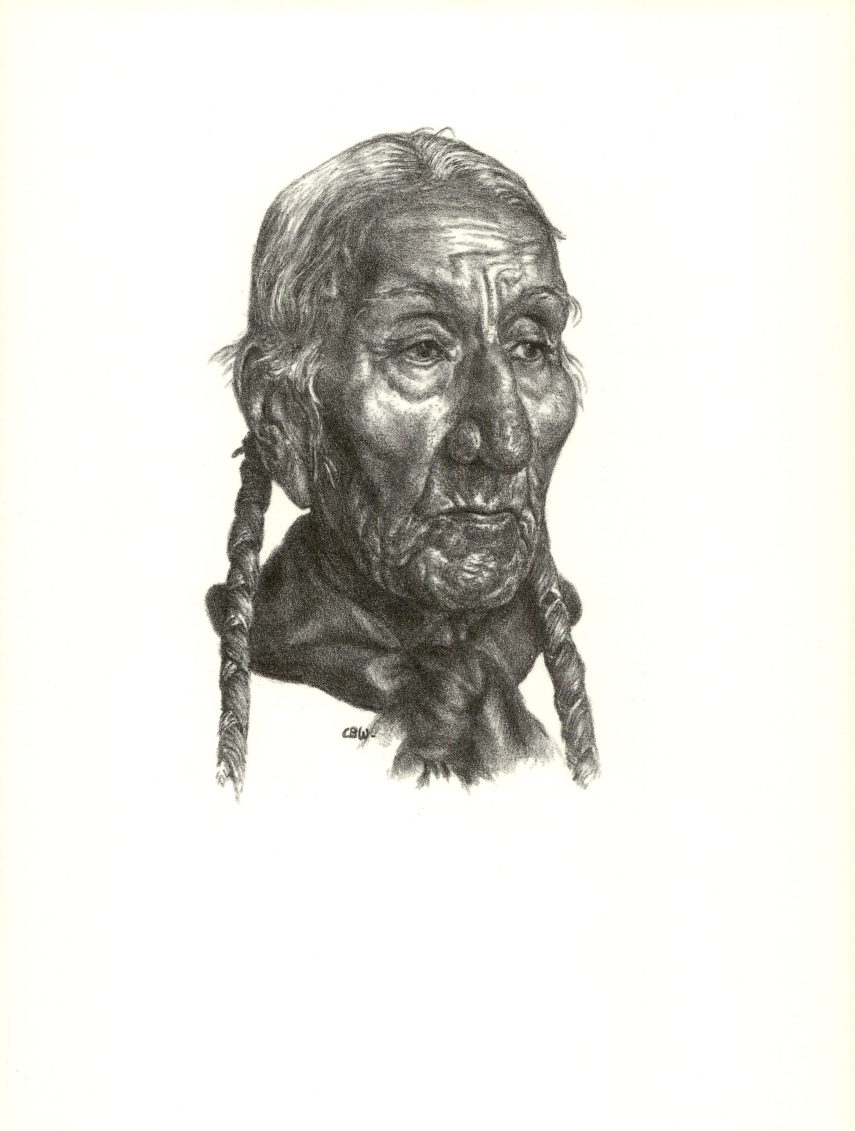

95 *Earth Mother*

7¼ × 4¾

1980 / Edition 100

While filming a special feature on Wilson for "The Tom Snyder Show," an NBC camera crew photographed this woman cooking fry bread at her home in Longdale, Oklahoma, as the artist sketched her portrait.

"The history of the world seemed etched in her face. A Quaker and stalwart in the Indian community, she recalled that when she was young, strangers took the children off to mission school, never to be seen again. Her grandchildren hid in the bushes when I approached."

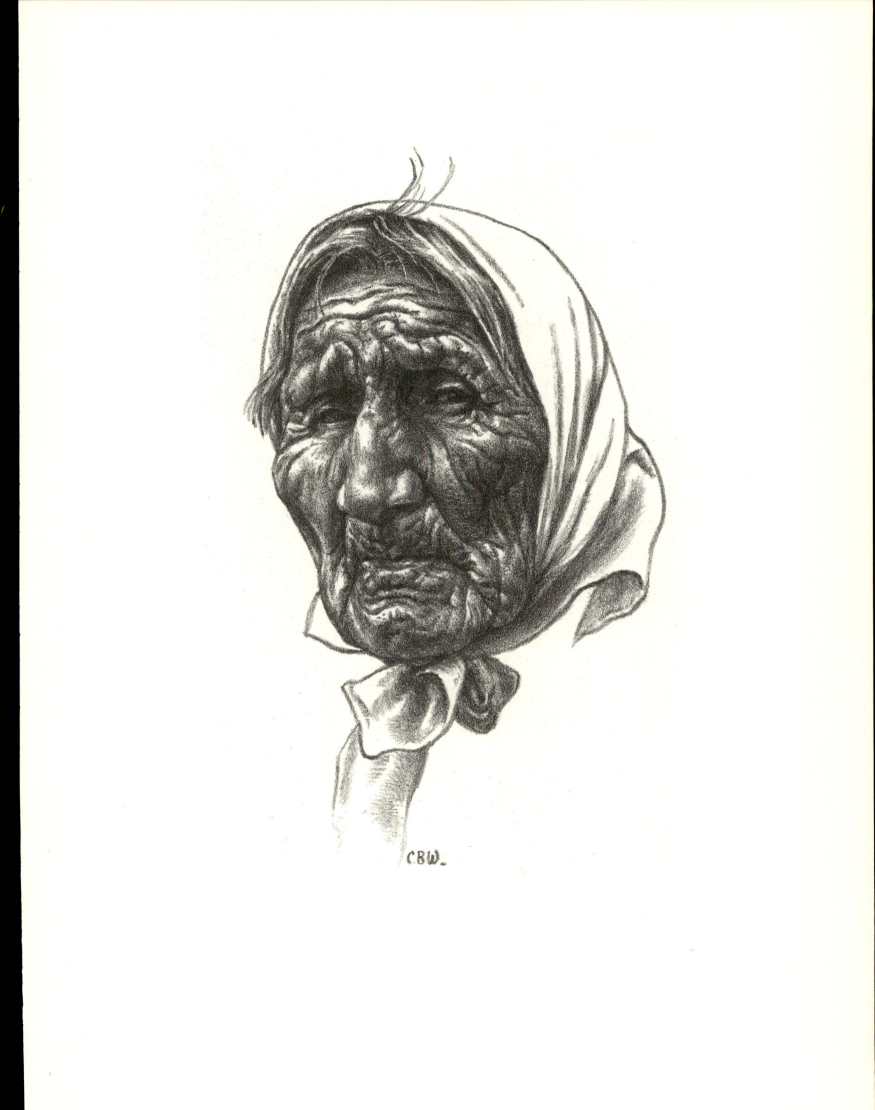

96 *Indian Chief*

6¾ × 4⅝

1980 / Edition 75

Subject of another "Pureblood" portrait, this old Sac and Fox man, since deceased, was the last hereditary chief of his tribe.

"When I finally located this man, I found that he was completely deaf and nearly blind. I had to ask his granddaughter if I might make a drawing of him. She asked me, 'but how much will we have to pay you?' They had been buffeted about so much they didn't realize that I was the one who should be paying them."

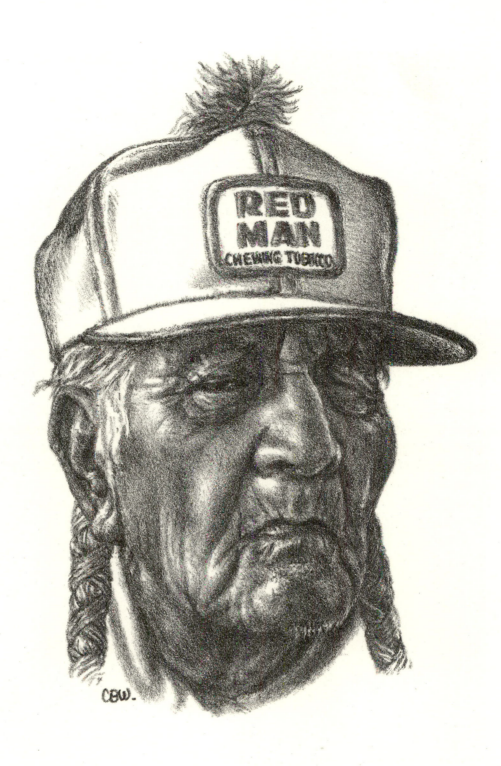

97 *Sequoyah*
14½ × 10½
1980 / Edition 200

In researching Sequoyah's physical traits, Wilson found what he thought was the best-written description at the Gilcrease Museum in an old accounts ledger that had belonged to a merchant in Fort Smith, Arkansas.

"While preparing my Oklahoma capitol portrait of this noble Cherokee, I trekked around Tahlequah, Oklahoma, showing people a copy of an old crayon drawing, supposedly of Sequoyah, and asking if they knew of anyone who resembled it. I ended up using a little of six different men and one woman in the final study."

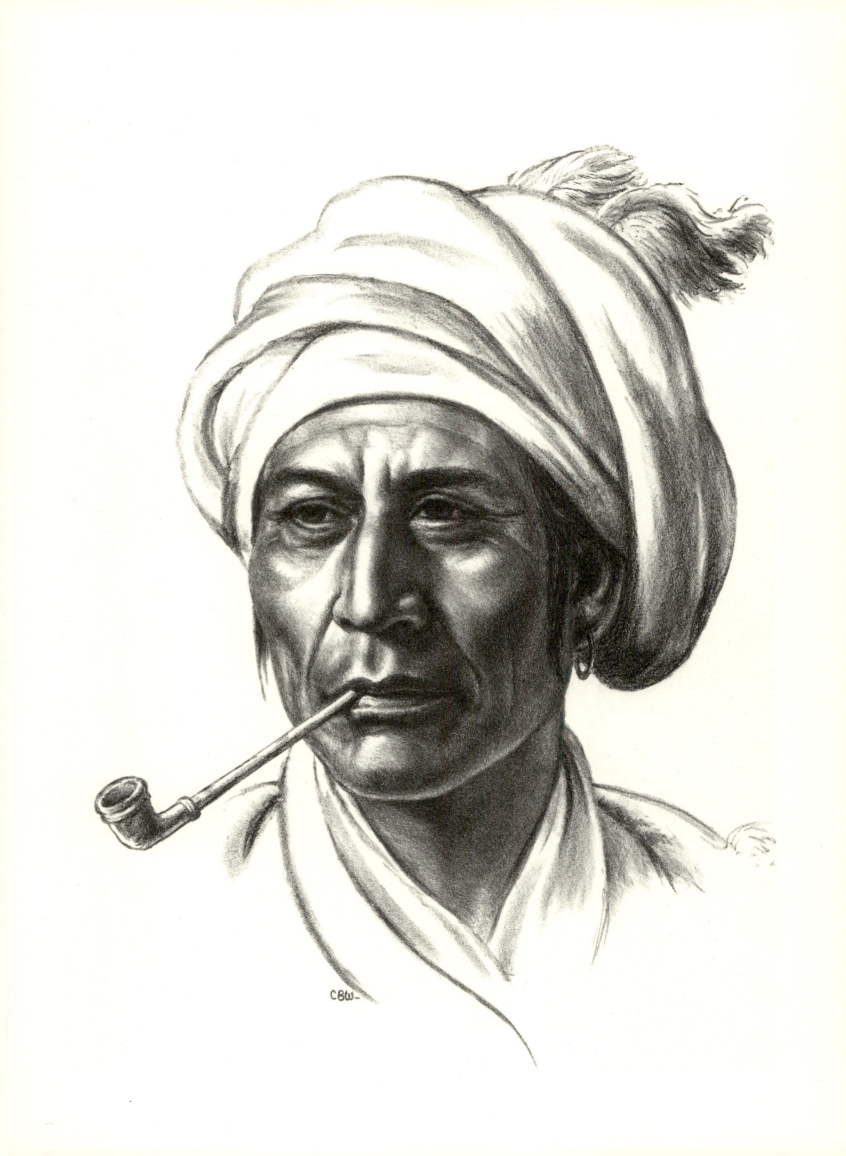

98 *Powwow Afternoon*

13¼ × 16⅛

1980 / Edition 150

Initially entitled *War Dancers' Camp*, this print is based on an earlier painting by Wilson now in the Gilcrease collection, in Tulsa. Burr Miller, George Miller's son, printed this for Wilson, who also more recently has had Miller's grandson print lithographs for him.

"The patterns of the tents dominated the camp-grounds, canvas tents replacing the tipis of long ago. Few activities were scheduled in the heat of the day. Dancers lazed about, old men traded songs, and women cooked; many campers, not just the young, headed for a swimming hole on the river nearby."

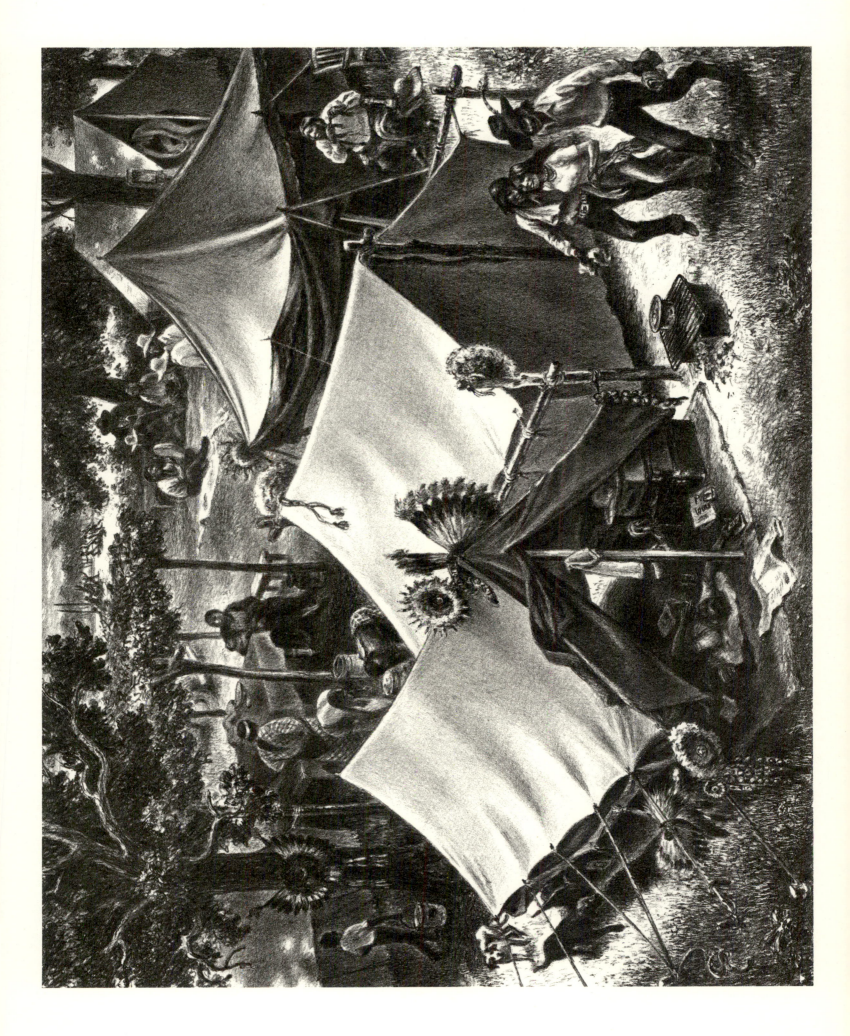

99 *Henry Turkeyfoot*

13⅛ × 9¾
1981 / Edition 150

Henry Turkeyfoot, also represented in other lithographs (see plates 11 and 18), was an Eastern Shawnee man who lived halfway between Miami, Oklahoma, and Seneca, Missouri.

"He was the most colorful character in the community, notorious for being unpredictable and unfettered, and a crack shot. He first posed for me in 1937 when I was only nineteen. I drew him by the barn he had moved into after his house burned. On my first approach, he hid his six-foot-four-inch frame in the nearby brush as was his custom when strangers came unannounced."

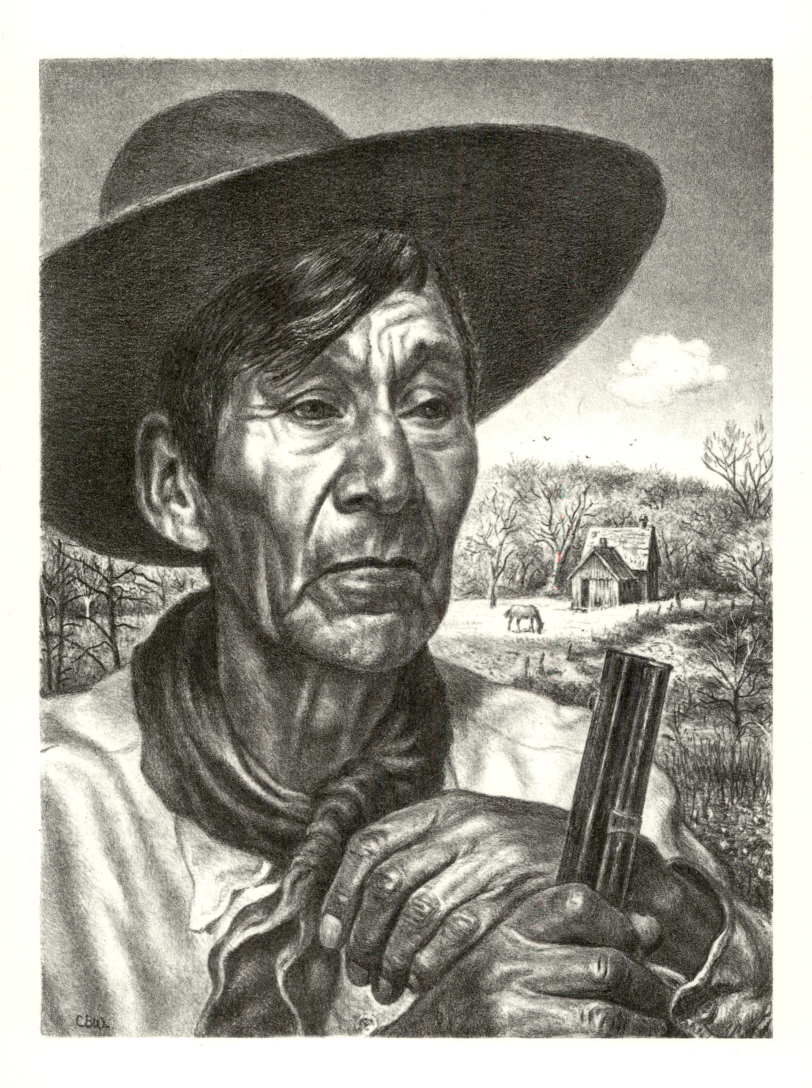

100 *Low Water*
15⅛ × 9¾
1982 / Edition 100

A love of natural forms and rhythms inspired this lithograph describing the relationship of trees and water along a riverbank.

"This is one of those pictures you sometimes have the good fortune to stumble upon. That dead tree pushed forward from its surroundings like the prow of a boat. The stream looked as deep to me as the reflection of the tree. When I returned the next day, however, cattle from the nearby pasture had drunk it dry. It had never been more than six inches deep anywhere."

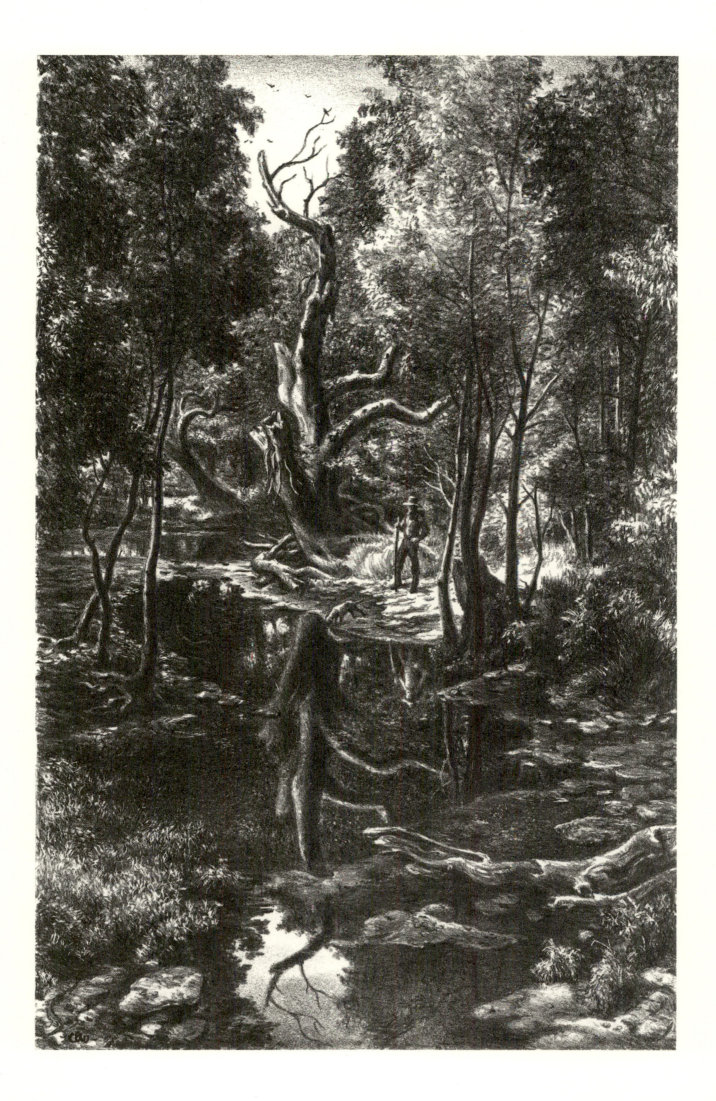

101 *Hiding Place*

13 × 10⅜
1982 / Edition 100

Presenting another view of Coal Creek, or Joe's Creek (see plates 67, 72, and 82), this print was based on a drawing made in 1967.

"On a turtle hunt with Carrie I drew this tree, its roots clinging for dear life to the creek bank. It had anchored itself to the roots of other trees on higher ground. I never knew if the man fishing was hiding from the fish or from his wife."

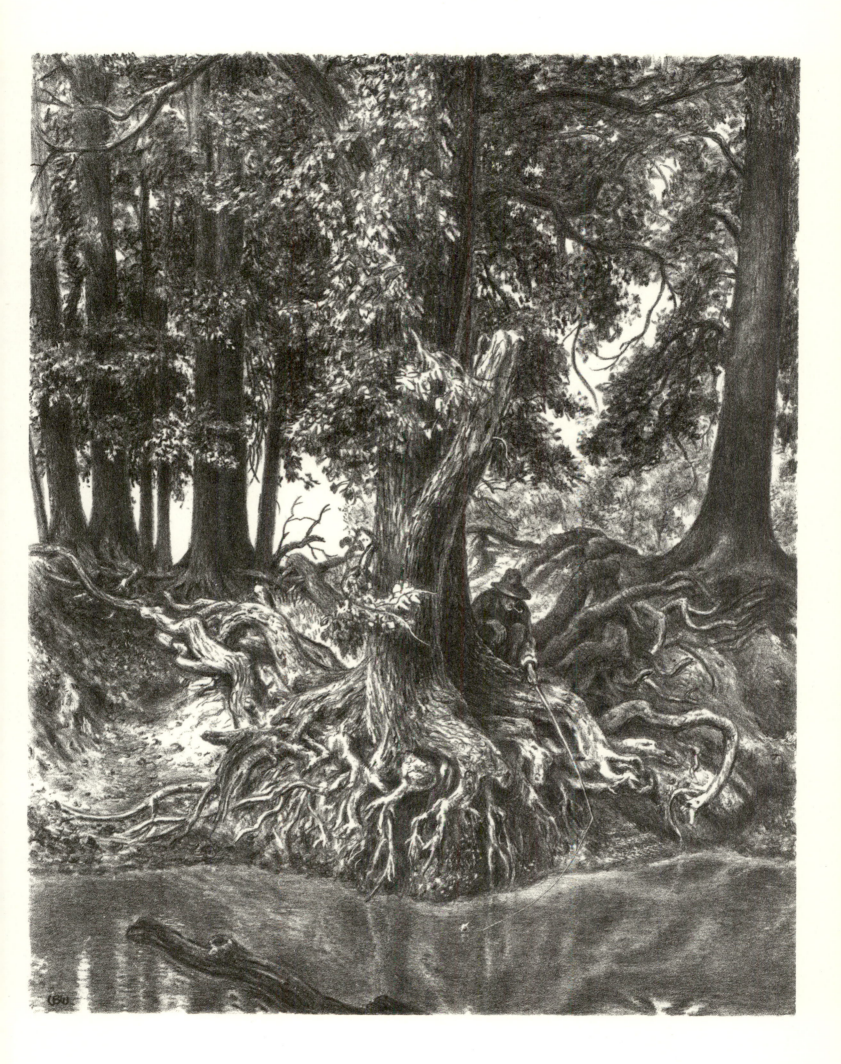

102 *Awee*
6½ × 4¾
1982 / Edition 100

The Navajo word for "baby" supplied the title for this portrait, based on studies made for the *Indian Immigration* mural in Oklahoma City. The subject later appeared as the infant in the cradle in the *Plains Madonna* print (see plate 87).

"This is the happy result of my search for a full-blood American Indian baby. He was three months old in 1973 when I drew him while his mother held him in her lap. I know that he is growing up somewhere with no knowledge of his fame, because his mother never came to see the murals."

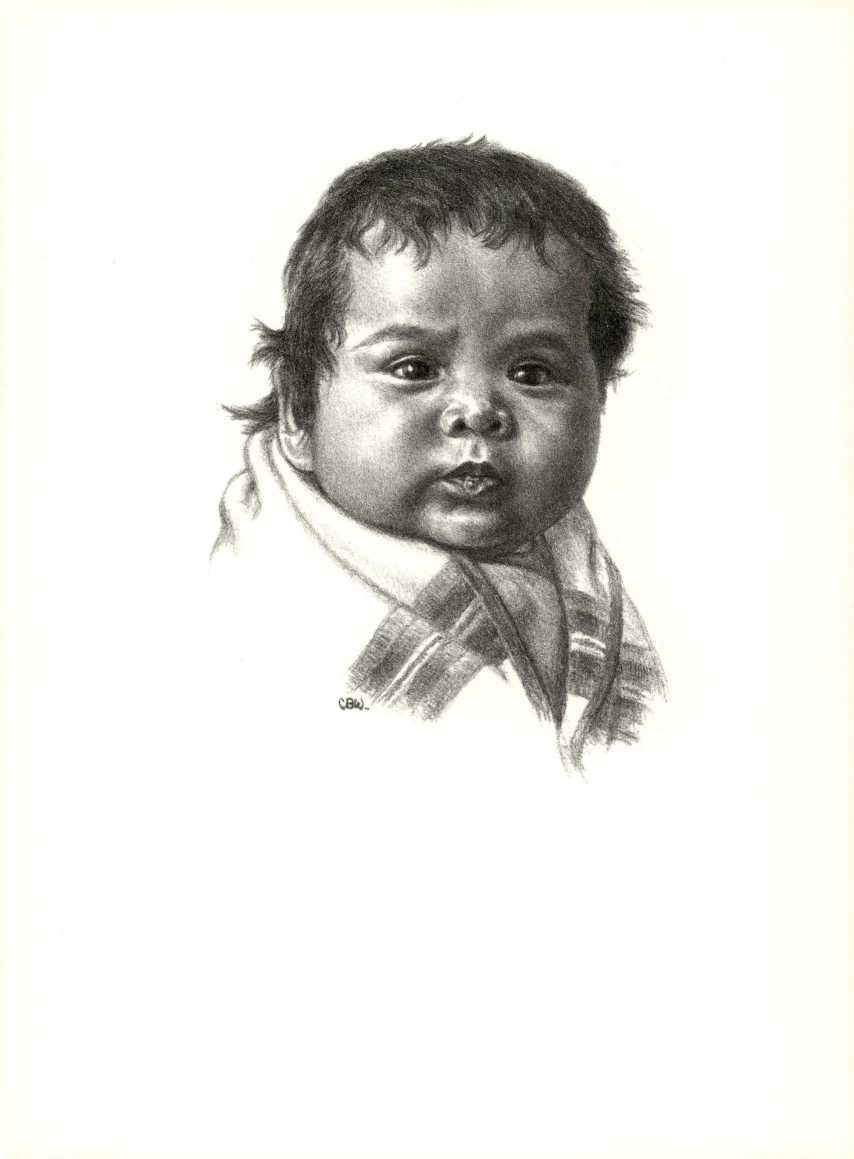

103 *Carrie's Dad*
8⅛ × 5⅛
1983 / Edition 300

One of the two stones that Wilson did of himself, this represents him in his sixty-fifth year.

"A receptionist at the Sac and Fox tribal office in Stroud, Oklahoma, pointed at me when I went there one day for information. 'We know who you are,' she told me. I suppose it impressed me to be so well known until she added, 'You're Carrie's dad.' Carrie had been Miss Indian Oklahoma and was very popular with the Indian community."

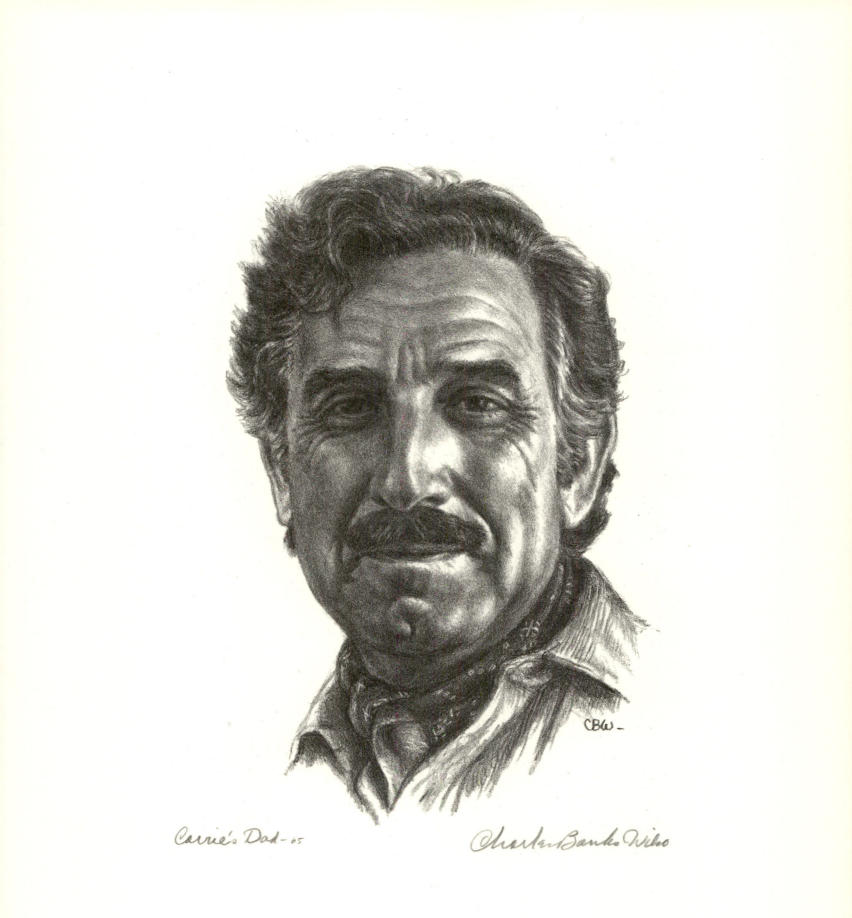

Carrie's Dad - 65 Charles Banks Wilson

104 *Feelin' Good*
12½ × 8
1983 / Edition 130

A local Modoc man posed for this portrait. Wilson later added the original sketch to his "Search for the Purebloods" collection.

"'Why, I look like an Indian!' he told me, and seemed truly surprised by that when he saw the drawing I had made of him. It was nearly forty years later that I did this lithograph."

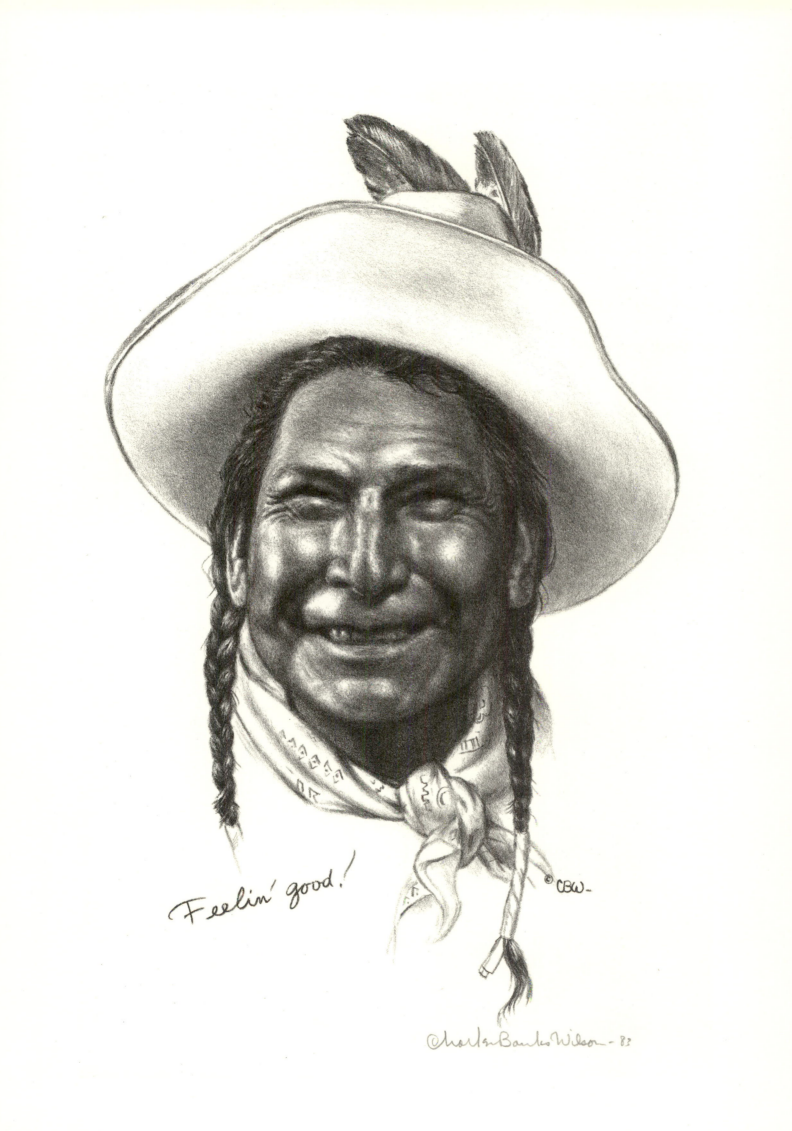

Feelin' good!

105 *Will Rogers Sketches*

17 × 11
1983 / Edition 100

Wilson's many portraits of Will Rogers include the life-size canvas at the Oklahoma capitol, three paintings for nationally sold calendars, the cover illustration for a Southwestern Bell telephone book, and a portrait commissioned by the Oklahoma Press Association.

"I first drew Will Rogers in 1934 when he performed in a local theater. I intend for this to be my last picture of him. The larger drawing represents the true-to-life man. The smaller sketches are characterizations he did for the films."

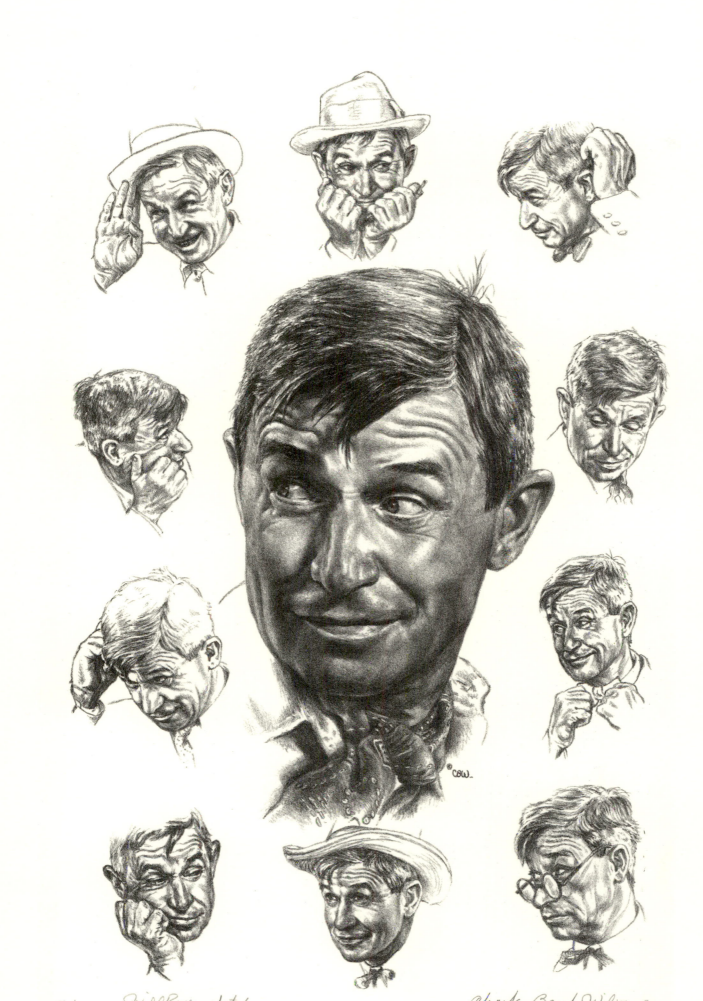

artists proof — Will Rogers sketches Charles Banks Wilson -83

106 **Spring River Float**
10¾ × 13¾
1983 / Edition 145

Popular with canoeists, Spring River flows from the north out of Kansas and Missouri past the big rocks pictured here to join the Grand and Verdigris rivers below Miami, Oklahoma. Beyond the bluffs in this vicinity the Quapaws have held their annual powwows for nearly a hundred years.

"I had to lower myself with a rope down a high bank to get in position on a gravel bar to sketch this scene. The opening of the floodgates upriver shortened my working time each day."

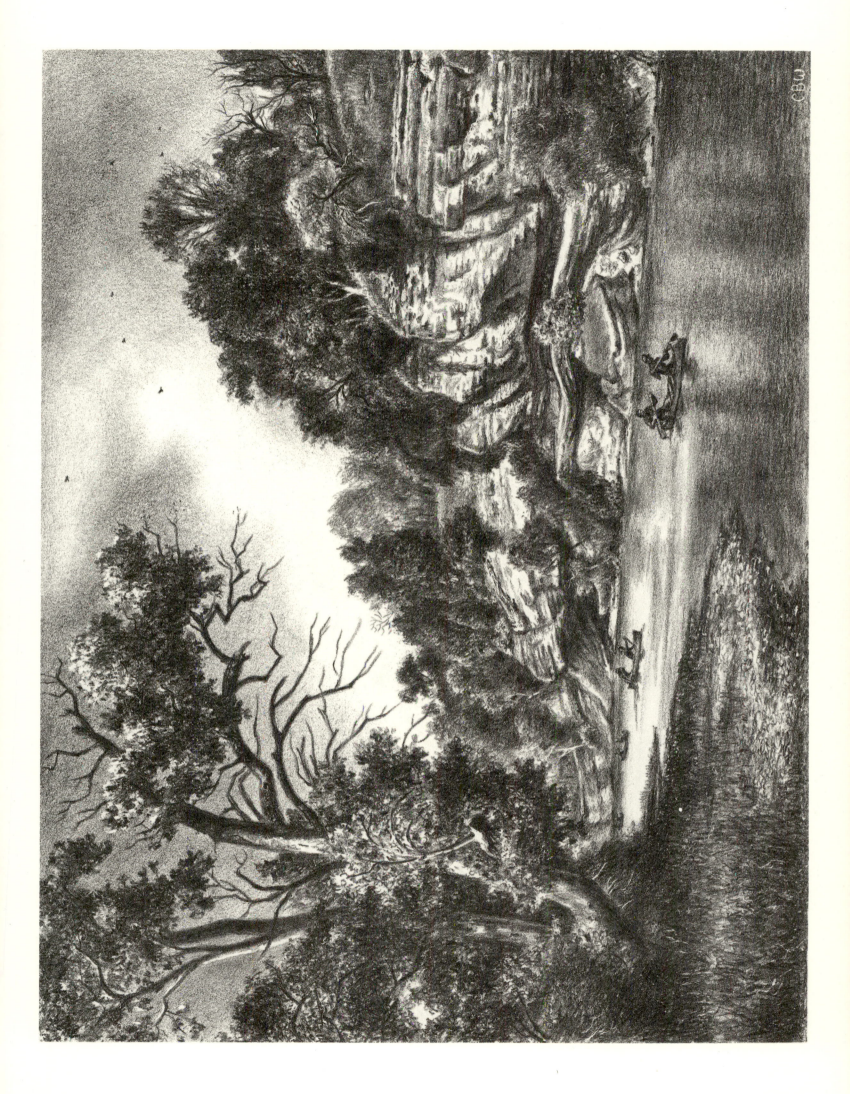

107 *Bear Hollow*

13⅛ × 10½
1983 / Edition 100

The man in this picture is not hunting but merely walking with his dog.

"My family often walked here after Sunday dinner. Many an overhang like this has been called 'Bear Hollow.' This is ours. It was always creepy fun to peer under the rock shelf and wonder what wild animals had slept there. In early winter the water seeping down the draw toward nearby Spring River would freeze going over the ledge."

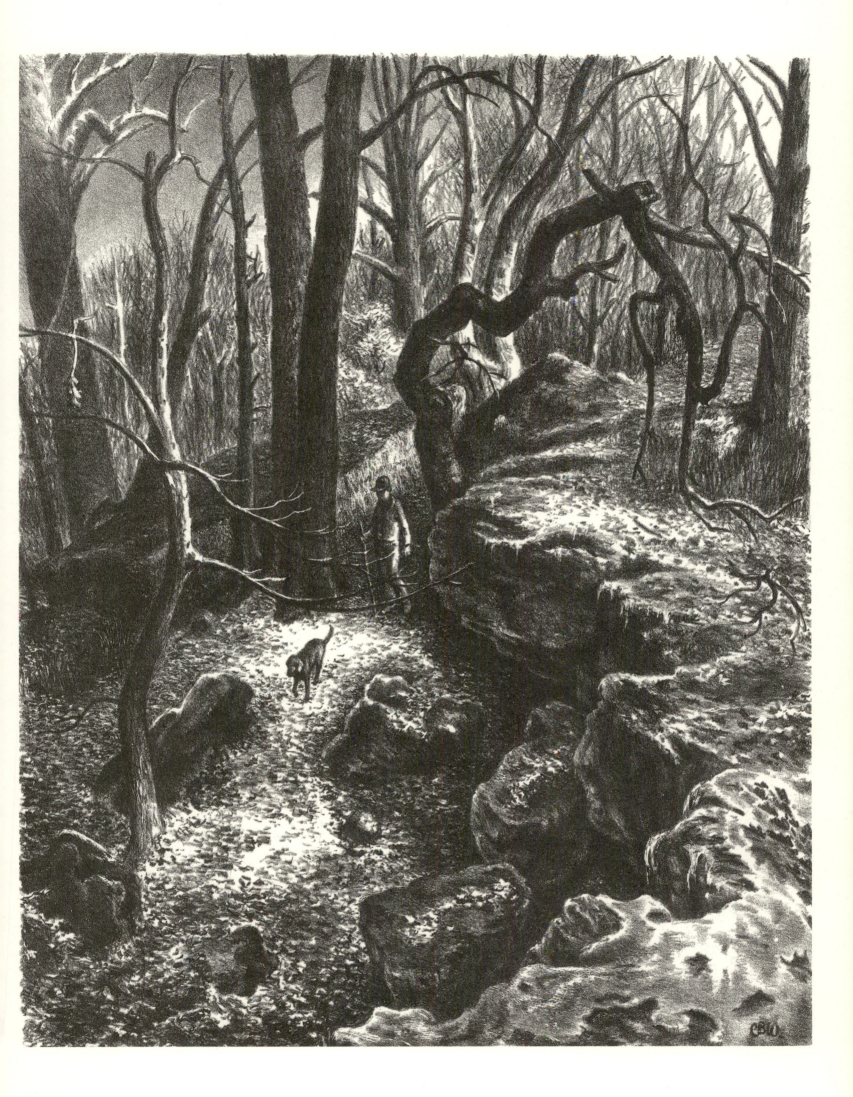

108 *Morning Chores*
8 × 11
1983 / Edition 145

In the artist's opinion this lithograph retains
much of the spontaneity of the original drawing.

*"Busy sketching the cabin, the trees, the road, and
the distant landscape, I took little notice of the boy
who came outside a number of times to get wood
from a freshly cut pile. When I did recognize what
he was doing, I knew he had given my picture a
subject."*

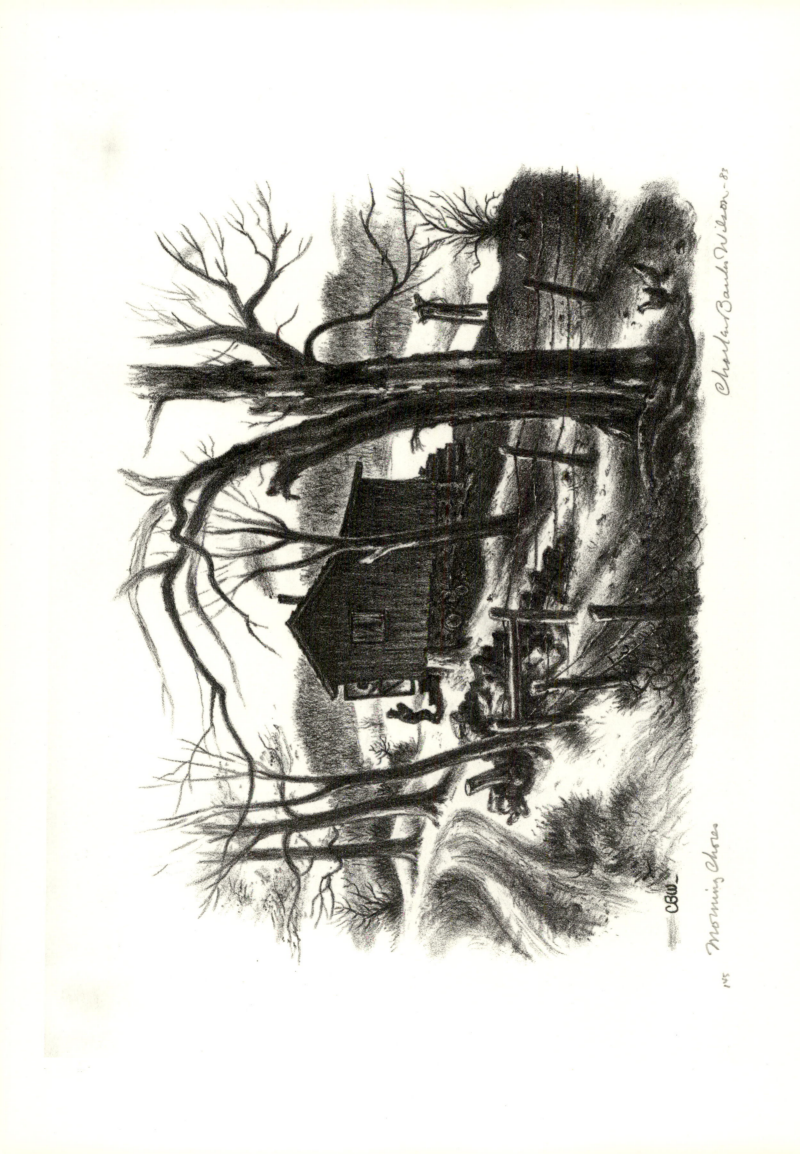

Morning Chores

Charles Banks Wilson – 83

109 **Indian Fancy Dancers**
3½ × 17½
1983 / Edition 150

Wilson returned to the subject of contemporary Indian dance in this print. The following year he produced a companion piece featuring women dancers.

"This lithograph was made from pencil sketches done at the 1983 Quapaw powwow and incorporates the figures and dress of several outstanding American Indian men dancers."

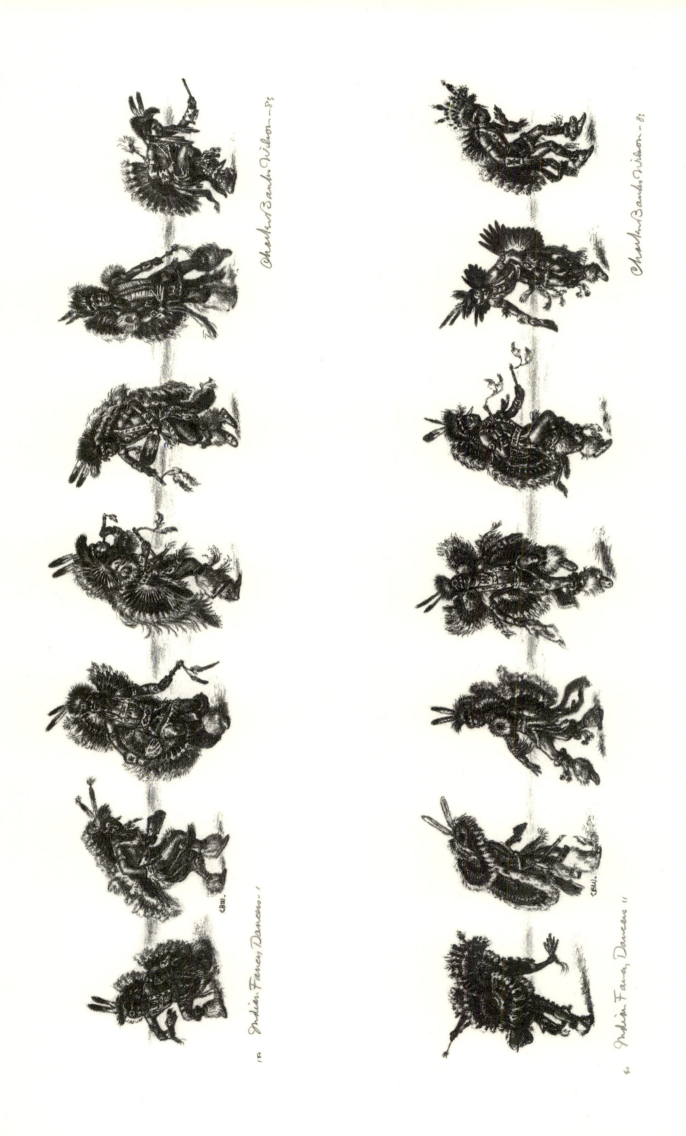

Indian Fancy Dancers I

Charles Banks Wilson —83

Indian Fancy Dancers II

Charles Banks Wilson—83

110 **Indian Women Dancers**
3⅛ × 16⅜
1984 / Edition 150

In developing these studies, Wilson had to attend several powwows before he found what he was looking for. His daughter, Carrie, a champion dancer, is pictured twice: as the fourth figure from the left and again as the small girl at the extreme right.

"Age-old tradition limits the women to a short, dignified dance step. Because of this I was forced to look for variety in dress. Among the women only the northern-style dancers, usually with a swirling shawl, break with this earlier style."

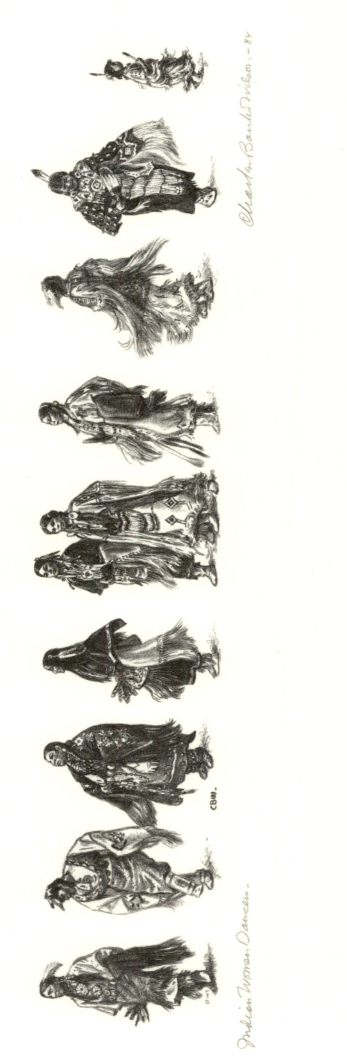

Indian Woman Dancer –

Charlie Bands Wilson – 84

150.

111 **Rabbit Tracks**

8½ × 12⅞

1984 / Edition 65

Field sketches have provided the subject matter for many fine prints. This sparkling lithograph served in its turn as the basis for a later painting.

"After I found this little stream with its uncommon cutback, I waited for a virgin snow before starting a picture. When the snow came and I went prepared to sketch, rabbits scampered every which way all over my landscape, adding texture and subject to the composition."

112 *Young Solomon*
6 × 3⅞
1984 / Edition 100

Wilson represented this member of his family as a young Jewish boy. The blanket serves him as a tallith.

"My grandson, Carrie's boy, was eighteen months old when I did this drawing. His great-great-grandfather was Solomon Quapaw, a tribal leader."

113 *Oklahoma Melody*

11¼ × 7⅝

1985 / Edition 100

The oil painting on which this lithograph is based was the first of Wilson's works to be acquired by Thomas Gilcrease for his Tulsa museum.

"At the time I did the original for this, 1943, it wasn't uncommon for lighting at powwows to consist of only one light bulb, or three or four at most, suspended from a pole or the limb of a tree, providing the barest illumination. The painting later was reproduced on the cover of the Gilcrease quarterly, American Scene. I wanted to include the picture in my collection of lithographs, so in 1985 I did this stone and tried to stay as close to the painting as I could."

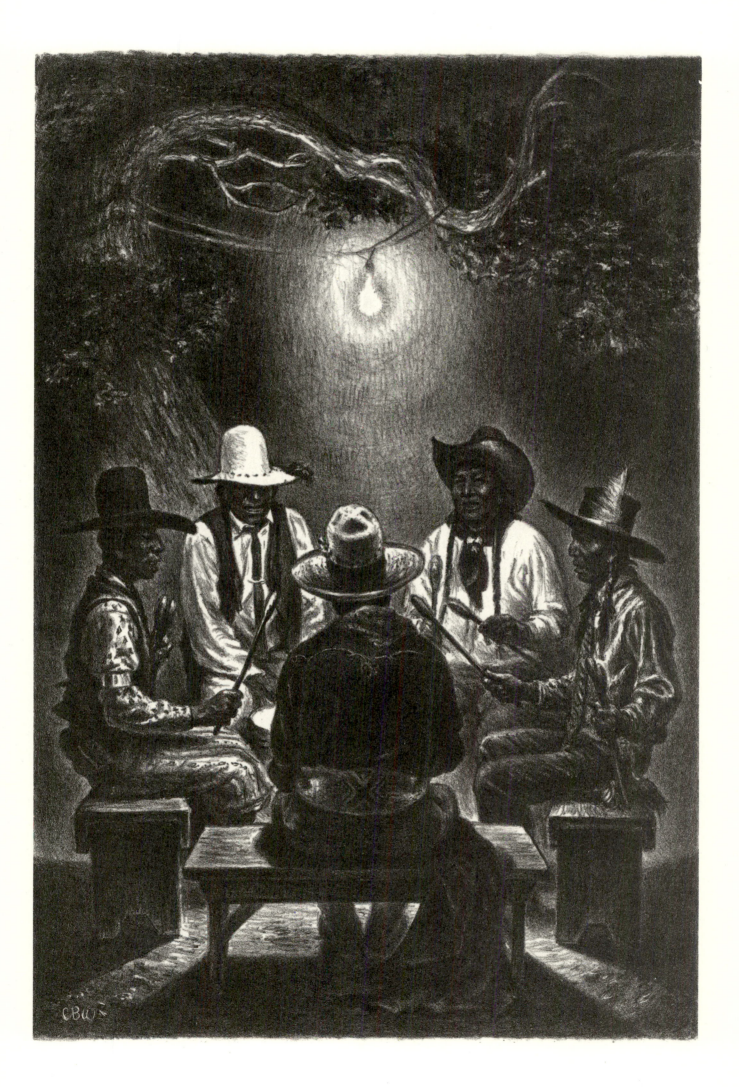

114 *Miss Angie*
14¼ × 11½
1985 / Edition 75

This print derives from one of five pencil sketches made in developing the official state capitol portrait of Oklahoma author and historian Angie Debo.

"We seemed to hit it right off. I felt that her integrity and great accomplishments deserved the best painting I could do. She was ninety-four years old in 1984 when she posed for me in the dining room of her small, spic-and-span white frame house in Marshall, Oklahoma, where everyone calls her 'Miss Angie.' She calls this lithograph her 'private face.' Her 'public face' is represented in the painting."

115 *Prairie Chief*

17½ × 12¼
1985 / Edition 300

For this print, Wilson employed the same model he had used in a painting entitled *Young Chief*. Here he presents the subject in a more aggressive, warlike attitude than the benign pose used in the painting.

"It took me a year to again locate this young man after I first saw him in town. Although the long trailer of eagle feathers usually is worn down the back, he posed with it in front of his shoulder so that it could be seen to better advantage. Since 1977, I had promised to do a companion print to the Plains Madonna. This is intended to be it."

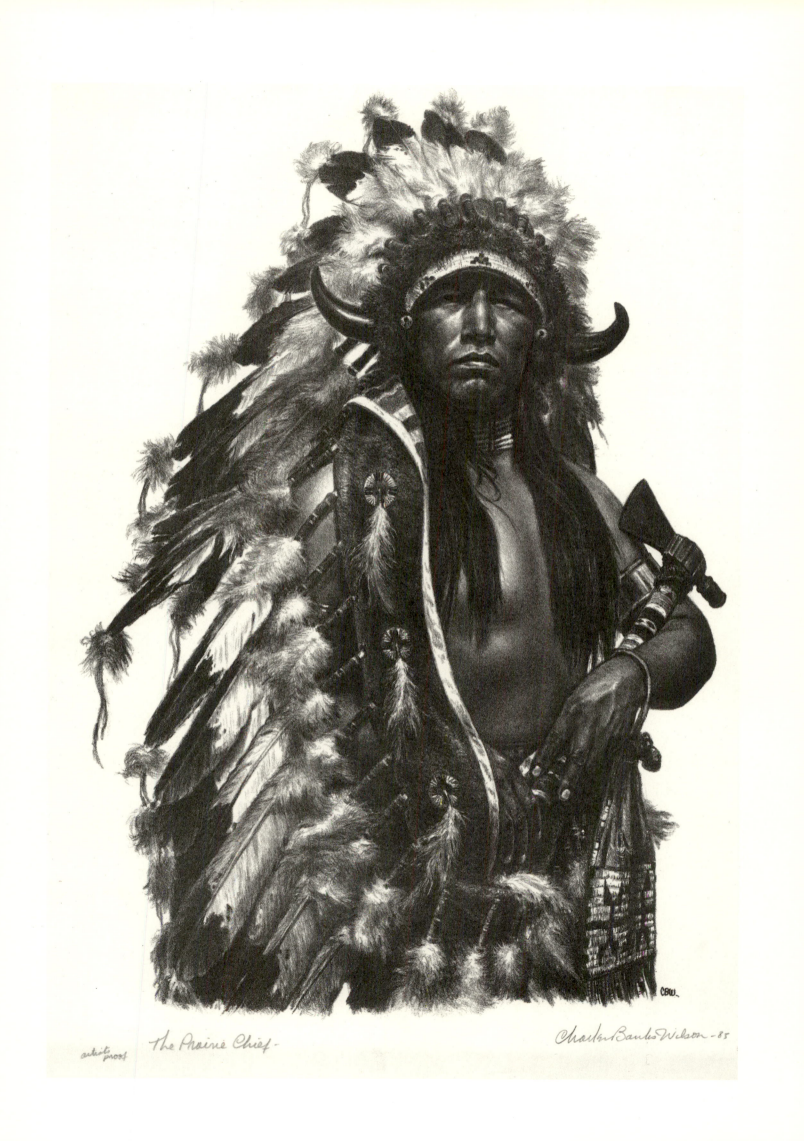

artist's proof The Prairie Chief· Charles Banks Wilson -85

116 *Trapper's Bride*
9½ × 15¼
1986 / Edition 175

This print takes its subject from a mural depicting a trappers' rendezvous in the Rocky Mountains, commissioned in 1955 by John D. Rockefeller, Jr. The original painting is displayed in Jackson Lake Lodge, in western Wyoming.

"In my research I came to the conclusion that the Shoshone women, reputed to be very beautiful, really were responsible for opening up the mountain country. To purchase a dowry for his Indian bride, the trapper often went so far in debt to the trader for goods that he had to keep trapping for more years than he had planned in order to pay off what he owed."

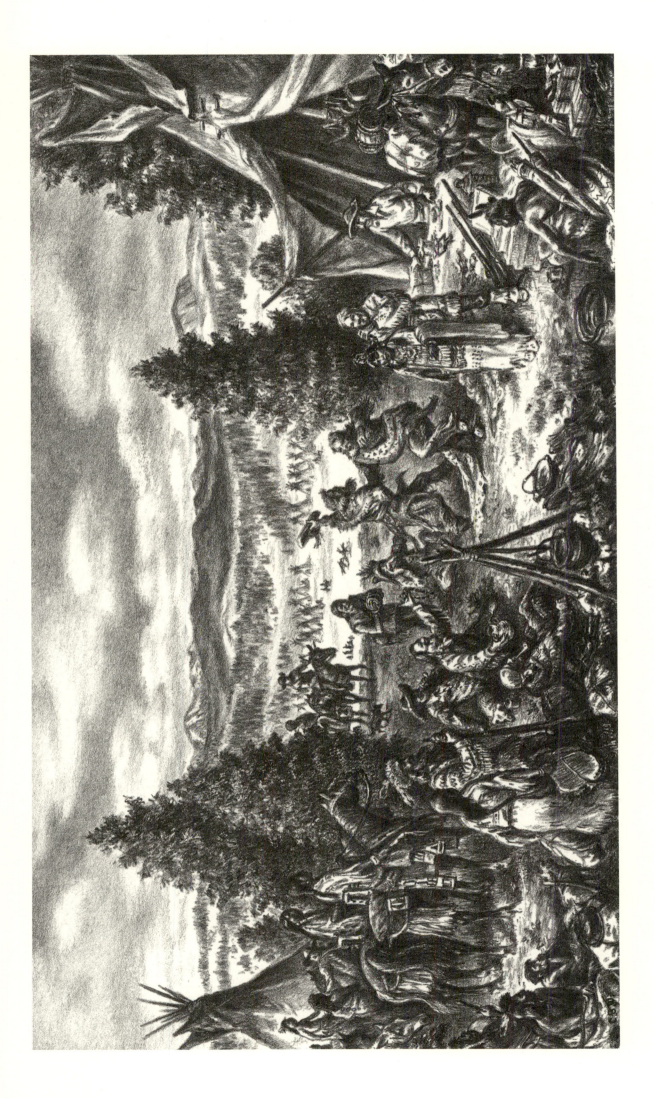

117 *Traditional Dancers*
14½ × 10
1986 / Edition 120

Developed from sketches made at an Oklahoma powwow, this lithograph portrays dancers whose dance style and dress are commonly associated with western Plains tribes.

"I have seen these costumes only in recent years. The dancers themselves prefer the northern-style songs of the Sioux. Their style of dancing evokes for me the traditional reenactment of a war party or hunt. Sometimes they are called 'Sneak Dancers' to distinguish them from 'Feather Dancers' or 'Straight Dancers.'"

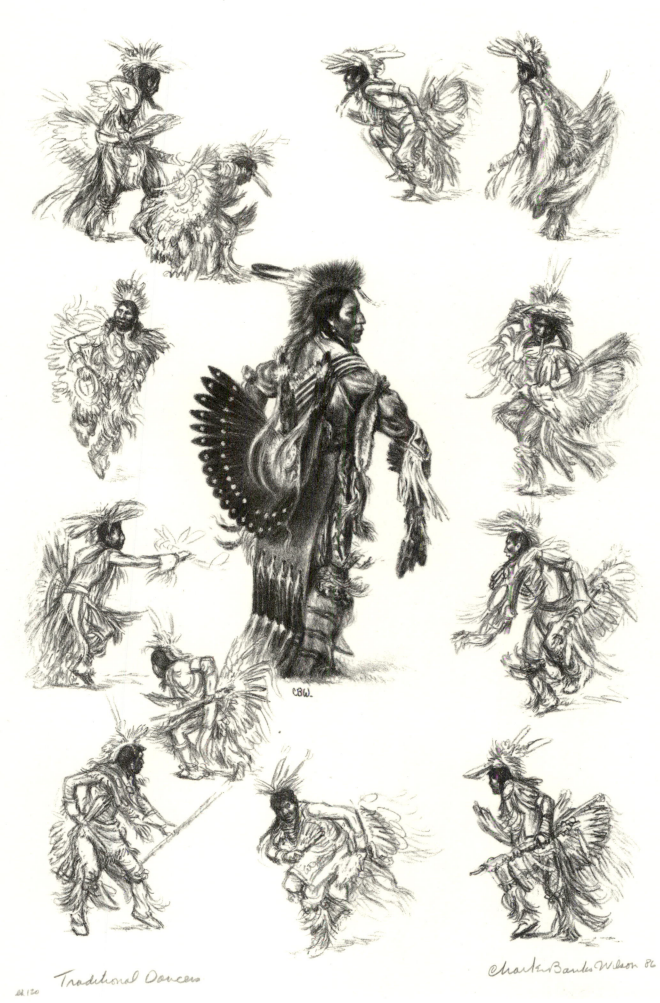

Traditional Dancers

Charles Banks Wilson 86

118 *The Quapaw—1700*
11¾ × 12¾
1987 / Edition 150

Wilson was fortunate to find this exceptional ethnic type in his own family. The model is a cousin.

"Through research, I discovered that no authentic pictures exist of the early Quapaw, a tribe that was very important in the establishment of the Arkansas Territory. Ed Quapaw, a true Quapaw, posed for this figure holding two calumets as sacred peace symbols. I added body decorations that I found represented on a Quapaw effigy pot unearthed from the Carden Bottoms in Yell County, Arkansas. Anthropologists call the design the 'Quapaw swirl.'"

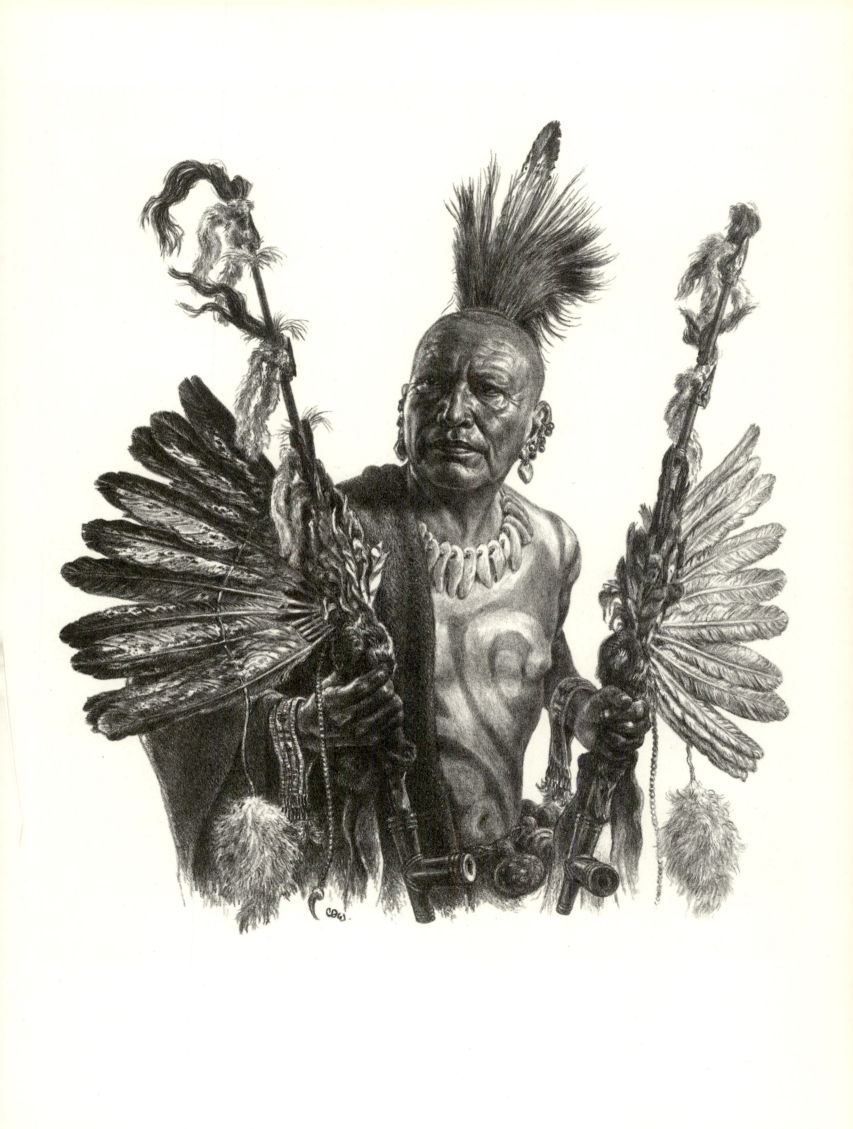

Index

Note: Since there are no page numbers in the section containing the lithographs, material in the annotations and the lithograph titles is indexed by *plate numbers*, printed in italic type.